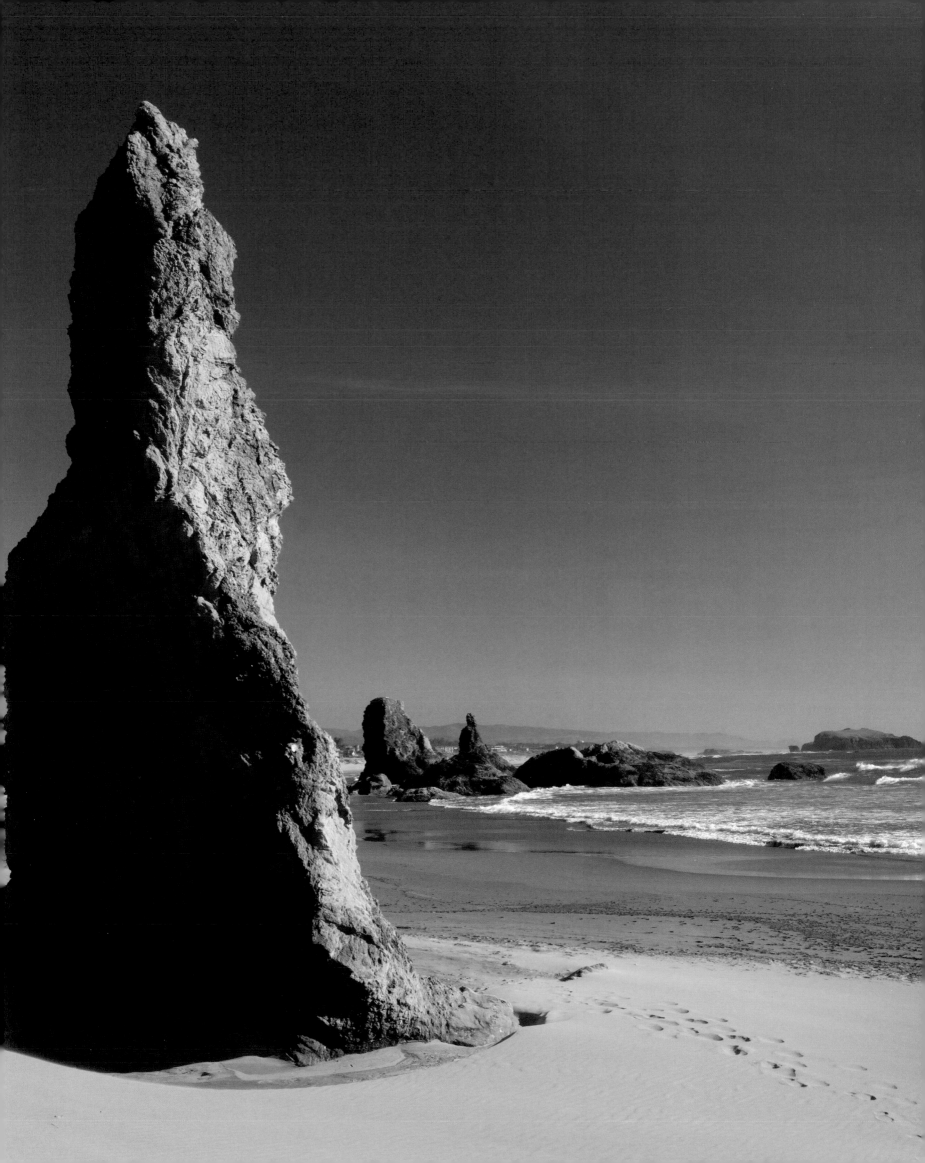

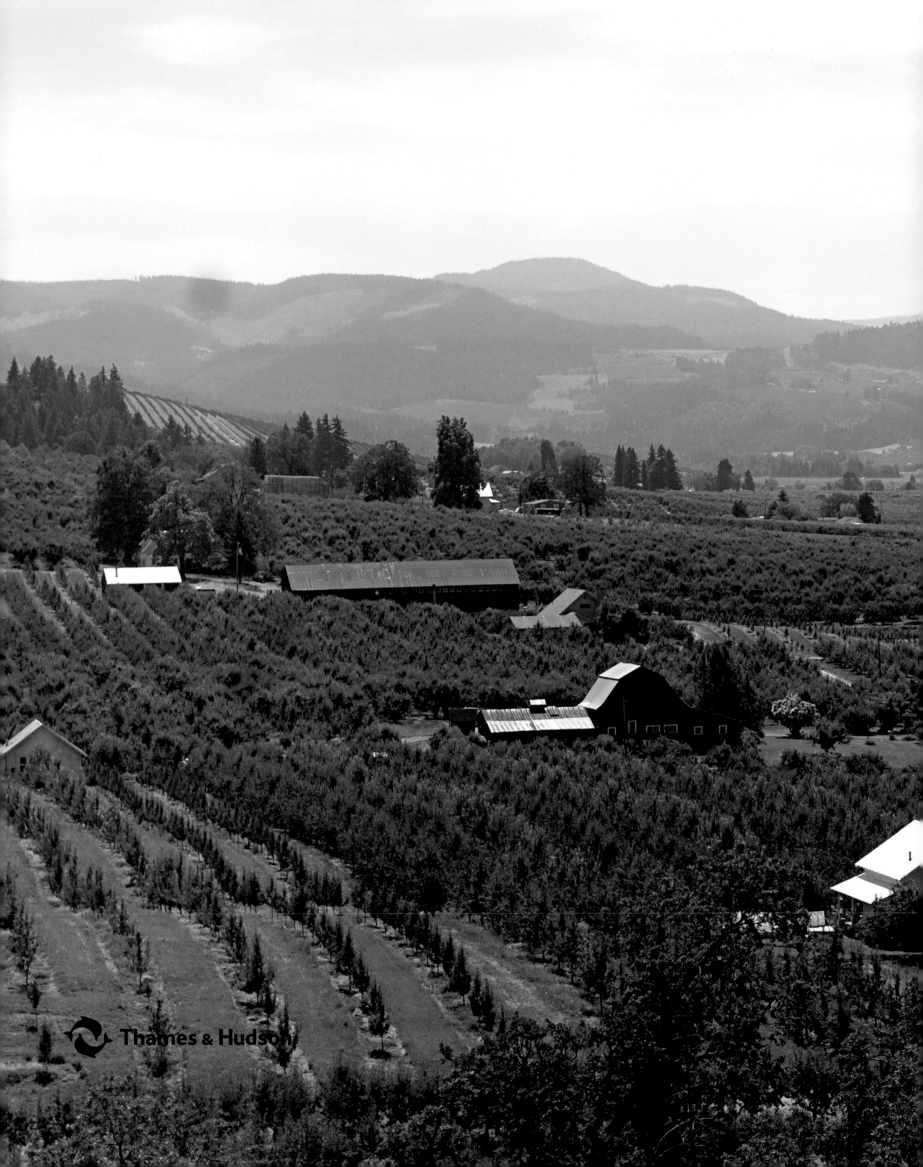

The Most Beautiful Villages and Towns

of the

Pacific Northwest

JOAN TAPPER

PHOTOGRAPHS BY NIK WHEELER

with 240 color illustrations

Half-title page: *Bandon State Beach, Oregon.*
Title pages: *Mount Hood and the Hood River Valley, Oregon.*
Opposite: *The Catholic Rectory in Jacksonville, Oregon* (top); *the town wharf in Coupeville, Washington* (middle); *the Three Sisters and the tower of the Holy Family Catholic Church in Fernie, British Columbia* (bottom).

First published in hardcover in the United States of America in 2010 by Thames & Hudson Inc., 500 Fifth Avenue, New York, New York 10110

thamesandhudsonusa.com

First published in the United Kingdom in 2010 by Thames & Hudson Ltd, 181A High Holborn, London WC1V 7QX

www.thamesandhudson.com

Library of Congress Catalog Card Number 2010923289
A catalogue record for this book is available from the British Library

ISBN 978-0-500-51534-1

Printed and bound in China by 1010 Printing International Ltd

Contents

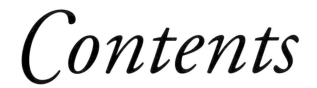

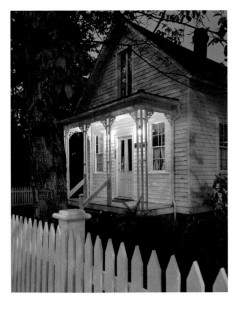
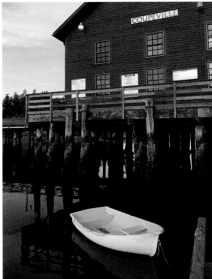
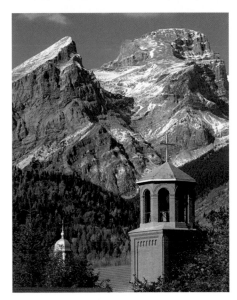

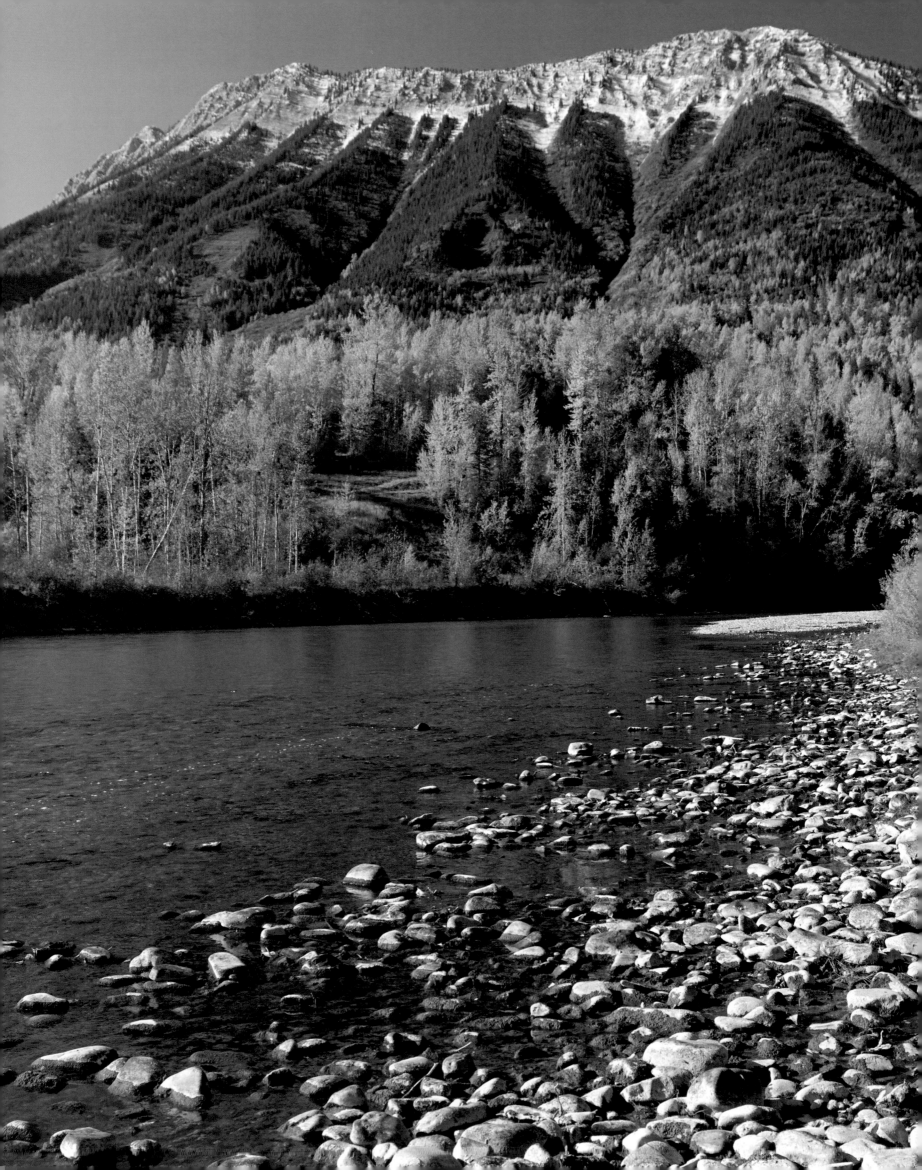

Introduction

What is the attraction of the Pacific Northwest? Is it the image of pine-covered mountains edging a sparkling cove? Or is it something more intangible: a realm of infinite possibility, a paradise where abundant natural resources once promised a prosperous future colored in rich earth tones. Long before this corner of North America had been divided into Oregon, Washington, and British Columbia, it was a bountiful wilderness whose first treasures were fish, towering forests, and fur-bearing animals. Much of the region had ample rainfall, lower elevations enjoyed a relatively mild climate, and ancient volcanic flows had laid down fertile soils. Later, settlers cultivated agricultural riches such as fruit and wheat, and discovered the glint of minerals – all gifts supposedly waiting for those who would go after them, although in reality it often required heroic efforts.

For one thing, this was a difficult place to get to. The Northwest was edged by the Rocky Mountains and divided by other forbidding ranges that impeded travel from east to west, leaving only tortuous rivers as the main thoroughfares in the region. The wide, sandy beaches on the Pacific offered few harbors, and where the rivers emptied into the ocean, the passage was tricky and dangerous.

The native peoples who had lived here for thousands of years – more than 100 tribes speaking 50 languages – knew how to capitalize on their environment. Along the coast they harvested fish and marine mammals, and used the trees, particularly cedar, for canoes, implements, and ceremonial objects. In the more arid east, they caught salmon that fought their way upstream, foraged for roots, and hunted elk and deer. Many tribes were also adept traders, a skill that was useful when Europeans began to enter the area from several directions.

The English explorer Sir Francis Drake was perhaps the first European to land on the Northwest coast, in 1579. Nevertheless the Spanish, from their base in Mexico, simply considered the Pacific "theirs," though for centuries they did little to defend the territory or set up pueblos beyond California. In the 1770s, however, they were shaken out of their lethargy by Russian explorers seeking furs in Alaska and, not incidentally, a Northeast Passage to Europe. For their part, the British had been looking for a Northwest Passage to the Pacific since the late 16th century, and though their efforts had come to naught, the elusive route still intrigued them as they worked their way across the North American continent by land.

The Elk River flows gently in front of forested slopes in the Rocky Mountains around Fernie, British Columbia (opposite), inviting fly fishermen to try their luck. Yellowing leaves herald the coming of autumn and, perhaps, the arrival of skiers to replace summer sportsmen in this Northwest playground. The 123-foot-high Astoria Column (below) marks historic events in Oregon Country with sgraffito decoration that begins with the forest primeval and ends with the arrival of settlers in the 1800s.

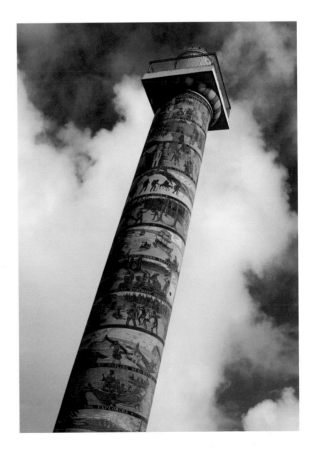

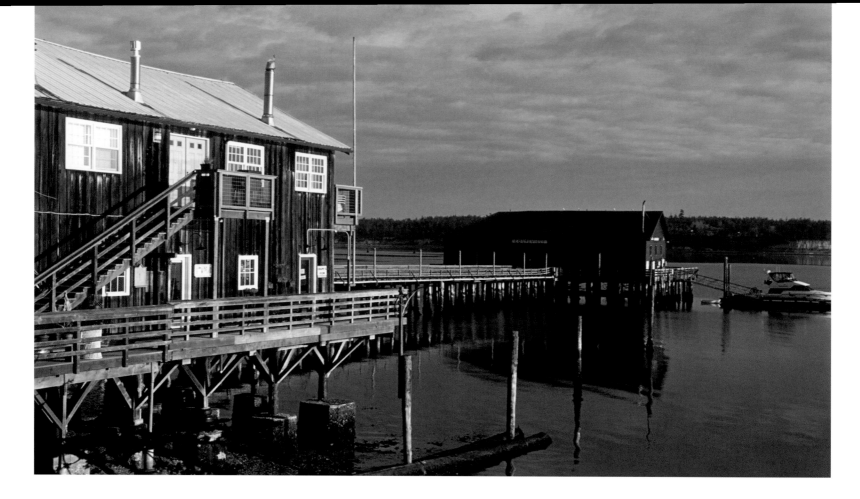

Coupeville's town wharf (above) *extends off Whidbey Island into Washington's Penn Cove, whose waters once buzzed with the ferries and other small vessels that made up Puget Sound's "mosquito fleet." Below: The Adler House museum in Baker City, Oregon, preserves the look of the late 1800s, when the residence was home to a well-to-do merchant family.*

By 1775, Spaniards Juan Pérez and Juan Francisco de la Bodega y Quadra explored as far as the Queen Charlotte Islands before turning back, and Bruno de Heceta actually spotted the Columbia River but feared to enter it. English explorer Captain James Cook soon followed in their wake. On his third voyage of discovery, in 1778 (with subalterns who included George Vancouver and William Bligh), he made landfall on the Oregon coast and traded with the Indians of Nootka Sound (on Vancouver Island) for some sea-otter pelts. Bad weather kept Cook from noting the entrance to the Columbia River and penetrating Puget Sound, but he got as far as the Bering Strait. Facing icy seas, he sailed south to Hawaii, where he was killed in 1779. Remember those sea-otter pelts? On their homeward journey, Cook's men sold the furs for an astonishing price in China, launching an enterprise that would have far-reaching consequences.

In 1792 Captain Vancouver returned to the Northwest at the helm of his own ship. He sailed around the huge island he named after himself and charted the intricacies of the sound he christened after Lieutenant Peter Puget. In fact, Vancouver gave a name to pretty much everything in sight, from Admiralty Inlet, Deception Pass, and Whidbey Island to Mount Adams, Mount Baker, and Mount Rainier. He did miss one major feature: It was an American trader, Captain Robert Gray, who managed to steer the *Columbia Rediviva* over a formidable sandbar and up the great river that is still known by his ship's name.

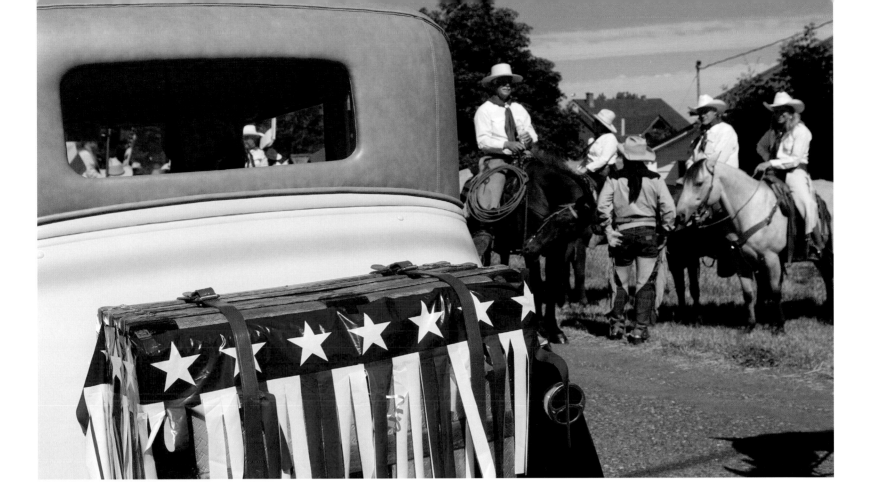

As seafarers began to develop the fur trade along the coast, others attempted to reach the lucrative region from the east. The British mercantile North West Company dispatched Alexander Mackenzie to look for the source of the Columbia in 1793; unsuccessful, he made it to the Pacific coast much farther north. A dozen years later, another company man, Simon Fraser, would follow his eponymous river to the site of the modern-day city of Vancouver.

Meanwhile, two Americans had orders from President Thomas Jefferson to explore the newly acquired Louisiana Purchase all the way to the Pacific Ocean. In May 1804 Meriwether Lewis and William Clark and some 30 men set off by canoe up the Missouri River. They wintered with Mandan Indians in North Dakota and were on the move again in April. By then a French interpreter and his Shoshone wife, Sacajawea, had joined the Corps of Discovery, which crossed the Rockies and made its way down the Snake and the Columbia Rivers. The men took notes, mapped their route, and arrived at the Pacific in mid-November 1805. The group had traveled 4,000 miles, proving that such an epic feat was possible. But their mission was only half over. After a miserably rainy winter in makeshift Fort Clatsop, Lewis and Clark turned around and more or less retraced their route back to Missouri – and everlasting fame.

Once their journals were published, it was as though someone had opened the gates to the wilderness. In 1811 John Jacob Astor sent two expeditions – one by land and one by sea – to set up a Pacific Fur Com-

Stars-and-stripes trimming adds an air of patriotism to the festivities of Chief Joseph Days, which celebrate cowboy skills and Native American traditions, in the Wallowa Valley of eastern Oregon (above). *The decorative stone and brick cornices on Front Street, in Kaslo* (below)*, date to the mining and ore-shipping days of the British Columbia town.*

An antique automobile – part of a classic car show – brings a little polish to Main Street (above) *in Winthrop, Washington, which adopted a community-wide Old West look to attract visitors after the North Cascades Highway opened. Below: Port Townsend architect George Starrett designed a magnificent spiral staircase for the Queen Anne residence he built for his wife, Ann, in 1889.*

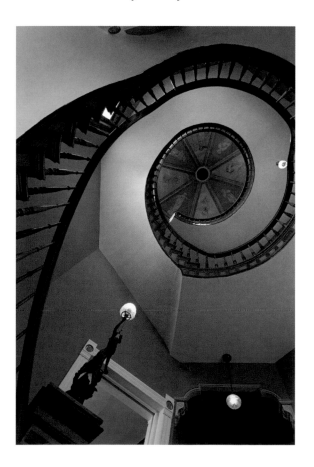

pany trading post near the mouth of the Columbia River. When David Thompson, another intrepid North West Company explorer, finally discovered the source of the Columbia River and traced its passage to the ocean, he was astounded to find Americans there ahead of him. Although Astor's men sold out to their British counterparts as the War of 1812 loomed, their settlement had established America's claim to the area. As for British interests, the North West Company, later absorbed by the venerable Hudson's Bay Company (whose initials were jokingly interpreted as "Here Before Christ"), essentially acted as a government representative.

The influence of the Spanish and the Russians was clearly on the wane; both those powers would soon give up their claims. But the British and Americans were in the Pacific Northwest to stay. From the northern border of California to the edge of the Alaskan islands, "Oregon Country," with its plentiful natural resources, was a territory well worth wrangling over. That conflict would play out commercially and diplomatically over the next 30 years.

In 1827 the Hudson's Bay Company established Fort Langley on the Fraser River, not only as a fur-trading post, but also to ship salmon, produce, and other goods around the globe. A year later, the Company built Fort Vancouver across the river from modern-day Portland and appointed John McLoughlin to preside over its vast trading empire. He was there in 1836 to welcome the small group of American missionaries – including Marcus and Narcissa Whitman – who had crossed the continent. The Whitmans would build a mission on the east side of the Cascade Mountains, not far from another Company fort at Walla Walla. Although the Whitmans' preaching ended with their death at Indian hands in 1847, their travels across the plains and over the Rockies had helped to lay the groundwork for the Oregon Trail.

In 1843 a thousand emigrants set off for Oregon Country on what became known as the Great Migration. Thousands more would follow, fueling American sentiment for Manifest Destiny, the belief that the U.S. should control all land west of the Rockies, as far north as Alaska. "Fifty-Four-Forty or Fight" was the slogan, referring to the goal of a boundary at 54°40' north, but in 1846, the U.S. and Britain agreed to an international boundary at the 49th Parallel and gave Vancouver Island to the English. Oregon joined the Union as a state four years later, Washington in 1889.

Borders were irrelevant, however, when the search for gold was involved. The discovery of ore in the Fraser River region lured so many American prospectors north that Britain worried about losing its authority. In response, on November 19, 1858, it created the colony of British

Columbia with a ceremony at Fort Langley, and eight years later added Vancouver Island to the province.

With the exception of Astoria and Fort Langley, which both had their beginnings in the fur-trading era, the towns in this book were founded from the mid-19th century onwards. Many owe their birth to settlers who followed the Oregon Trail west in pursuit of a better life, or who first tried their luck in the California gold fields and then fanned out to put down roots elsewhere. The pioneers took advantage of the forests and fisheries, carved out lucrative farms on fertile lands, and used advantageous locations – first along waterways, then at crossroads, and finally on railway lines – to found settlements and make their fortunes.

For the most part, these towns had grand ambitions, which prosperous merchants showed off by building fine houses, impressive hotels, and ornate commercial blocks. But often something stopped them in their tracks: Another, better port emerged; roads or railways shifted their routes; the Depression took the steam out of local enterprises. By the time the communities were on their feet again, the region's attention had irrevocably focused on its three great cities – Portland, Seattle, and Vancouver.

The little towns may have languished, but they didn't disappear. Artists discovered them. Vacationers flocked to their beaches and mountains. Preservationists renovated their architectural treasures. Farmers replanted their lands with desirable new crops. Decades later, these places are travelers' delights, charming gems populated by passionate advocates for local heritage who are happy to share their corner of paradise.

In choosing the towns for this book, Nik Wheeler and I began with the decision to include southern British Columbia, since that province shared its early story with Oregon and Washington. In the past it was often easier to transport goods – whether ore or whiskey – across the border to the U.S. than to move them east or west within Canada itself. And today, too, tourists to the Northwest frequently visit both Canada and the U.S. in a single trip.

We also wanted to reflect the region's different environments and its various eras. We set a limit of 40,000 on population, though most places are only a fraction of that size. These are small towns, communities where a pause to admire a house in Albany will bring out the owner to tell you about its history, and where someone always has the keys to a local museum or, as in Fernie, to the magnificent courthouse. Above all, we looked for towns with both man-made and natural beauty as well as interesting stories.

In Oregon, Astoria has a fascinating early history and preserves a wealth of Victorian architecture. Jacksonville, too, retains the look of a 19th-century town, thanks to the historic district status that kept it

Hospitality pours out of the bar at the Windsor Hotel (above) *in Fort Steele, where a heritage town re-creates the British Columbia outpost of the 1890s. Lighthouse keepers at Oregon's Yaquina Bay led a solitary existence for the three years – 1871–74 – that the original beacon was lit. Today their parlor* (below) *and other accommodations are on display for visitors.*

Time has stood still in Roslyn, Washington (top), where the peaked wooden façades of Main Street are little changed from the community's coal-mining days a century ago. The Church of the Holy Redeemer (above), built between 1897 and 1902, offered a spiritual home to the Kwantlen First Nation band on McMillan Island, across a channel of the Fraser River from British Columbia's historic Fort Langley.

from obliteration. Albany and Brownsville are also preservationists' treats. Bandon, Florence, and Cannon Beach all have incorporated their seaside history into their modern reputations as coastal getaways. Baker City not only is near the Oregon Trail but also boasts a turn-of-the-century downtown. Joseph has combined its Western atmosphere with a new focus on bronze sculpture. Ashland's local arts are more dramatic, including a renowned Shakespeare Festival. Hood River has welcomed skiers in winter and windsurfers in summer while retaining its lovely orchards. And McMinnville has become the heart of Oregon's wine country,

In Washington, Port Townsend's 19th-century seaport is known for magnificent old residences and quirky contemporary artists. Coupeville, La Conner, and Gig Harbor were also once hubs for water traffic; now their waterfront downtowns are filled with art galleries and boutiques. Oysterville's past is poignantly preserved in its historic district, while its neighboring towns on the Long Beach Peninsula continue their longstanding traditions as resorts. Ellensburg, in the center of the state, has rediscovered its Victorian past without giving up its love of rodeo; Winthrop, in the North Cascades, also has embraced an Old West look. And Walla Walla's wheat fields share space with vineyards.

In the San Juans, Friday Harbor and Eastsound, which once played a small but crucial role in international history, now tempt visitors with their easygoing island lifestyle. Bucolic, artsy Ganges, on Salt Spring Island, is in many ways their Canadian counterpart.

Fort Langley re-creates an early chapter of British Columbia's past, just as Fort Steele Heritage Town represents the province in the 1890s. Nelson's fine architecture dates to its time as a mining district center;

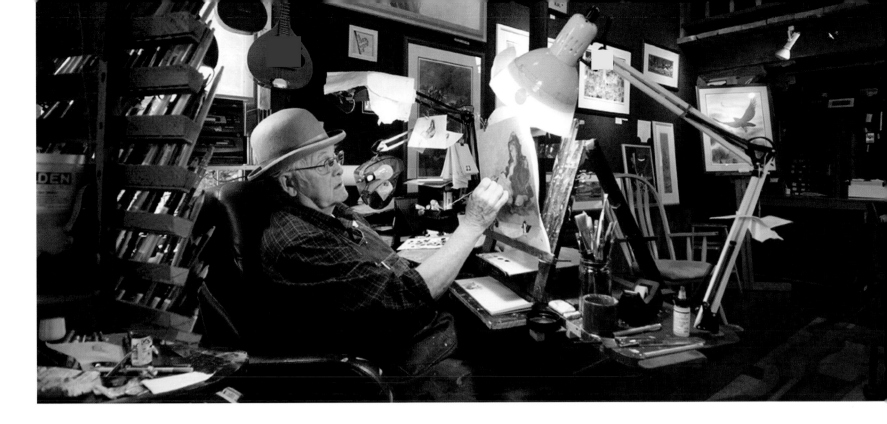

its lively atmosphere today comes from its community of artists and individualists. Ladysmith and Fernie both started as coal towns, while Revelstoke sprang up with the Canadian Pacific Railway, which engineered a route though daunting mountains and in the process ensured that British Columbia would join the Canadian confederation in 1871. Today Revelstoke is a skiers' mecca, as is Whistler, which transformed itself from a onetime fishermen's summer resort to the site of the 2010 Winter Olympics.

Interspersed with these towns, we've included three broader essays on other aspects of the region: the picturesque historic lighthouses of the coast, the lush gardens nurtured by the climate, and the wine areas that offer the prized vintages – and fine cuisine – that are hallmarks of the Pacific Northwest today.

Of course, every rose garden has its thorns. The most charming towns may attract overwhelming numbers of visitors at certain times of year and, in emphasizing tourism, may have given up the nitty-gritty necessities that locals count on. And even in a part of the world that once seemed blessed with unending resources, we now know the bounty of the sea is not limitless and the forests will only be there if we choose to keep them.

So what is the siren call of the Pacific Northwest today? It may still be that image of a forested cove, a place where you can kayak and watch for sea otters and other marine mammals. It may be untracked snow on mountain peaks, or a superb meal of fresh salmon with a glass of pinot noir. Or perhaps it's finding the good life in a close-knit community, a joy in the natural environment, and a belief in an earth-toned future that relies not on limitless abundance but on a sense of balance.

Artist at work: William Steidel (top) *welcomes visitors to his studio-cum-gallery in the oceanside Oregon town of Cannon Beach, a home for many painters and sculptors. In Jacksonville, the elegant Italian-inspired brick mansion that lawyer Benjamin Franklin Dowell constructed in 1861* (above) *is just one of dozens of homes that are part of a designated National Historic Landmark District.*

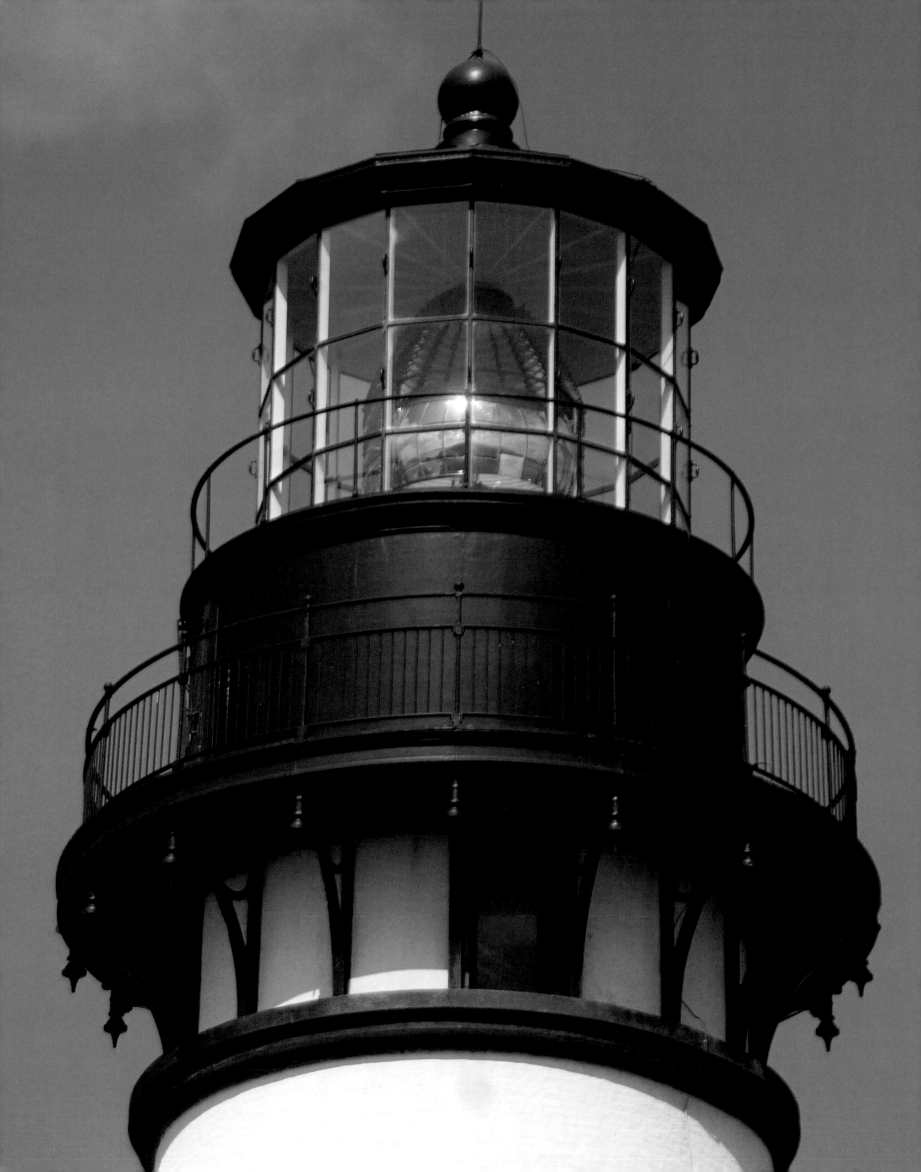

Lighthouses
BEACONS ON THE COAST

Amid the exhibits on noted shipwrecks and rescues, the Columbia River Maritime Museum displays a second-order Fresnel lens that once illuminated the North Head Lighthouse near Cape Disappointment. It looks like a huge, multi-sided cyc, with prisms that can focus a beam and send it miles out to sea. Beautiful as these lenses are, they were hardworking tools, playing a crucial role in ensuring the safety of ships along the treacherous coasts of the Pacific Northwest.

The coasts were treacherous indeed – with towering waves, frequent blinding fogs, and obstacle courses of shoals, rocks, and jutting headlands. Where rivers flowed into the ocean, there were also the problems of unpredictable currents and shifting sandbars. The area around the mouth of the Columbia alone was responsible for sinking 2,000 ships since 1792. There's a reason it's called the Graveyard of the Pacific.

In response to these threats, by the end of the 19th century there were a score of lighthouses in Washington and Oregon. British Columbia had several dozen, too, both on Vancouver Island and along the mainland. Most lights had a distinctive beam color or pattern that allowed ships at sea to identify them.

In the early days, maintaining the lights called for constant vigilance and unceasing chores by a keeper and an assistant or two. At first, most lights were lit by coal oil, so fuel had to be hauled up to the tower. The wicks of the lamps had to be regularly trimmed, and the lenses kept clean of soot. Clockworks, which had to be wound by hand every four hours, turned the beacons from sunset to sunrise.

For the lighthouse keepers – in the U.S. they were members of the exacting Lighthouse Service – and their families, it was generally a lonely life in remote locations. They might keep a cow and cultivate a garden, but other supplies had to be delivered by boat – or sometimes by wagons that ran on sandy beaches at low tide. Inspections were regular and rigorous, though the Lighthouse Service thoughtfully provided a portable library stocked with new books every few months.

In the 1930s the Coast Guard took over the management of lighthouses in the U.S., and over time both coal lamps and clockworks were

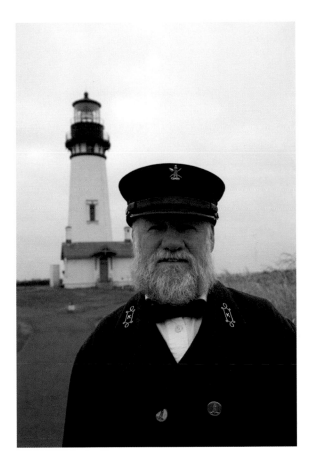

The honor of Oregon's tallest lighthouse goes to Yaquina Head (opposite)*, whose 93-foot-high tower was completed in 1873. The original Fresnel lens made in Paris in 1868 was electrified in 1933 and automated in 1966. In the early days, a member of the Lighthouse Service tended the works; today a costumed docent* (above) *at the interpretive center, north of Newport, explains the strict daily routines of a 19th-century keeper and his family.*

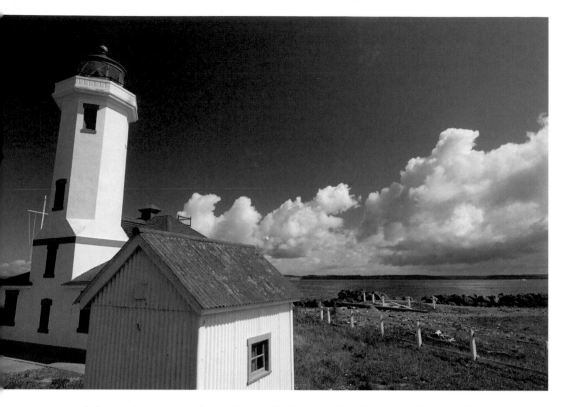

A whale-watcher's delight, the diminutive lighthouse in Lime Kiln Point State Park (opposite), *on the west coast of San Juan Island, has been turned into a research station for the porpoises, dolphins, and whales that frequent Haro Strait. Fogs, tricky tides, and a strategic location prompted the construction of Point Wilson Lighthouse* (above) *on Admiralty Inlet outside Port Townsend. The 1914 octagonal tower was the second built here.*

replaced with electricity and automation. And though the Fresnel lenses had been state-of-the-art for their time, almost all were supplanted by smaller, brighter lights.

Today the lighthouses of the Northwest are fascinating, picturesque exclamations on an already beautiful coast, often maintained as parks with the help of contributors and loyal volunteers. Many of the lighthouses include interpretive exhibits. Along with their varied sizes, shapes, and locations, each has a slightly different story to tell.

Fisgard Lighthouse, just outside Victoria on Vancouver Island, is the oldest on Canada's west coast. Built in 1860, its two-story red-brick keeper's cottage is now a museum at the end of a spit of land off Fort Rodd Hill.

The Admiralty Head Lighthouse, on Washington's Whidbey Island, occupied a strategic location not only for shipping but also for defense. The 1903 lighthouse is now within Fort Casey State Park, whose fortifications were built as part of a planned "triangle of fire" to protect Puget Sound from naval attack. Point Wilson, across Admiralty Inlet, came to be part of Fort Worden, another corner of the defensive triangle that has become a state park. Magnolia Bluff, at the bottom of Puget Sound in Seattle's Discovery Park, is home to the West Point Lighthouse, which began operation in 1891 and was the last in the state to be fully automated, in 1985.

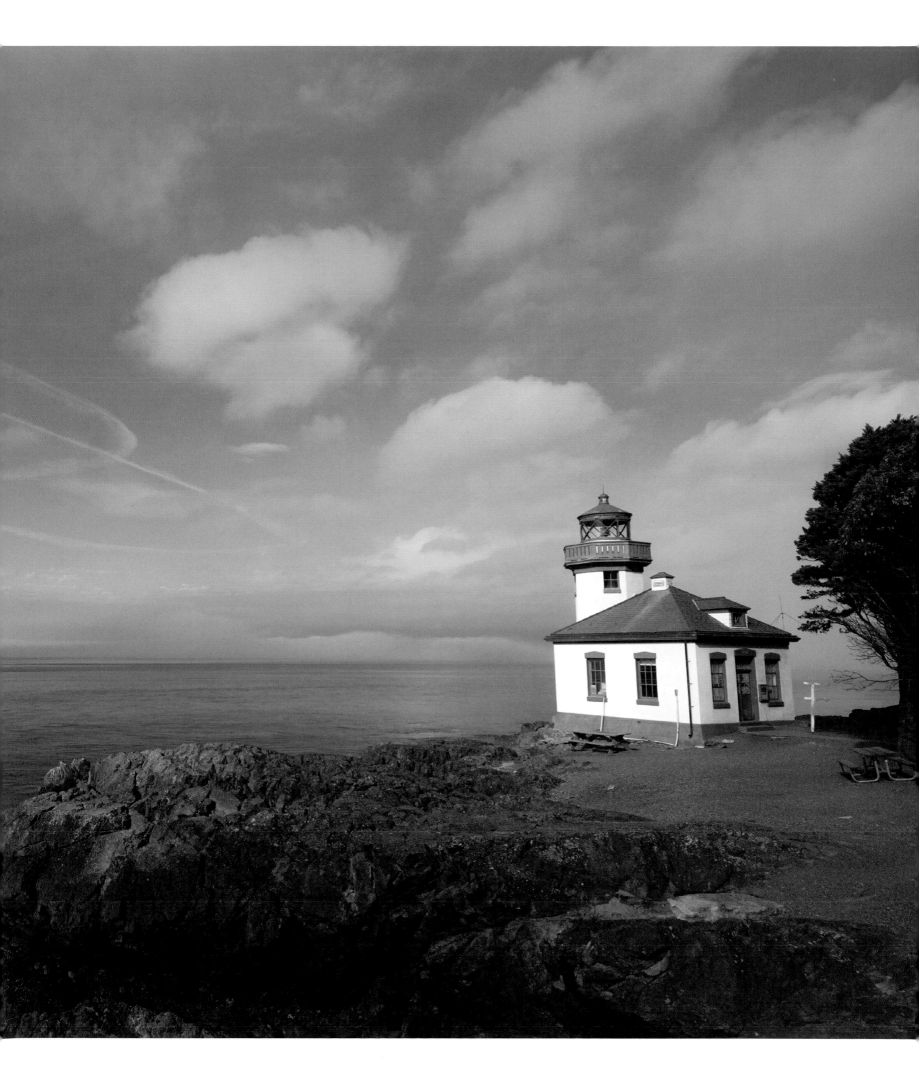

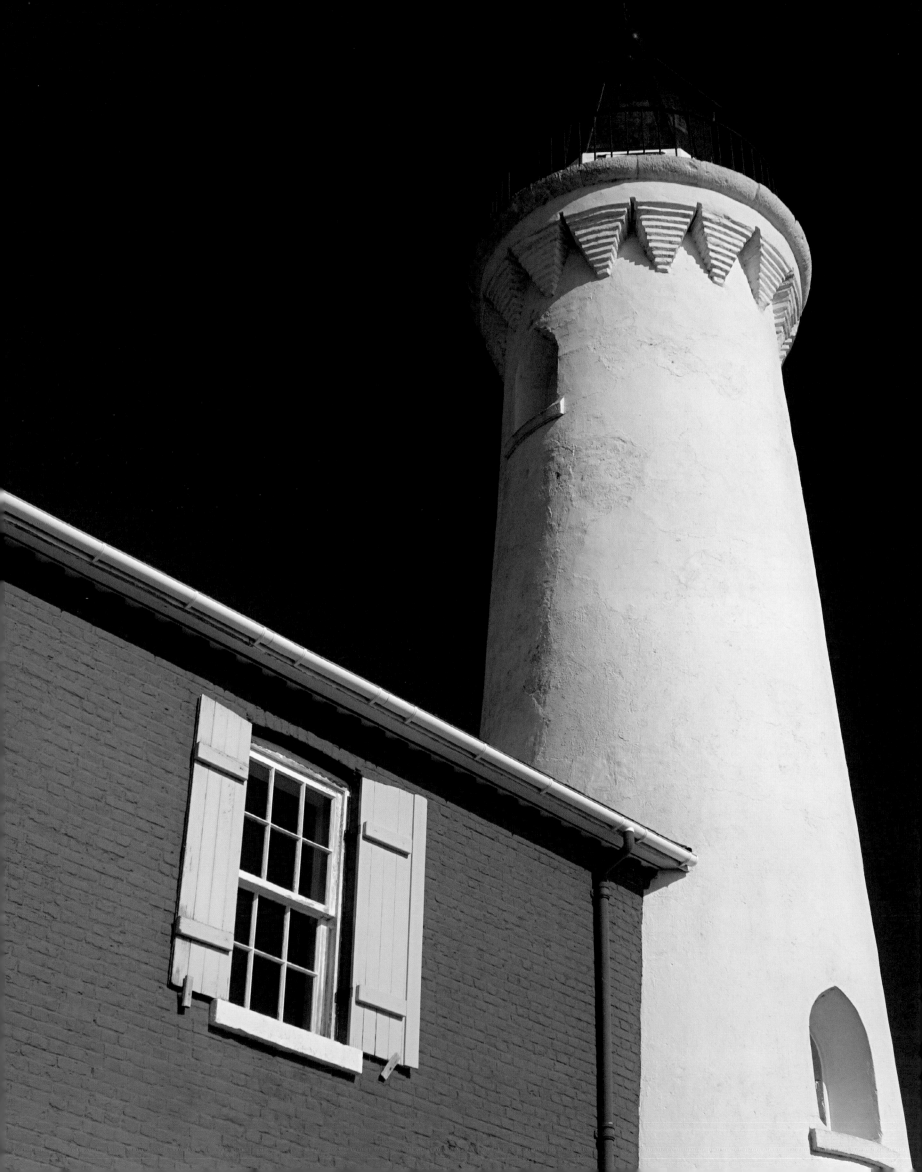

The first lighthouse built on the Oregon Coast was Umpqua River, in 1857, but its foundation was eroded by sand, and it collapsed four years later. More than 30 years passed before a second beacon – which still sends out red and white flashes – replaced it. Yaquina Bay served only from 1871 to 1873, though it was relit in 1996 and is still operational today. Its successor, only a few miles away, is Yaquina Head Lighthouse. Oregon's tallest, it has a 93-foot tower that stands 162 feet above the ocean. A nearby interpretive center offers extensive exhibits on the area's history and natural wonders, and tours by docents in period dress.

Oregon's shortest lighthouse is Cape Meares, whose stubby 38-foot-high brick tower is faced with iron plates. Only slightly larger is the Coquille River Light Station, which went up in 1896 on an island known as Rackleff Rock, named after the captain of a schooner that had run aground here decades earlier. The last lighthouse to be built on the Oregon coast, Coquille River was abandoned in 1939 and restored 40 years later, along with its pretty Victorian keeper's house.

A red-brick cottage gives Fisgard Lighthouse (opposite), *the oldest on Canada's west coast, its distinctive look, while exhibits inside detail shipwrecks and rescues. The museum at Yaquina Bay Lighthouse* (above) *includes period furniture, portraits, and clothing. Below: inside the Admiralty Head Lighthouse on Whidbey Island.*

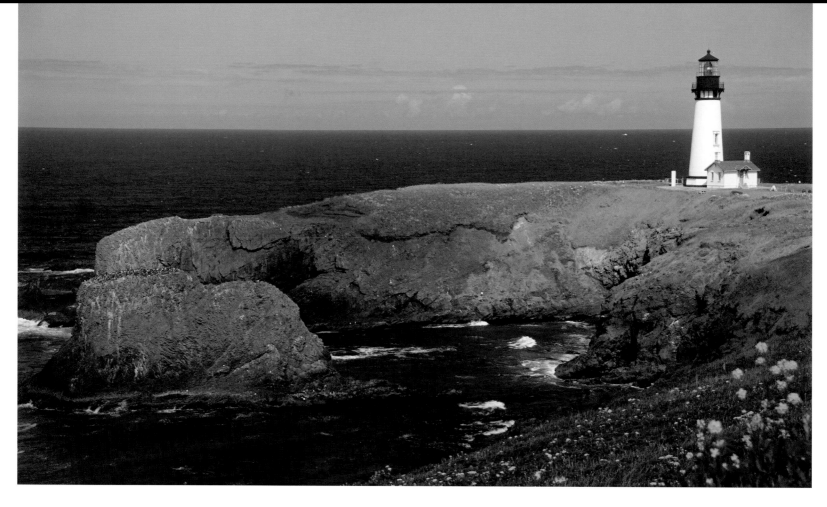

Given their locations, it's hardly surprising that most of the light-houses make fine stops for wildlife watching. Cape Meares is noted for its Steller sea lions as well as the thousands of seabirds that nest on the cliffs and rocky outcrops. Yaquina Head is another place to scan the skies for seabirds and watch the waves for whales, while Lime Kiln, now part of a state park on Washington's San Juan Island, has actually turned its station overlooking Haro Strait into a whale research lab.

Heceta Head Lighthouse, a graceful, red-topped tower built in 1893, is spectacularly perched part-way up a cliff that rises 1,000 feet above the Pacific. It boasts an additional attraction: Still standing is the assistant lightkeepers' house, once the residence for two families and now a six-room bed-and-breakfast with flawless turn-of-the-century decor – though it's unlikely the lighthouse keeper's wife served seven-course breakfasts. What a modern guest does share with the families that lived here is the panorama of the turbulent Pacific seen from a chair on the veranda, and a view of the beacon through a bedroom window. And, after the tourists and guides have left for the day, a hint of the utter quiet and isolation that came with lighthouse life.

Yaquina Head Lighthouse (top) *sits atop a spit of land – dubbed Cape Foulweather by Captain James Cook in 1778 – that juts out a mile into the Pacific. Trails criss-cross the headland, and tide pools reveal small marine creatures. This is also a prime viewing spot for seabirds, whales, and seals. Roughly 40 miles south lies Heceta Head Lighthouse* (above), *with an interior spiral staircase that climbs its 46-foot-high tower.*

Opposite: *Horsetail Falls, in the Columbia River Gorge.*

Oregon

Albany & Brownsville

You'd never guess what surprises await inside the nondescript building at the edge of Albany's historic downtown district. When you step inside, you encounter a colorful menagerie of fantastic animals, along with a roomful of volunteers working away at almost every stage: from life-size drawings and roughly blocked-out basswood templates to fully detailed creatures waiting for final coats of paint. The Dentzel American Carousel Museum not only displays historic examples of carousel craftsmanship, it's also the headquarters and workshop for a grassroots creative project.

The fanciful zebra, leaping salmon, playful puppy, and patriotic horse are just four of what will be 52 gorgeous steeds when the merry-go-round is completed in another few years. They also represent the kind of community involvement – from financial sponsorships for each animal to the training of hundreds of carvers and painters – that has energized Albany's preservation movement. Today the community boasts three historic districts and a long roster of heritage homes and buildings in 100 square blocks.

The emphasis on restoration really got going here around 1971, when the owner of Monteith House – a two-story frame dwelling built by Albany's pioneer founders in 1849 – threatened to demolish the building. The city stepped in, bought the deteriorated property, and the Monteith Historic Society was formed to restore and maintain it.

Thomas and Walter Monteith had crossed the continent on the Oregon Trail in 1847. Not far from the confluence of the Willamette and Calapooia Rivers, the brothers bought a land claim for $400, platted a town (which they named for the capital of their home state), and set up a general store in their residence.

Today the house is a museum that recreates the Monteiths' home and shop in the mid-1800s, when it was a gathering place for leaders of the fledgling community, including the founders of Oregon's Republican Party. Successful businessmen, the Monteiths expanded their investments to other stores and a flour mill.

Not everyone in town agreed with their politics, however. Another pioneer family, the Hacklemans, led the Democrats, who clustered in a working-class precinct to the east. During the Civil War, the two factions found themselves on opposite sides, literally, separated by a hedge that grew along Baker Street and

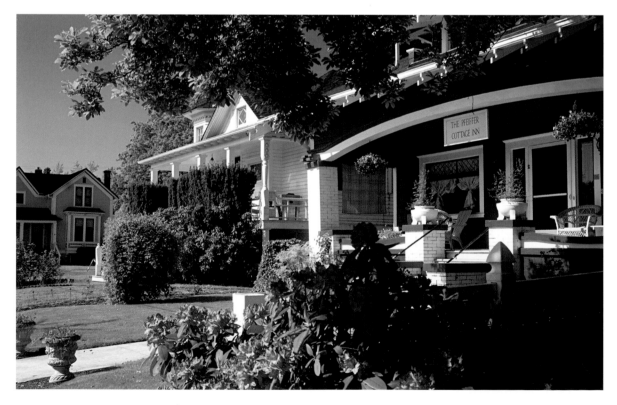

Mindful of their climate, Oregonians favored covered bridges, including the 1939 Gilkey span (opposite) *across bucolic Thomas Creek, roughly 15 miles northeast of Albany. The town itself encompasses some 700 historic buildings in districts that range from a commercial center to residential neighborhoods filled with examples of varied architectural styles, like this 1908 Craftsman cottage* (above), *now a bed-and-breakfast.*

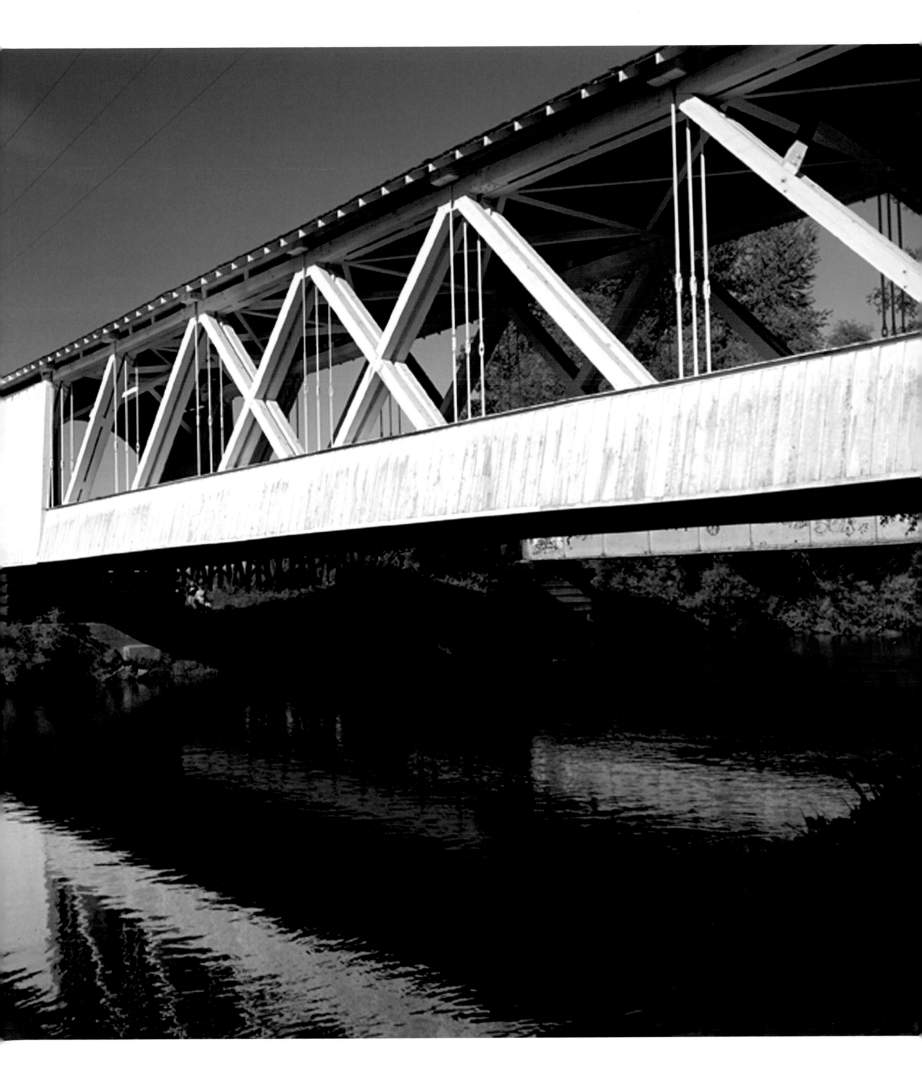

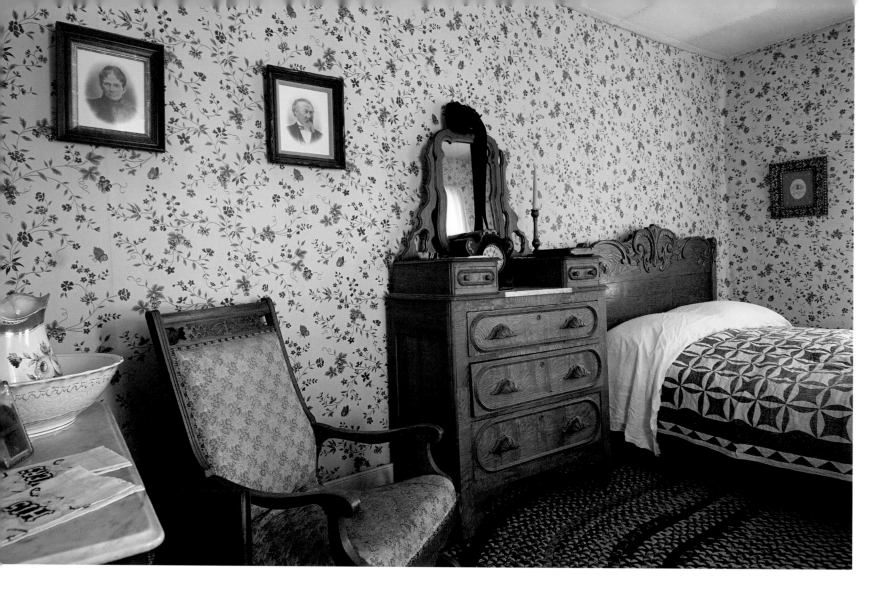

With turrets, gingerbread, and a wraparound porch, the Llewellen C. Marshall house (opposite), built in 1898, epitomizes elaborate Queen Anne style. Albany's preservation movement began with restoration of the far simpler Monteith House (above), the 1849 residence of the town's founding brothers who maintained a store on the first floor. Rescued from demolition, the home is now a museum. As Albany grew into a regional center, prosperous residents commissioned elegant dwellings such as the cream-colored Italianate 1889 mansion constructed by attorney and judge Charles Wolverton (right).

divided Union and Rebel supporters in the community. When a cannon on the courthouse steps saluted increasingly frequent Northern victories, the Southern sympathizers could stand it no longer. The Hacklemans threw the cannon into the river, where it remained until the 1930s.

Despite their animosity, the two sides knew when to pull together, and they pooled their efforts to bring the railroad to Albany in 1871. As trains replaced steamboats and stagecoaches, and a newly dug canal provided water power for local mills, the Willamette Valley's manufacturing and transportation centered on Albany, whose residents built distinguished homes, churches, and commercial structures.

The streets are still lined with farmhouse-style residences, turreted and towered Queen Anne mansions, columned Greek Revival dwellings, and Craftsmen cottages. The most elaborate dwelling may be the pumpkin-colored Ralston House, built in 1889, which has sunburst trim and stained glass. Across the way is a strikingly tall house that belonged to attorney George Chamberlain, later governor of Oregon and a U.S. senator. The Gothic Revival Whitespires church, from 1891, boasts vibrant stained-glass windows designed by the Povey brothers that demonstrate why

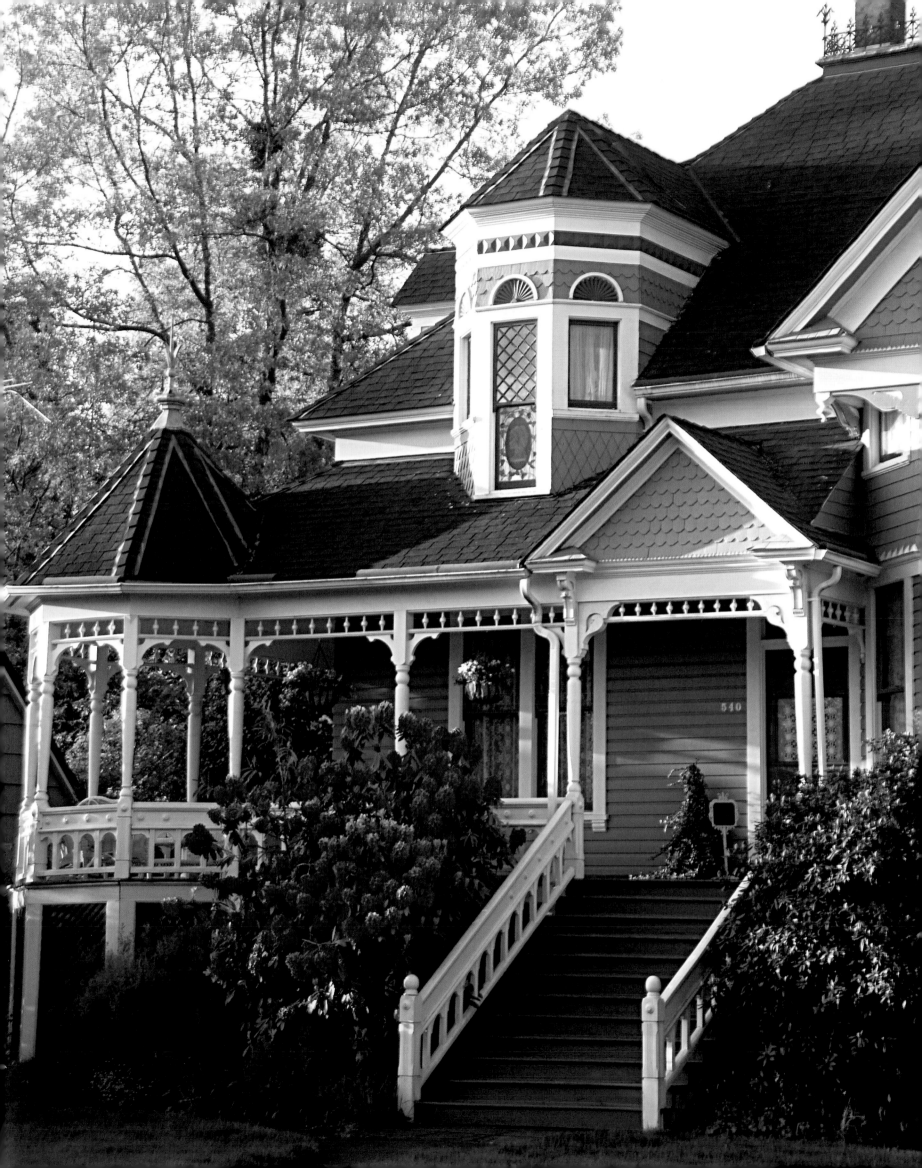

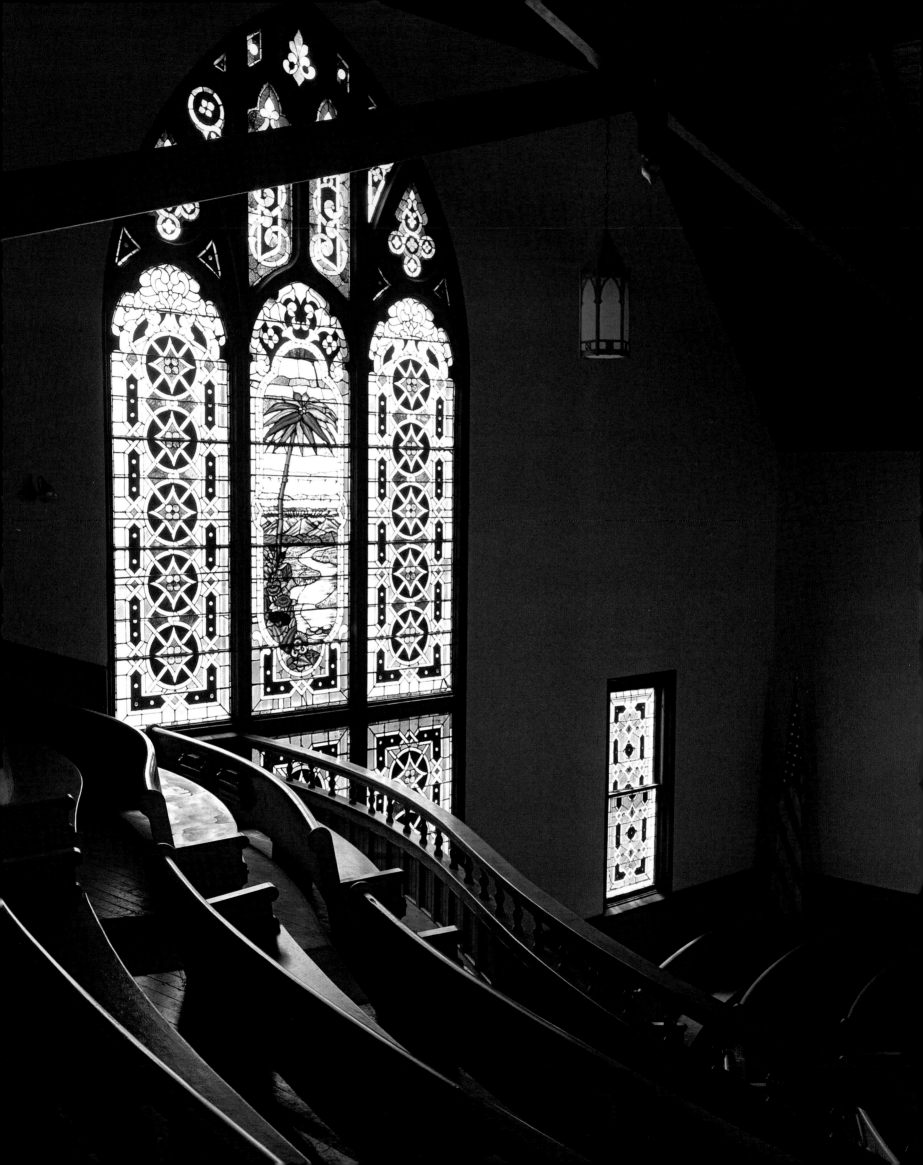

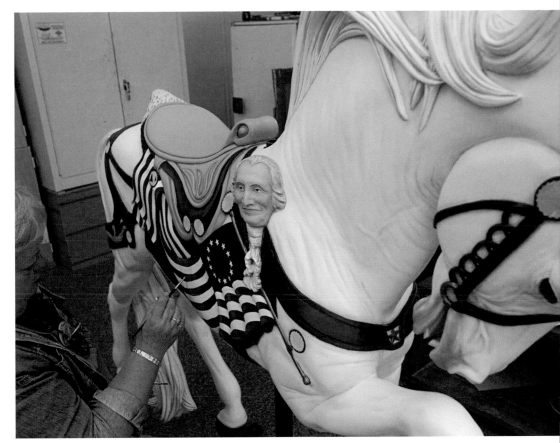

the pair were known as Tiffany's West Coast competition. One window panel depicts palm trees and purple mountains behind the River Jordan; a second shows a bucolic Willamette Valley.

The area surrounding Albany was, and still is, largely rural. The back roads northeast of town are lined by fields where baby goats gambol in the spring, and picturesque wooden covered bridges span slow-running streams.

To the southeast, Brownsville began as a market town on the Calapooia River in the mid-1800s, and its main street retains an antique small-town feel. A railroad depot and several train cars have been turned into the Linn County Historical Museum, where a rare covered wagon, which once traveled the Oregon Trail, highlights the collection that spans pioneer life and 19th-century shops and lifestyle, and includes a vintage theater that screens historic reels. A block away, the Italianate Moyer House, also part of the museum, is a showcase of fine architectural details.

Albany has its own museum, which began in 1887 as a grocery store and later was a haberdashery before it was jacked up and moved on rollers in 1912 to its current site. Inside, among the memorabilia, are photographs of a changing town. The Second World War and an army camp brought many newcomers to the area, and by the 1950s and 60s businesses and housing had begun to sprawl out to the interstate that sidestepped the historic riverfront core.

In the last decade, echoing the residential restorations that began 20 years ago and more, fine restaurants, wine bars, and chic boutiques have moved into the old downtown buildings with their decorative cornices, cast-iron pilasters, and arched windows. The lavish Flinn Block, now an event space, is graced by gargoyles and garlands, while the Pix Theater – once a livery stable – is a popular spot for movies. Eventually, hinting perhaps at the way a town's fortunes can go up, down, and round and round, there will be a carousel here, too.

The Jordan River Valley forms the centerpiece of a magnificent stained-glass window – the work of the Portland-based Povey brothers – in the Whitespires church (opposite). *In the Dentzel American Carousel Museum, local artists and volunteers are handcrafting a merry-go-round that will eventually include 52 animals and two chariots. A traditional highlight is a patriotic horse* (above), *complete with a relief portrait of the first American president.* Above left: *Feathered friends enjoy an unexpected waterway, the remains of a canal dug to power a mill.*

Ashland

From its beginnings in the 1850s, the Plaza (opposite) *has been the heart of Ashland. The town's founders started a sawmill here and donated plots of land to fellow pioneers to encourage other businesses. The Odd Fellows Hall on one edge of the square was built after a fire in 1879. Made of local bricks and trimmed with eclectic decorative touches, the building retains old columns inside its modern shops. Homes along Siskiyou Boulevard* (above) *share Ashland's aura of turn-of-the-century gentility.*

Lithia Park winds through the heart of Ashland like a green streamer, an inviting spot for the usual recreational activities. There's a duck pond, tennis courts, quiet places to picnic, a band shell – and a nice open meadow where a group of young men are strapping on armor and practicing swashbuckling swordplay. Are they would-be thespians? Fencing enthusiasts? Whoever they are, they add theatricality to the scene. Drama has always played an important part in Ashland's story, which, like a Shakespearean play full of unlikely coincidences, has had its share of fortunate convergences.

It was here, just over the forested Siskiyou Mountains from California, that two unsuccessful Gold Rush prospectors staked their land claims in 1852. Abel Helman and Eber Emery, who hailed from Ashland County, Ohio, thought this was a likely spot for a sawmill. They were successful enough to open a flour mill soon thereafter, attracting a dozen other businesses – a blacksmith, a meat market, a cabinet shop, and a livery stable, among others – to join them around an elongated plaza.

Outside town, other pioneers also catered to foot travelers who made their way along the Siskiyou Trail.

The Ashland Mountain House – today a historic register bed-and-breakfast – was built in 1852 and later served as a stagecoach stop until trains arrived in the valley in 1887.

Meanwhile, Ashland grew, as prosperous merchants built homes on expansive estates that fanned out beyond the central plaza. Claim shacks and simple homes from the 1860s gave way to more elaborate residences by the 1880s, and grand columns, cornices, and balconies were added to the commercial buildings. Turn-of-the-century architecture still graces Ashland's leafy neighborhoods. Victorian splendors like the gingerbread-trimmed "Three Sisters" stand in a row on North Main Street, while the McCall House from 1883, with its yellow-and-green bay-windowed façade, was the home of a woolen-mill owner who became town mayor. Later, Craftsman-style dwellings and bungalows filled in spaces as the original lots were divided and sold.

Hand in hand with Ashland's building spree came an interest in culture and civic improvement. Residents organized an academy of higher education that developed into the state normal school. A ladies' civic beautification society, horrified by the deteriorating

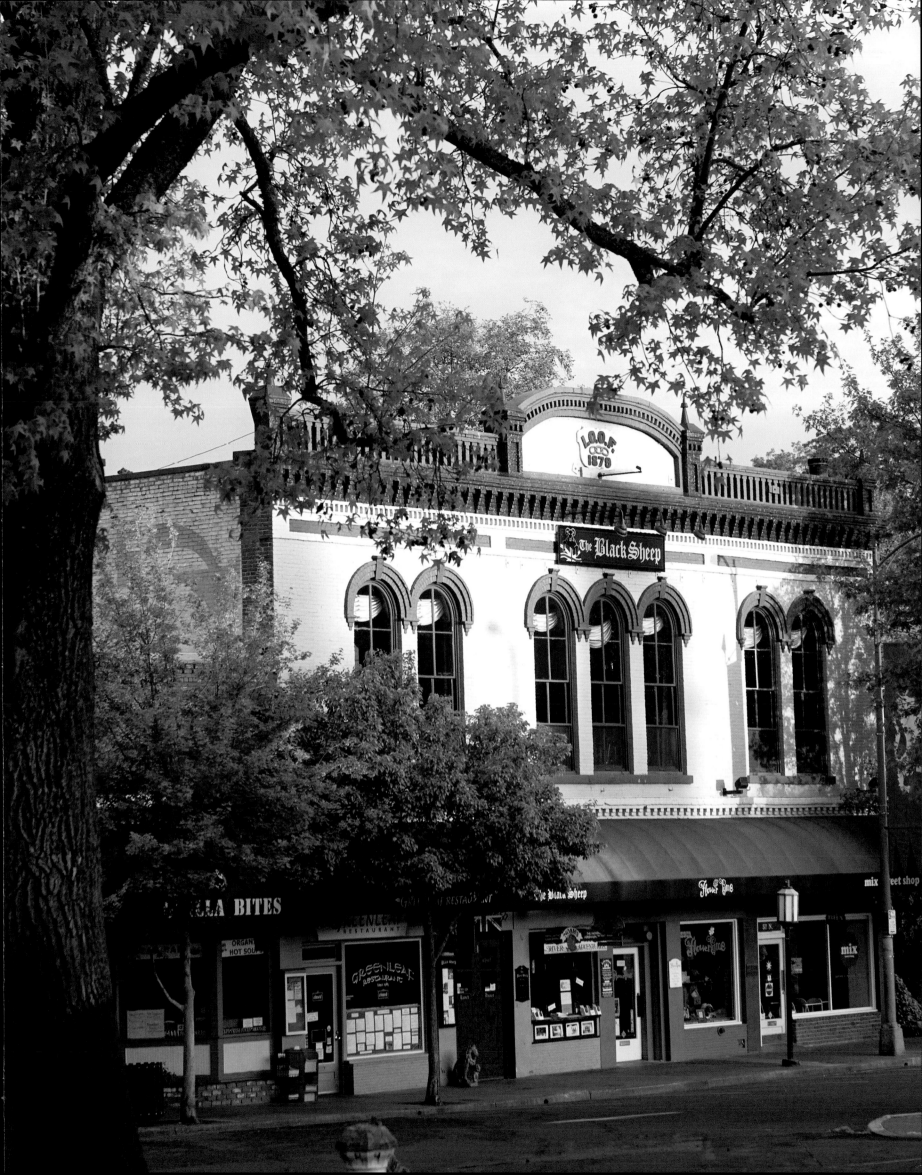

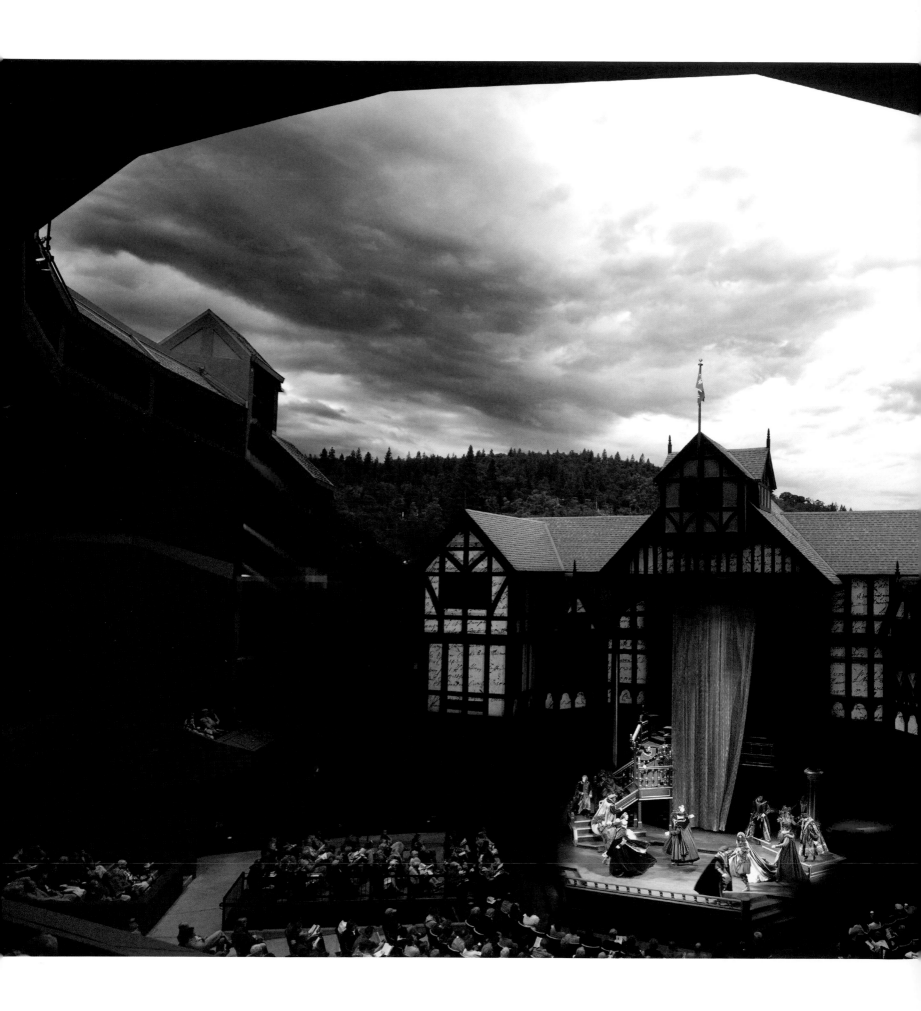

sawmill, in 1908 convinced town fathers to replace the decrepit building with the entrance to today's Lithia Park. Several years later, entrepreneurs piped water from the local springs to fountains around town, promoting the healthful qualities of its mineral content in a quest to turn Ashland into a destination for spiritual growth and healing.

What really drew people, though, were the Chautauqua lecturers and entertainers, who put Ashland on the circuit in 1893 and kept it there until 1923. Every summer, visitors and locals alike flocked to a domed tabernacle near the Plaza to hear Susan B. Anthony, John Philip Sousa, Billy Sunday, and others enlighten and delight them.

Radio put an end to the Chautauqua movement, and Ashland's dome was torn down, leaving only low ivy-covered walls. The mineral water enterprise closed, too, as the cost of maintaining the pipeline became prohibitive. The posh, 100-room hotel that had opened in 1925 to cater to wealthy railroad passengers saw the railroad shut down passenger service soon thereafter. By the end of the decade, Ashland, like the entire nation, was in the grips of the Great Depression.

Enter Angus Bowmer. A 30-year-old English professor at Southern Oregon Normal School, Bowmer had a love of classical drama and enough imagination to think that the Chautauqua ruins vaguely resembled

Sunset brings drama to the ensemble acting in the Bard's Henry VIII *on the Oregon Shakespeare Festival's Elizabethan Stage* (left). *Lithia Park* (top) *was a 1908 project of the local Women's Civic Improvement Club, which fought to replace a run-down sawmill with green space.* Above: *The Varsity movie theater was a state-of-the-art cinema when it opened in 1937.*

illustrations of Shakespeare's Globe. In 1935 he proposed a three-day theater festival, with performances of *Twelfth Night* and *The Merchant of Venice*. He even wrangled a grant of $400 from the city, which insisted on boxing matches before each play to ensure that the enterprise was a success. In the end, though, it was Shakespeare and not slugfests that made the profit, and a new tradition was born.

The Oregon Shakespeare Festival (OSF) continued modestly – with five performances, then six, then eight – until Bowmer went off to fight in the Second World War. When he returned in 1947, the festival resumed with summer repertory productions on an open-air stage that was replaced in 1959 with a new Elizabethan-style theater, patterned after the 1599 Fortune Theatre in London.

Even so, the 1950s and 60s were tough times in Ashland. Locals remember lumber trucks driving down Main Street…until the sawmills closed. Storefronts were boarded up, and restaurant choices were limited to a diner, a Chinese eatery, or a steakhouse. Even the interstate highway bypassed Ashland – though that setback proved an advantage, since it left the downtown untouched. When the OSF added a second theater in 1970, enlarging and extending its season, scores of large homes were available for affordable bed-and-breakfast accommodations.

Forty years later, the OSF has three theaters and an eight-month season of eleven plays in rotating rep-

ertory that includes Shakespeare, other classic plays, modern drama, comedy, and experimental readings. On any given day, a visitor might see some oversize prop – a giant horse, for instance – being loaded onto a truck, catch a glimpse of stagehands readying a new set, or hear actors sharing stories on a backstage tour.

The influx of theater aficionados has encouraged other companies – the Oregon Cabaret Theatre, which performs in a decommissioned church; the Oregon Stage Works, housed in the old Tank and Steel Building; and Southern Oregon University's own theater arts program – to say nothing of other artists and artisans who find Ashland an inspiring place to work.

The boarded-up shops long ago gave way to chic boutiques and dozens of restaurants, both elegant and casual, while the bed-and-breakfasts are sought-after romantic accommodations. The historic Railroad District around the long-defunct depot – for many years a neighborhood of yoga studios, health shops, and alternative healing venues – now also boasts upscale art galleries, cafes, and bookstores. Dare one say "All's well that ends well"?

Built to accommodate the well-heeled travelers of the 1920s, the Ashland Springs Hotel (opposite) *still towers over other downtown shops. Robbed of business by a changing railroad route, the historic hostelry declined for many years before being renovated with flair a decade ago. Ashland abounds with charming eating and shopping spots, like the restaurant beside Ashland Creek* (above right) *and the peachy Patina boutique* (above left).

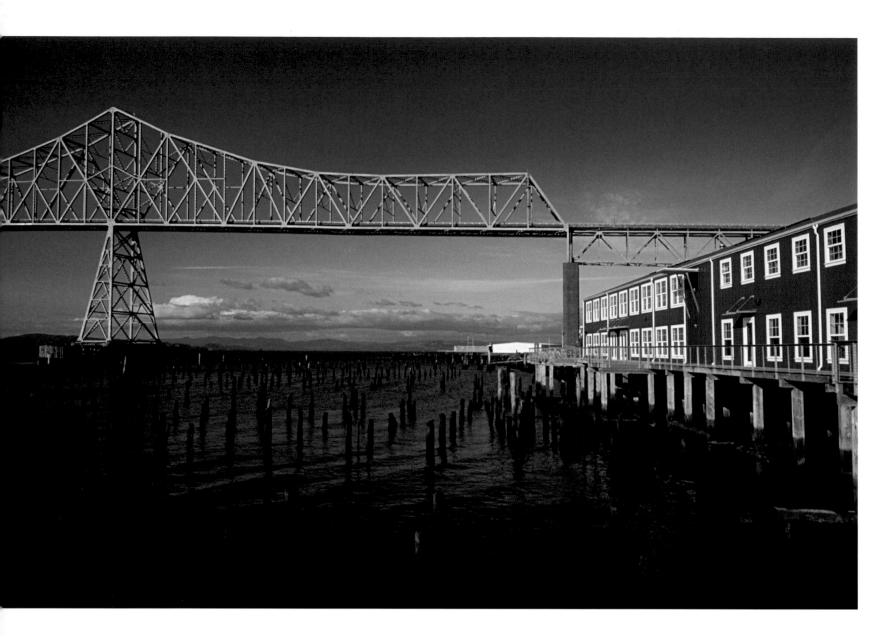

Astoria

A guidepost for mariners on the Columbia River since the late 1800s, the tall steeple of St. Mary's Catholic Church (opposite) *still dominates the streetscape along Astoria's Fifteenth Street, with its row of Craftsman-style homes. Pilings for long-gone wharves and boardwalks* (above) *punctuate the shallows beneath the bridge that has connected this Oregon peninsula to Washington since 1966.*

Scenes from local history spiral their way upward on the Astoria Column, which rises 125 feet above a leafy residential neighborhood on Coxcomb Hill. From these heights, the panorama is breathtaking, extending beyond the downtown blocks to the very edge of the peninsula, where streams flow into Youngs Bay, then into the Columbia River and on to the Pacific. It's easy to see why this spot – once rich with beaver and salmon and strategically located on a great water highway – appealed to the explorers, traders, and settlers whose achievements are etched in delicate sgraffito on the towering symbol of civic pride.

Near the base, for example, is Captain Robert Gray, the New England fur trader who sailed the *Columbia Rediviva* into the river in 1792 and named the waterway after his ship. A few scenes upward are Lewis and Clark, whose arrival here in November 1805 marked the culmination of their mission to explore the Northwest. They would spend the winter in a cramped, rain-soaked stockade called Fort Clatsop, just across the bay. A re-creation of the site – complete with buckskin-

clad, musket-bearing interpreters – is part of the Lewis and Clark National Historical Park. In a sense, however, Astoria itself is a monument to Lewis and Clark's Corps of Discovery, whose reports attracted others to the area.

John Jacob Astor, for one, was quick to seize on the wild land's opportunities. The wealthy German-born merchant formed the Pacific Fur Company, outfitted a ship and an overland expedition, and sent them off to found a fort. By 1811, his seafaring contingent had come ashore and put up log cabins and storehouses with cedar-bough roofs. The settlement, named Astoria for its patron, was a poor affair, but the group got by until the War of 1812 threatened to bring the attention of a British warship. The Americans promptly sold the fort – lock, stock, and furs – to a group of British traders, who renamed the place Fort George and carried on.

Eventually, as the fur trade waned, American missionaries, settlers, and sea captains determined Astoria's next stage of development. Among the first pioneers were James Shively and John McClure, who platted a

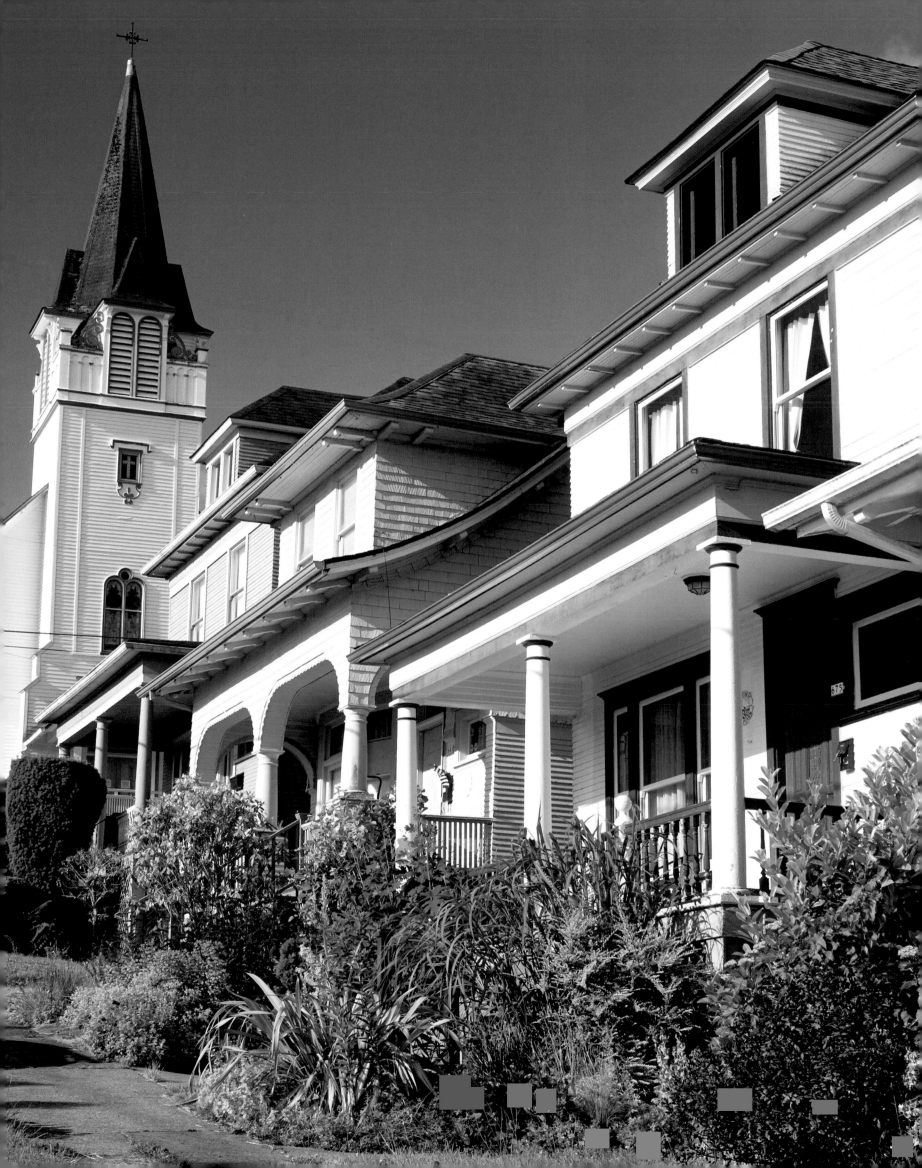

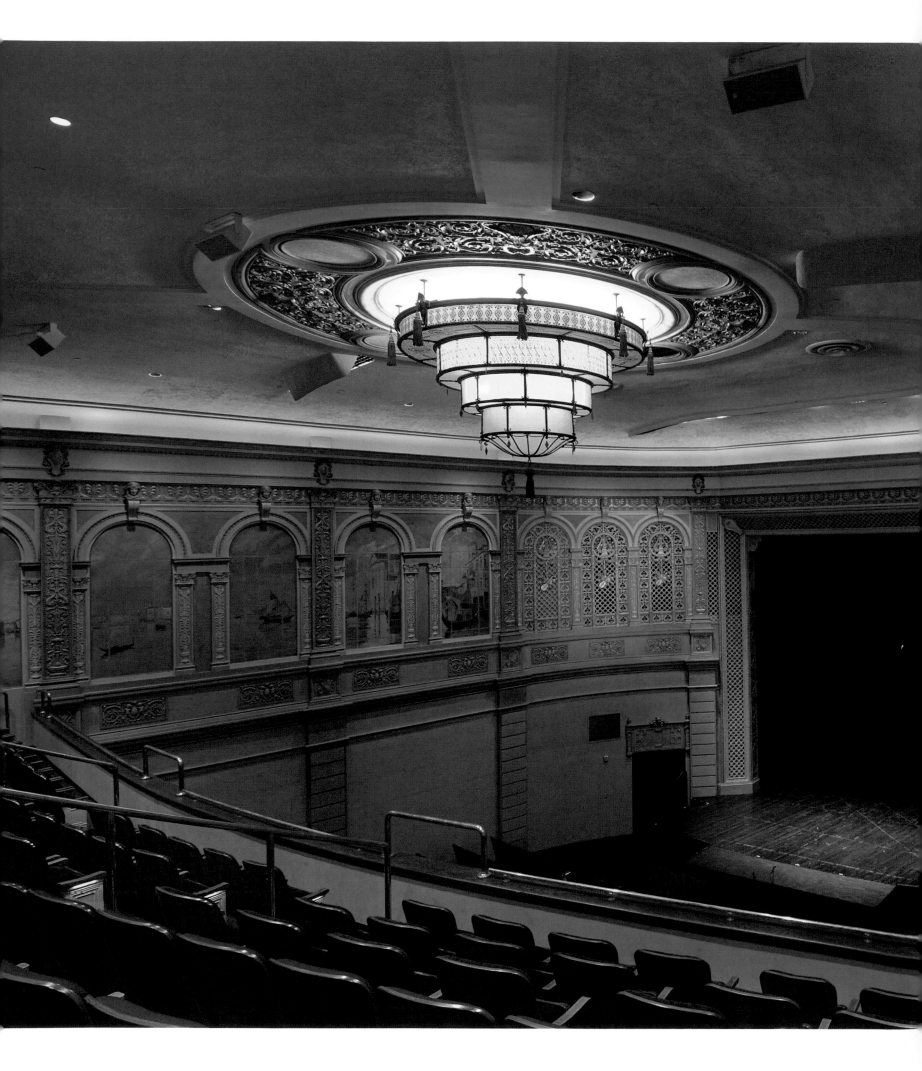

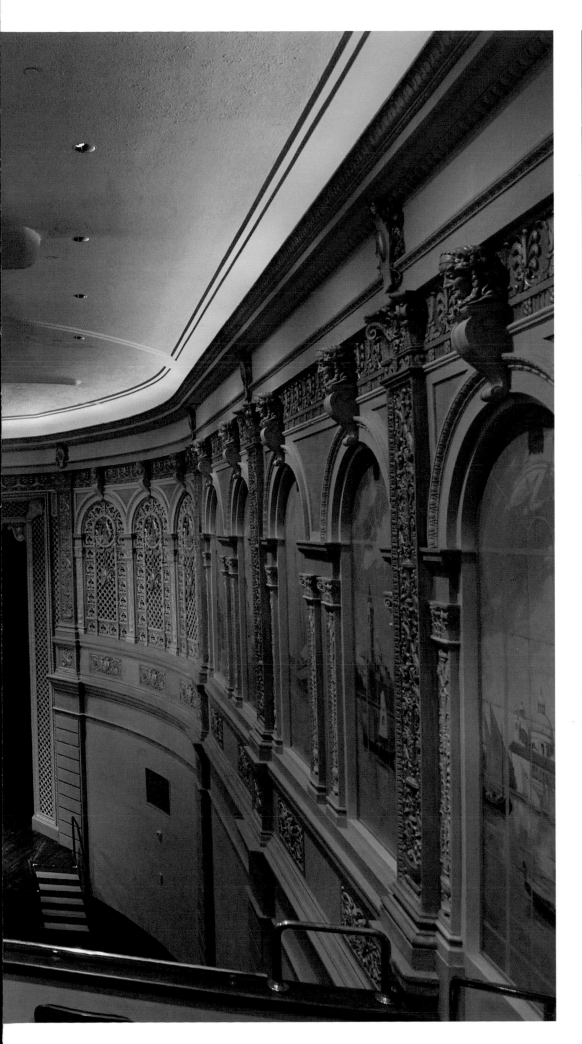

Scenes from the lagoons of Venice fill the painted niches of the 1925 Liberty Theater (left), which began as a silent movie house and now echoes with the sounds of an annual music festival, among the other shows it hosts. Evoking the look of the Union cooperative cannery that once occupied its riverside site, the sophisticated Cannery Pier Hotel (above) provides vintage autos to chauffeur its guests around town.

town in 1846 on their adjoining land claims. A year later Shively was running the post office out of his house, serving some 250 residents just four years later.

Among the most valued settlers were river pilots who could safely guide ships over the treacherous bar at the mouth of the Columbia River. Fog, 40-foot waves, and shifting sands had caused so many shipwrecks along the coast that it was called the "Graveyard of the Pacific." Stories of those disasters – as well as tales of heroism, and the saga of salmon fishing and canning – are part of the interactive displays at the stunningly designed Columbia River Maritime Museum, whose exhibits include an actual lightship anchored outside.

In the mid-1800s, Captain George Flavel was one of the seamen who parlayed his navigational skills into lumber, banking, real-estate development, and politics. In 1885 he paid $36,000 for a Queen Anne confection – now a museum – graced with dormers, columns, gingerbread, and a three-story tower above a wraparound porch. Inside, the rooms are filled with the Victoriana that denoted the finest appointments of their time, while a stained-glass ship in the front door transom recalls the owner's source of wealth.

The Flavel House is just one among the scores of 19th-century residences that line Astoria's hillside streets. Often brilliantly painted and lovingly restored, the houses' Italianate façades, Queen Anne verandas, and Arts and Crafts details testify to the prosperity of this port town in the late 1800s.

Riverboats transported passengers and cargo up the Columbia to Portland, and ocean-going ships lined the wharves waiting for shipments of lumber and other goods. In those days the streets closer to the waterfront were mere wooden planks laid over tidal mud flats, connecting the salmon canneries, which had sprung up in the 1870s. The atmosphere was rough-and-tumble… and dangerous. One particularly unsavory area was dubbed Swilltown for its many saloons, gambling dens, and bawdy houses, where customers were routinely plied with drink and "shanghaied" onto ships for long sea voyages. Memorabilia of those wild times, including a bar, card table, and roulette wheel, are collected in the Heritage Museum, housed in a 1904 building that originally served as City Hall. The displays highlight both the town's history and its ethnic heritages.

The Chinese, for example, came by the thousands to process the fish, while Swedes and Norwegians often began as lumbermen and sawyers, then turned to other enterprises. Most of all, there were the Finns, who manned the fishing boats and helped swell the local population to about 7,000 in 1880. They clustered in Uniontown on Astoria's west side, where they lived in boarding houses, congregated in Suomi Hall, patronized a sauna, meat market, and café, and, eventually, formed the Union Fishermen's Cooperative Packing Company.

Some of those structures still stand, though the rest of Astoria's turn-of-the-century commercial district was swept away in a conflagration on December 8, 1922, which fed on the wooden buildings and boardwalks and wiped out 25 blocks of downtown.

The community rebuilt, filling in the mud flats and creating real streets, putting new banks and shops over the ashes of luxury hotels and restaurants. In 1925 the Liberty Theater opened its doors with a Harold Lloyd silent film and later hosted vaudeville shows. An artistic picture palace, it boasted tiered chandeliers, a pipe

Built by a river bar pilot-turned-businessman, the Flavel House (below) is a masterwork of Queen Anne architecture, with a two-story tower, bracketed eaves, a columned entry, and gingerbread decoration over and around its hexagonal veranda. Finished in 1886, the 11,600-square-foot residence was home to George Flavel and his wife until the captain's death in 1893. The rich and influential Flavel had a hand in many Astoria enterprises, from a lumber mill to land development, and also dabbled in politics. The home remained in the family until 1934; today it's a museum.

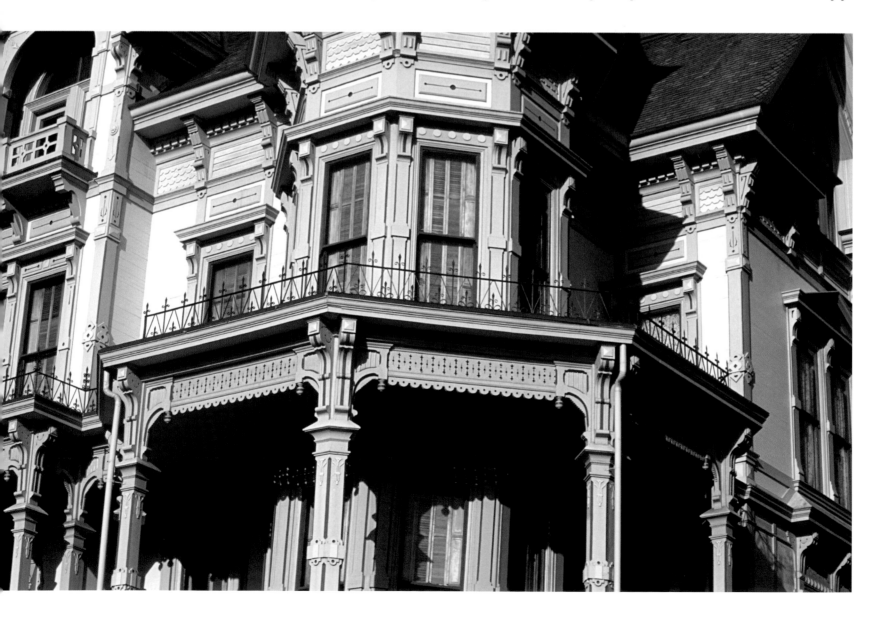

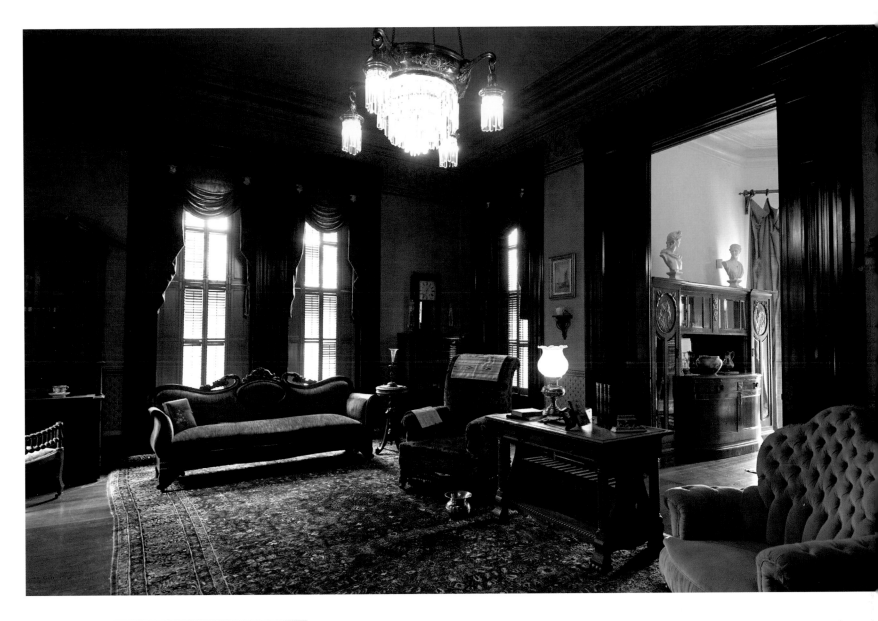

organ, and wall panels painted to suggest a Venetian palazzo. Magnificently restored, the theater once again stages performances of all kinds.

The fire weakened the economy, which suffered even more as the canneries declined and the Depression took hold. By the 1960s, this was a subdued working-class town, albeit one with a trove of Victorian architecture that gradually attracted those with an interest in old houses. Two decades later, that group included the producers of *The Goonies*, who used a residence, the jail, and other local spots as locations for the children's adventure film, ensuring an enduring cult following for Astoria.

Now visitors find a working port, chic renovated hotels, art galleries, ethnic restaurants, coffeehouses, and offbeat lounges interspersed among longtime downtown businesses. And if they seek out architectural treasures on the residential streets, they may very well find that the owners emerge to point out details, share a tidbit about the town's history, or even invite them in to savor the view, filling in, you might say, where the Astoria column left off.

The formal parlor (above) *of the Flavel House, used by the family on special occasions, shows off Victorian-style settees and other furniture under an antique chandelier. A 19th-century master woodworker finished the Douglas fir doors and windows to look like mahogany and burl rosewood. The original coal fireplace in the room beyond is one of six in the mansion, which had five bedrooms on the second floor and a tower that gave the owner a view of river traffic. Left: Astoria's Scandinavian traditions live on during its annual Midsummer Festival, as youthful celebrants join in a maypole dance. Finnish, Swedish and Norwegian emigrants all contributed to the town's personality around the turn of the 20th century.*

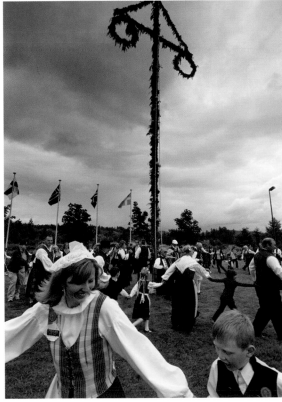

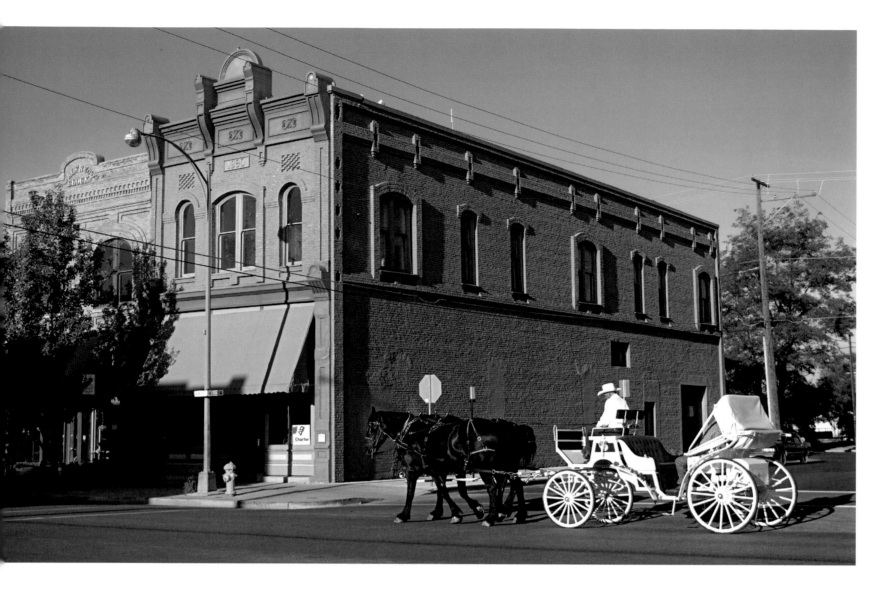

Baker City

Brilliantly illuminated by a stained-glass ceiling and crystal chandeliers, the Geiser Grand Hotel (opposite) once again sparkles with 19th-century elegance. The hotel was empty for decades, but a five-year renovation brought back the original woodwork of the grand staircase, wainscoting, and Ionic columns, while a contemporary craftsman used antique glass to redo the ceiling over the Palm Court in period style. Horse-and-buggy days return for a sightseers' ride down Baker City's Main Street (above), where brick commercial buildings have also regained the decorative touches of the town's turn-of-the-century heyday.

Up on Flagstaff Hill, 5 miles outside Baker City, a woman in a sunbonnet and ankle-length dress is spinning yarn from wool, while another, similarly attired, is serving up stew from a Dutch oven over an open fire. A few steps away, three musicians are knocking out a rollicking tune on guitar, fiddle, and mandolin, while children in 19th-century dress play with hoops and marbles. This wagon encampment, outside the National Historic Oregon Trail Interpretive Center, re-creates a stop made by some of the 300,000 men, women, and children who passed by on their westward journey in the mid-1800s. In front of them lay the Blue Mountains and a final push to the Willamette Valley.

Ruts left by the wagon wheels still dent the earth at the bottom of the hill, but for a deeper understanding of what the travelers encountered, step inside the interpretive center, where state-of-the-art exhibits use life-size figures, oral histories, artifacts, maps, and photos to make you feel what it would be like to

walk beside a Conestoga wagon for six months across 2,000 miles of parched plains and daunting mountains. There were plenty of dangers: buffalo stampedes, prairie fires, rattlesnakes, cholera, and the possibility of attack by Indians, though many Native Americans traded the settlers fresh food for goods and helped families ford dangerous rivers.

The Oregon Trail was a thing of the past by the time Baker City got its start, but in a roundabout way, one wagon train was responsible for its founding. In 1845 young westward travelers found tiny yellow stones beside a river southwest of the present town. Unaware of what they had, they left the nuggets behind in a blue bucket, giving rise to the legend of a "lost Blue Bucket Mine."

In 1861, prospectors returned to search for the ore and indeed found gold in the area, initiating a flood of miners and the rise of several mining camps. When an entrepreneur sought a site for an ore processor, he chose the tiny settlement on the Powder River. It would

be named after Edward Dickinson Baker, an Oregon advocate and congressional representative who died during the Civil War.

Baker City prospered as a trade and financial hub, and by 1868 it was a county seat, with a grid of streets forming today's historic downtown. Its earliest wooden structures succumbed to fire, but thanks to a second mining boom later in the century and the arrival of the railroad in 1884, Baker City went on a fine building spree, putting up brick edifices in late-Victorian style. Several of these still stand on Main Street and beyond, and if you look upward you'll see the period details – peaked dormers, ornate lintels, and decorative columns – that evoke the exuberance of the era.

Most notable is the Geiser Grand Hotel, constructed by the Warshauer brothers in 1889, with an impressive clock tower in a corner turret and a birdcage elevator (so female guests would not be caught out of sight with unfamiliar gentlemen). Sold to Al Geiser less than a year later, the hotel reigned as the finest stopping place between Salt Lake City and Seattle, welcoming dignitaries to its well-appointed rooms and serving gracious meals under a colorful skylight in the Palm Court. Though the Geiser Grand later fell on hard times, it was magnificently restored down to crystal chandeliers and antique furniture and is once again a showpiece.

At the turn of the century, Baker City, like most mining districts, had its share of saloons and gambling dens, but it also boasted two opera houses and impressive civic and religious institutions constructed from tuff, a soft volcanic stone. City Hall, built in 1903, resembles a Renaissance Revival fortress with its own clock tower, a feature it shares with the courthouse, while St. Francis Cathedral's stately façade and Romanesque interior were the work of the architect who designed the Geiser Grand.

Genteel residences dot the surrounding streets, like the simple 1872 cottage owned by S. B. McCord, the blacksmith, miner, and businessman who was the town's first mayor. A district judge commissioned a grand brick Queen Anne that is now a bank. Twin Italianate residences belonged to the Baers and the Adlers, Jewish merchants linked by marriage. Leo Adler, who grew up in one of these houses, went on to build a magazine-distribution empire, and when the gregarious bachelor died in 1993, he left his millions to Baker City. His home is now a museum. Family furniture fills the elaborate parlor, formal dining room, music room, and bedrooms, and personal memorabilia – like Leo's sister's diary evaluating all her beaux, and his brother's First World War uniform – poignantly convey the turn-of-the-century atmosphere.

The Romanesque interior of St. Francis Cathedral (opposite), *from 1908, sets off stained glass depicting Bible stories. Like many public edifices here, the church was built with local volcanic tuff stone. Czech architect John Benes turned to the Renaissance Revival style for the exterior of the Geiser Grand* (above) *in 1889. For many years the People's Store occupied several of the building's street-level shop fronts, purveying groceries, mining supplies, pots and pans, and other household necessities.* Above left: *Family heirlooms fill the Adler House museum, home to one of Baker City's great benefactors.*

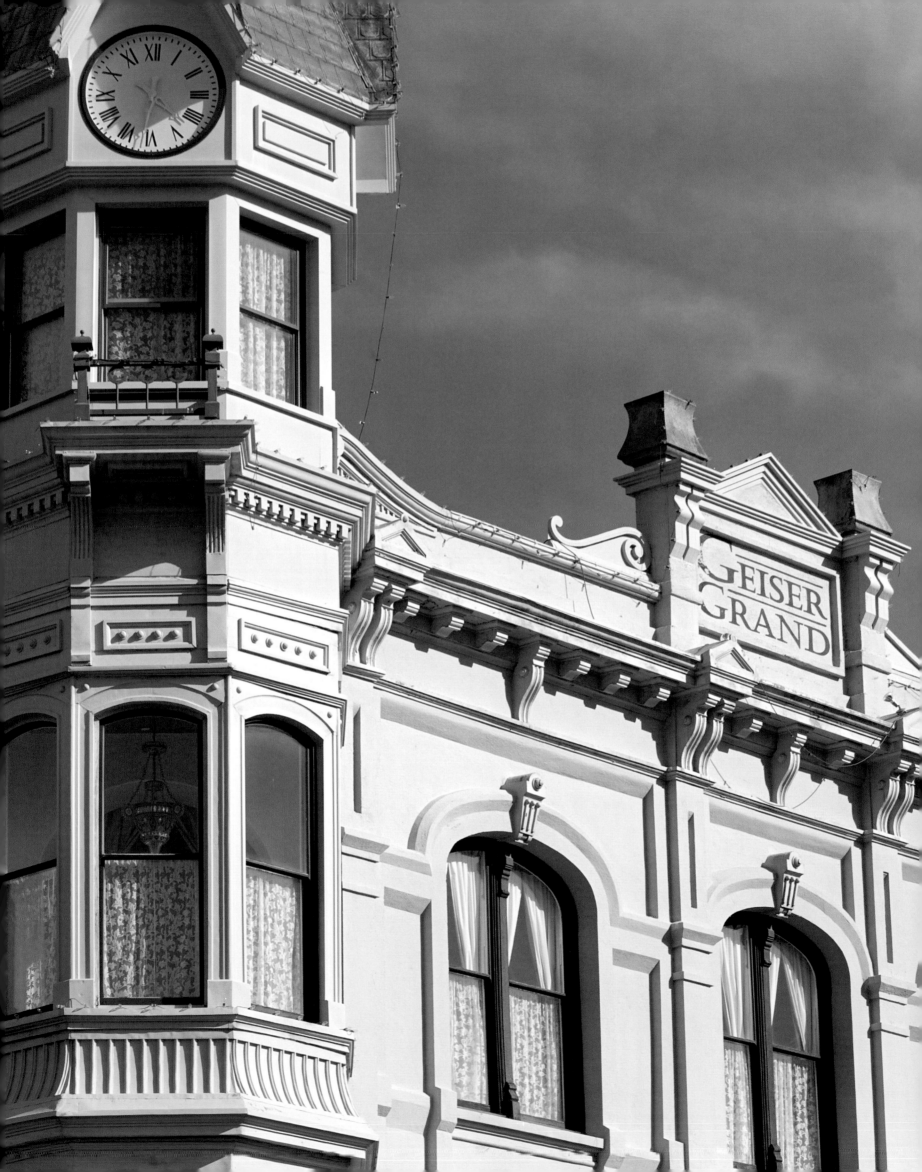

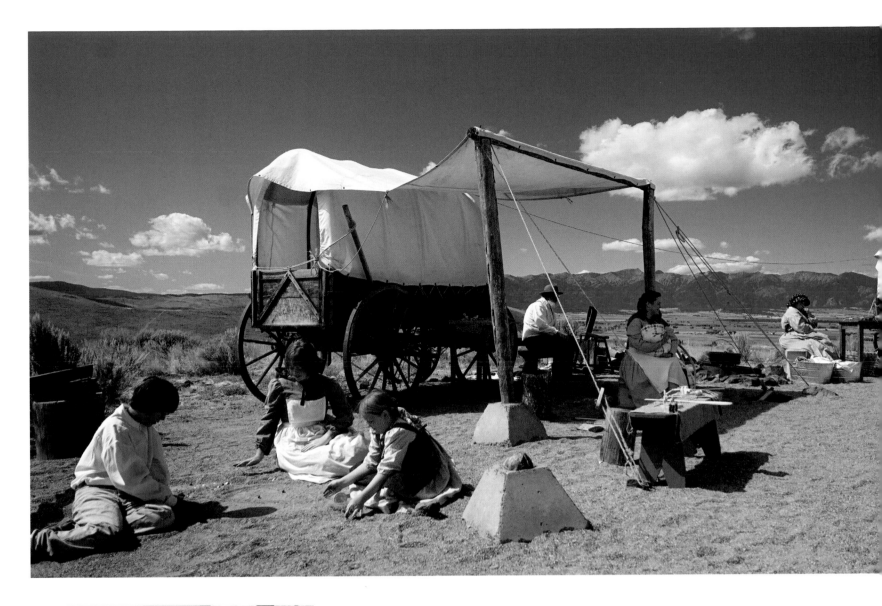

For more artifacts of the town's history, visit the Baker Heritage Museum, located in the old civic natatorium. Where teenagers once dived into the pool, a royal blue 1927 Whippet is parked next to an old-time gas pump, along with a printing press, sleighs, an 1898 taxi, and recreations of a blacksmith shop, a miner's shack, and a row of Main Street stores.

By the 1920s Baker City's boom times were over. The mines closed. The hotels catered to a less prestigious class of customers. After the Second World War, merchants covered over the old façades, and the downtown languished. In the 1960s, the filming of *Paint Your Wagon*, starring Clint Eastwood and Lee Marvin, brought a flurry of attention; then the town went dormant again.

Three decades later, a revitalization movement prompted property owners to uncover hidden architectural treasures and brought Baker City's heritage to center stage. Now hotels, lively restaurants, galleries, a bookstore, theater, and boutiques fill the 19th-century buildings. If this was a place to pass through on the way to a new life in the days of the Oregon Trail, Baker City has now been reborn as a destination to stop and savor.

Towering 110 feet over Main Street, the clock in the Geiser Grand's highly ornamented corner turret (opposite) *is a replica of the original that was taken down in 1930. Some 4,500 citizens turned out to see the new timepiece put up in 1995. Thousands of emigrants passed through the region in the mid-1800s. A wagon encampment at the National Historic Oregon Trail Interpretive Center* (above) *re-creates a stop on their westward journey, with food, games, music... and chores. An in-town bistro recalls a later wave of fortune seekers* (left).

Bandon

Rocky outcrops in fantastical shapes dot the pale sands of Bandon State Beach (opposite), providing fodder for legends and inspiration for photo buffs, especially at sunset. The boat basin (above) offers its own moment of reflection. Pleasure craft of all shapes and sizes find a quiet mooring at the edge of lively Old Town, where some restaurants offer a water view with their oyster specialties.

Toward the end of the day, as the sun hangs low in the sky, the photographers in Bandon – locals and visitors alike – head for the beach. They come with tripods and fancy digital cameras, simple point-and-shoots, or just their cell phones. Everyone, it seems, wants to get a shot of the sunset. No matter the weather or the height of the tide, the fantastic rock outcrops off Bandon's long, wide sands are at their most mysterious and evocative when daylight wanes. Their names reflect their eerie shapes: flat-topped Table Rock, Elephant Rock with its oversized ears, majestic Cathedral Rock, and the upturned silhouette of Face Rock, accompanied by a Cat and its litter of Kittens.

Face Rock has a legend attached to it, a reminder of the native people who lived along this coast centuries ago, fishing, hunting, harvesting shellfish, and gathering the wild cranberries that filled inland bogs. According to their stories, these outcrops represent a chief's daughter and her pets, captured by an evil sea spirit and turned to stone, destined to gaze at the moon forever after.

The girl may be eternally motionless, but, in fact, Bandon's natural coastal world is ever-changing, always revealing something new. Rock pools glisten with

colorful starfish at low tide, and sea lions emerge from the water to lounge on stony ledges. Depending on the season, cormorants, murres, oystercatchers, and gulls wheel overhead or find precarious perches on the towering sea stacks. Even the vegetation on the backdrop of sandy dunes changes color according to the time of year, bristling with brilliant yellow gorse and broom in time for early summer visitors.

Constantly shifting sands at the mouth of the Coquille River also made navigation and settlement here difficult in the mid-1800s. There was a flurry of gold mining on the black sand beach north of the river in 1853, but the metal quickly played out and the camp disappeared. A few years later, homesteaders did claim land in the valley, and ships finally managed to cross the river bar, laden with lumber bound for California.

Finally, in 1873, an Irish immigrant named Lord George Bennett bought land on the bluff, planted gorse that reminded him of his homeland, and called the area Bandon Beach. Another settlement called Averill took root in 1887 near a ferry landing on the river, and four years later the two communities merged. The shoals at the river mouth were still a dangerous place for shipping, but new jetties and a lighthouse mitigated the

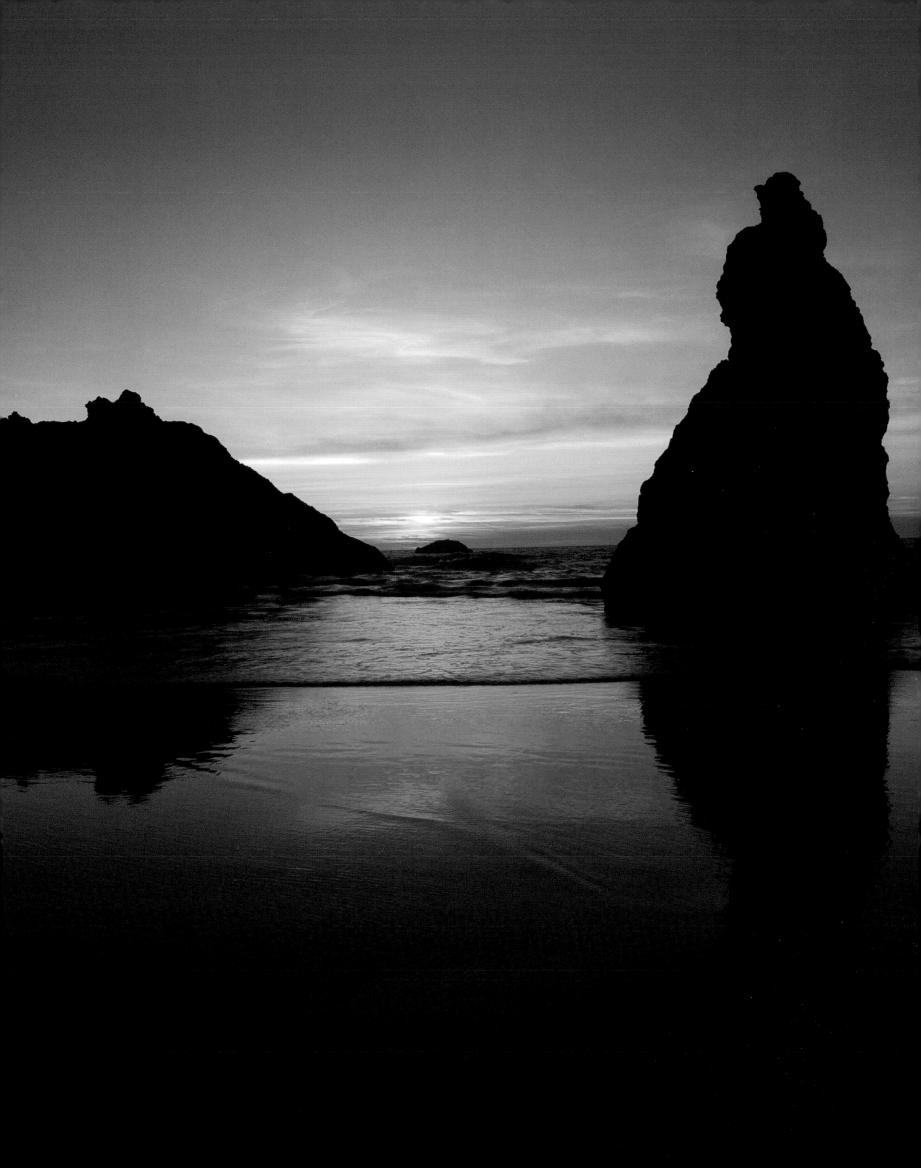

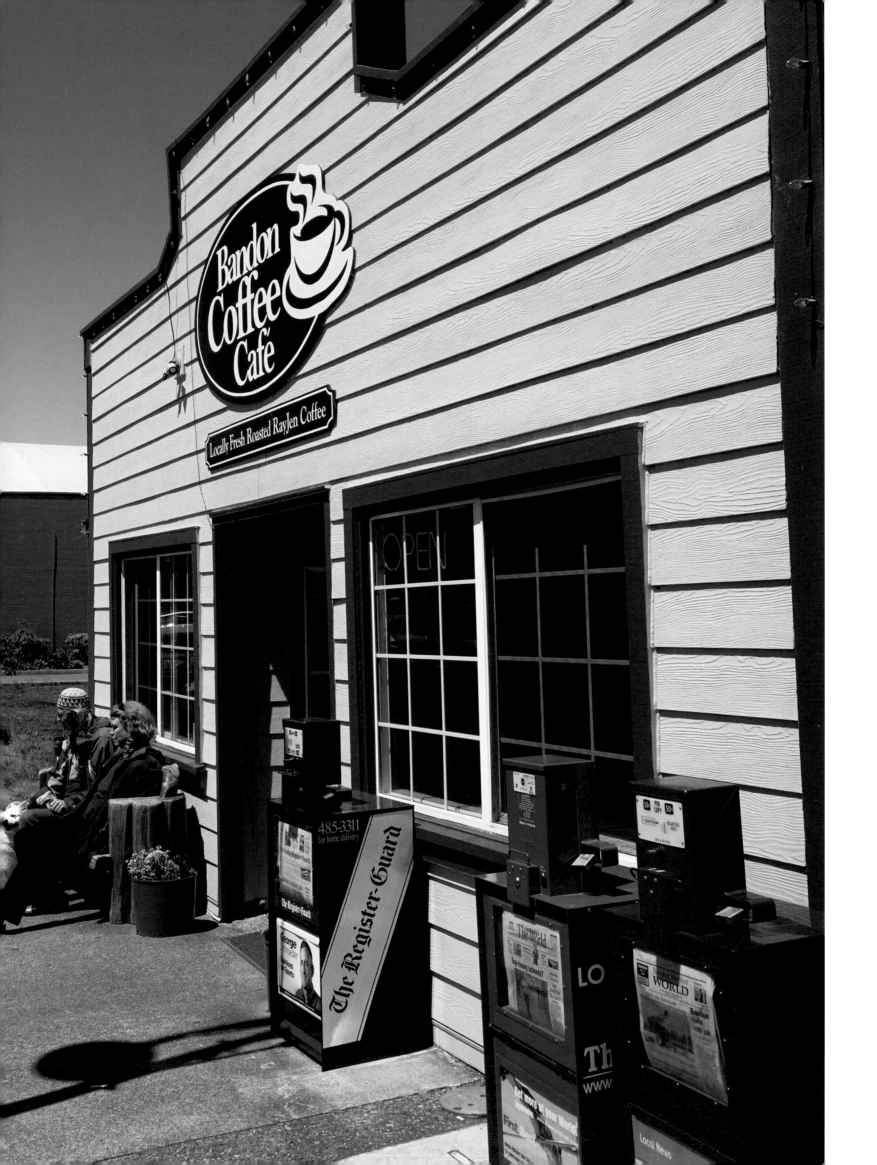

risks, and Bandon grew into a shipbuilding center and a busy port for vessels carrying timber, dairy products, coal, fish, and woolen fabrics – and passengers – down the coast to San Francisco.

By the turn of the century, the town had plank streets and sidewalks over tidal flats along the river, and canneries and mills built on pilings over the water. In the summer visitors flocked to the beaches, turning the place into a burgeoning bathing resort.

Everything changed, though, in late September 1936, when a wildfire broke out in the forests east of Bandon. By the time the flames reached the coast, they were beyond control. Fed by now-widespread gorse and aided by high winds and low humidity, the fire roared through the town, destroying 200 businesses and 400 homes. The walls of one bank – now the Masonic Building – were left standing, and luckily some mills and the fishing fleet also were spared. But the devastation prompted many Bandon residents to move away.

The story of the disaster forms one of the exhibits that fill the Historical Society Museum in the former City Hall at the edge of downtown. Ship models and memorabilia detail Bandon's maritime history, along with bootlegging "evidence," fishing, logging, and cheese-making artifacts, and pictures of the Cranberry Festival, which began in 1946 and continues as an annual celebration of the colorful crop.

Today many visitors also get an introduction to the local fishing industry at the informal crab shacks beside the downtown marina and a taste of cranberries in the gift shops of Old Town, which was reconstructed a few decades ago. Now galleries, boutiques, cafés, and restaurants cluster along the compact grid of streets, inviting tourists to stroll and shop between rounds on the seaside golf courses, a visit to the lighthouse, or a hike on the dunes. There's plenty of time before the late hour reminds them to grab a camera and head for the beach for one more shot at sunset.

A popular spot for a cup of java and the morning news, the Bandon Coffee Café (opposite) has adopted an old-style false-front façade. The town's original buildings mostly perished in a devastating fire in 1936, but the waterfront again anchors a downtown of shops and eateries, including seafood shacks and a fish market (above) with a playful allusion to its wares. Some 15 miles north, Shore Acres Historical Garden (above left) adds bronze cranes to the lush grounds that showcase rhododendrons, roses, and an Oriental garden.

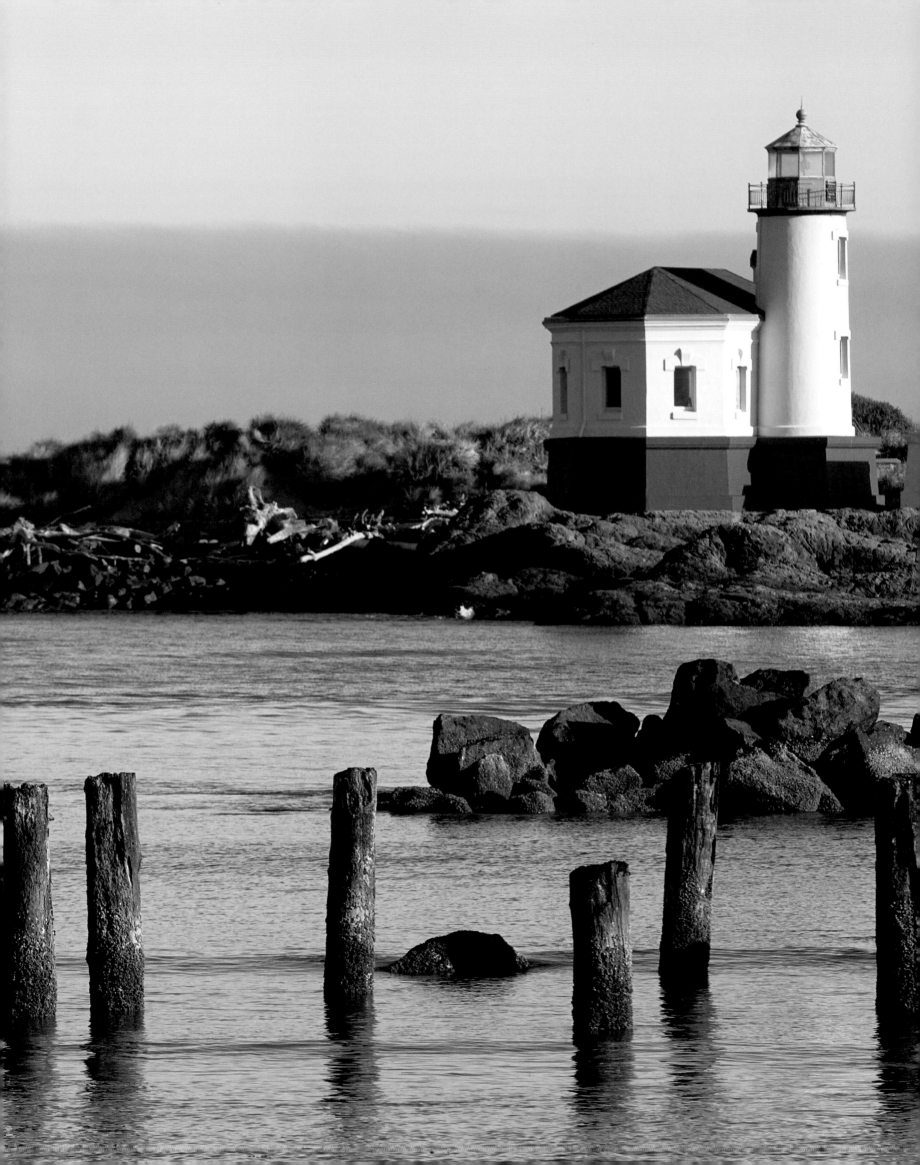

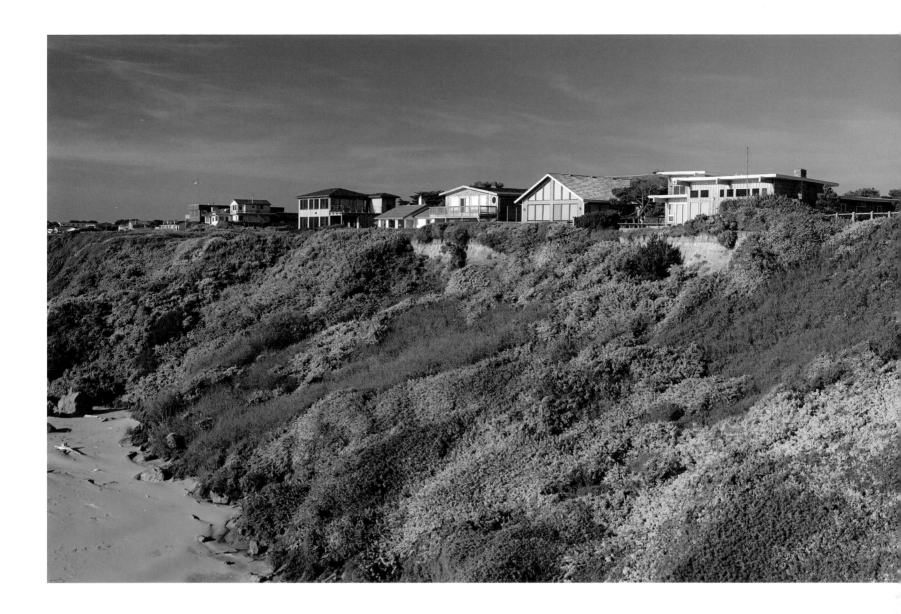

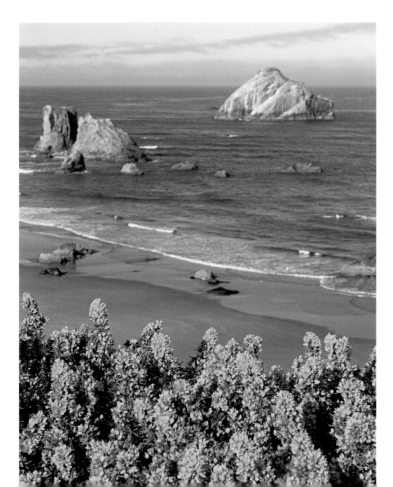

A stout sentinel built in 1896, the Coquille River Lighthouse (opposite) *marks what was a tricky river bar just outside Bandon. Homes crown the gorse-covered dunes* (above) *along Bandon State Beach. The vegetation was planted in the 1870s by Lord George Bennett to remind him of the Ireland of his birth. Unfortunately, when wildfires blew into town, the flammable gorse contributed to the conflagration. Today the plants bloom brightly in spring, contrasting with the rocky seascape* (left) *that is visually arresting all year long.*

Cannon Beach

All sorts of things are revealed at low tide on an Oregon beach, especially when you're standing only steps away from a 235-foot-high basalt monolith that resembles the haystack for which it is named. Studding the base of this amazing rock are fat purple starfish and sea-green anemones, as well as shelves and ledges of black-shelled mussels. Tide pools glisten among the stones and boulders that have been stranded by the outgoing sea, and a careful examination turns up sea-snail-like chitons and clinging barnacles.

This close, you can easily identify the seabirds that have colonized small patches of vegetation: noisy gulls; inky, long-necked cormorants; murres with distinctive white breasts; and the prize – tufted puffins that stand out from the avian crowd because of their orange feet and matching bulbous beaks.

Soon enough, the tide turns, and Haystack Rock, designated a Marine Garden by the Oregon Division of

With moody magic, Cannon Beach's coastal charm (right) exerts a spell on visitors whatever the weather. The town has been a getaway for Portland residents since early in the 20th century. Modern travelers also find warm hospitality, which includes plentiful eating and drinking spots, like the local tavern (above) that serves the beer it brews upstairs.

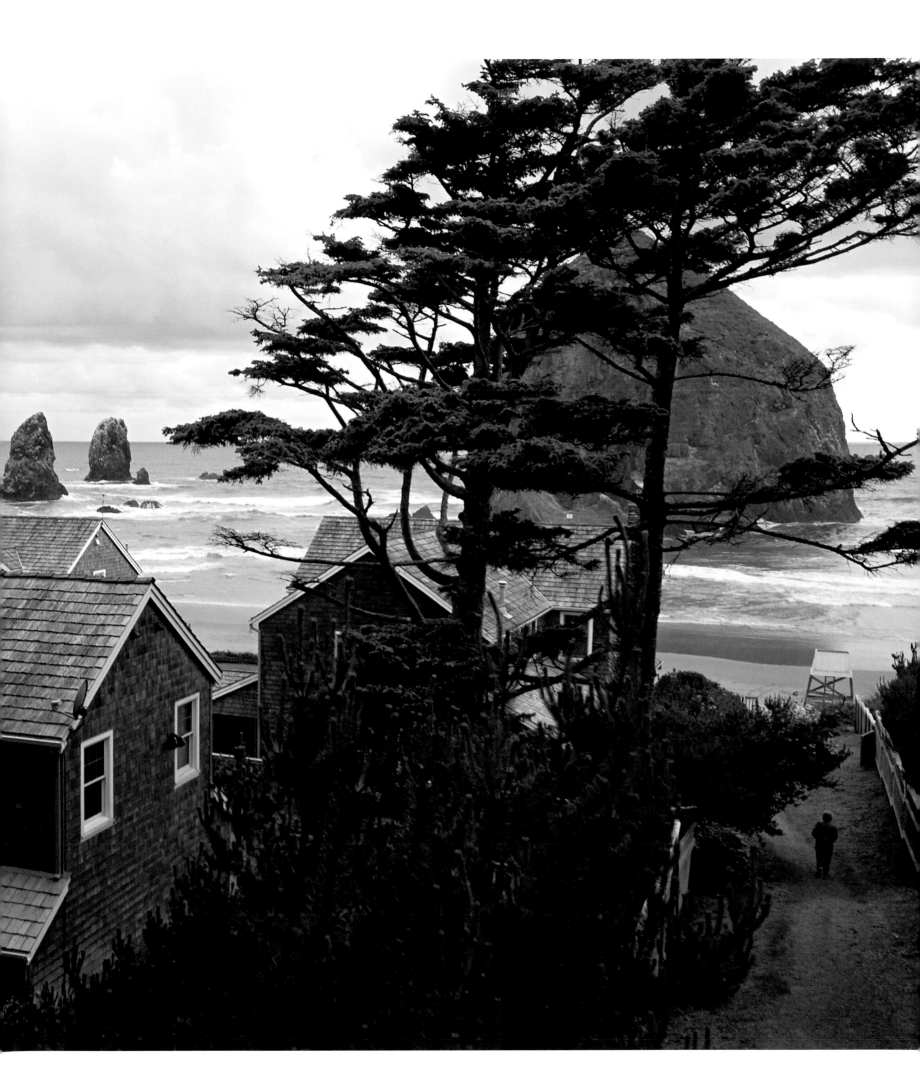

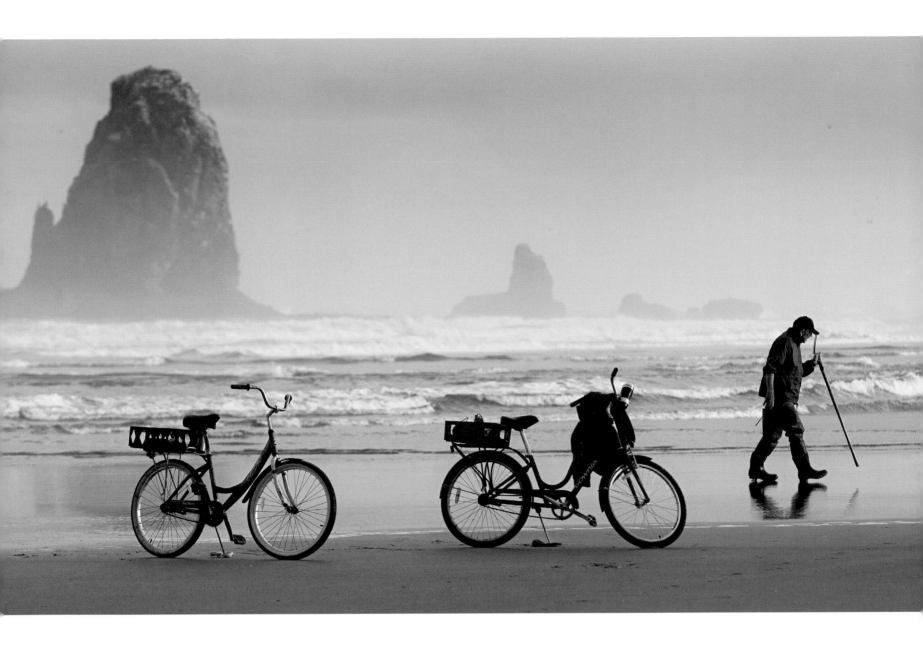

Fish and Wildlife for its wealth of sensitive sea life, is once again surrounded by ocean. Yet it remains an irresistible magnet for travelers to Cannon Beach, who come to see it from morning to night, in fine weather and fog.

With a landmark like this, it's little wonder that the town has been a summer resort since the early decades of the 20th century, though its weathered shingle-style, low-rise "downtown" shops lend Cannon Beach an understated air of contemporary chic. Less immediately apparent to visitors are the longstanding ties that bind the community together. Many of the innkeepers, artists, and business owners have been here long enough to remember roller-skating in the theater building, the boisterous loggers in the town tavern, and a sharply defined visitor season that began with Memorial Day and ended abruptly at Labor Day.

In one sense, the very first tourists made their appearance in January 1806, when Captain William Clark and several members of his Corps of Discovery, including Sacajawea, hiked over Tillamook Head to see a beached whale that Indians had told them about. The carcass had been stripped by the time the party arrived, but the explorer was able to buy some blubber and oil from the Native Americans.

Clark returned to Fort Clatsop, near modern-day Astoria, leaving the beach to Tillamook Indians, who lived in small villages of cedar plank houses near the mouths of coastal rivers. The tribes had been decimated, though, by the time the first homesteaders claimed land here. Of the 1,000 in the area at the time of Lewis and Clark, only 200 Native Americans survived less than 50 years later.

The earliest settlers put down roots along Elk Creek, since the rough timbered terrain near the beach was hard to farm. The offshore waters had their own perils, proved by the foundering of the schooner *Shark*, just to the north, in 1846. The captain tried to jettison his cannons, but the ship broke up anyway, and bits of the wreck, including the guns, washed up on beaches up and down the coast. One cannon was hauled above the high-water mark near Tillamook Head, while two others were left buried. Almost 20 years later, another

Sky-blue Adirondack chairs emphasize the New England style of the cedar-shake and saltbox architecture (opposite) *that prevails in town. Though most of the houses are new, many occupy the compact footprints of homes built in days gone by.* Above: *A clammer probes the sand for shellfish.*

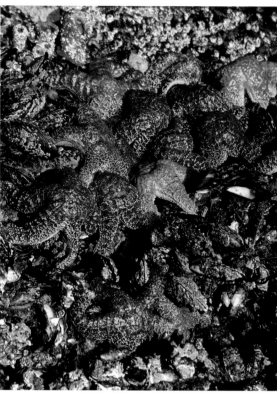

gun was spotted in the sand south of town, but it quickly disappeared.

Not until 1898 did a local mail carrier discover the artillery piece anew and pull it out. Today it occupies a place of honor in front of the Cannon Beach History Center and Museum. In an intriguing coda to the story, two more cannons were found in February 2008 and are being tested to determine if they really are, as is likely, from the *Shark*.

Inside the museum, entertaining exhibits trace the growth of the beach community from its beginnings. The construction of a lighthouse at Tillamook Rock – known as Terrible Tilly – eased the shipping hazard, and by 1904 hotels for vacation-seekers stood on both sides of Elk Creek, with tiny oceanside lots offered for sale at $100 each.

In 1911 Governor Oswald West came to sample the hospitality of the Warren Hotel, not far from Haystack Rock. Later generations can be glad he enjoyed his stay. A year later the governor declared the beach road, which was passable at low tide, a public highway, giving ownership of the beach to the state, setting a precedent that was followed throughout Oregon decades later.

Cannon Beach thrived in the 1910s and the 1920s, as Portland residents built or rented saltbox summer cottages so they could spend weeks walking on the beach, wading in the ocean, clamming and crabbing, and toasting marshmallows over campfires. The rest of the year, the permanent residents – perhaps 200 souls – were sustained by logging, millwork, and other small businesses.

The Depression stopped the logging and also took its toll on summer tourism. The town became quiet and a bit bedraggled, until the lumber industry revived in 1938, and highways made Cannon Beach more accessible to visitors in the 1940s. Some of the soldiers stationed nearby discovered this was a congenial place for R&R, but only in the 1960s did a few artists join them, adding a strand of countercultural spirit to the town's personality.

When a tsunami struck in 1964, Cannon Beach responded by organizing a Sandcastle Festival to prove that not everything had been washed away. In fact, there was new energy in town. The skating rink was renovated as a community theater. Artists' workshops and studios sprang up; hotels, motels, and cottages once again filled during a season that gradually extended throughout the year.

Today, along with the vintage saltbox-and-shingle architecture, an old-style friendliness greets visitors who stroll the galleries and boutiques, throng the cafés and seafood restaurants, marvel at the public sculpture that's a legacy of a town full of artists, or simply stop in a bakery for loaf of "haystack" bread.

With the landmark itself protected, it's an approved way to take home a piece of the rock.

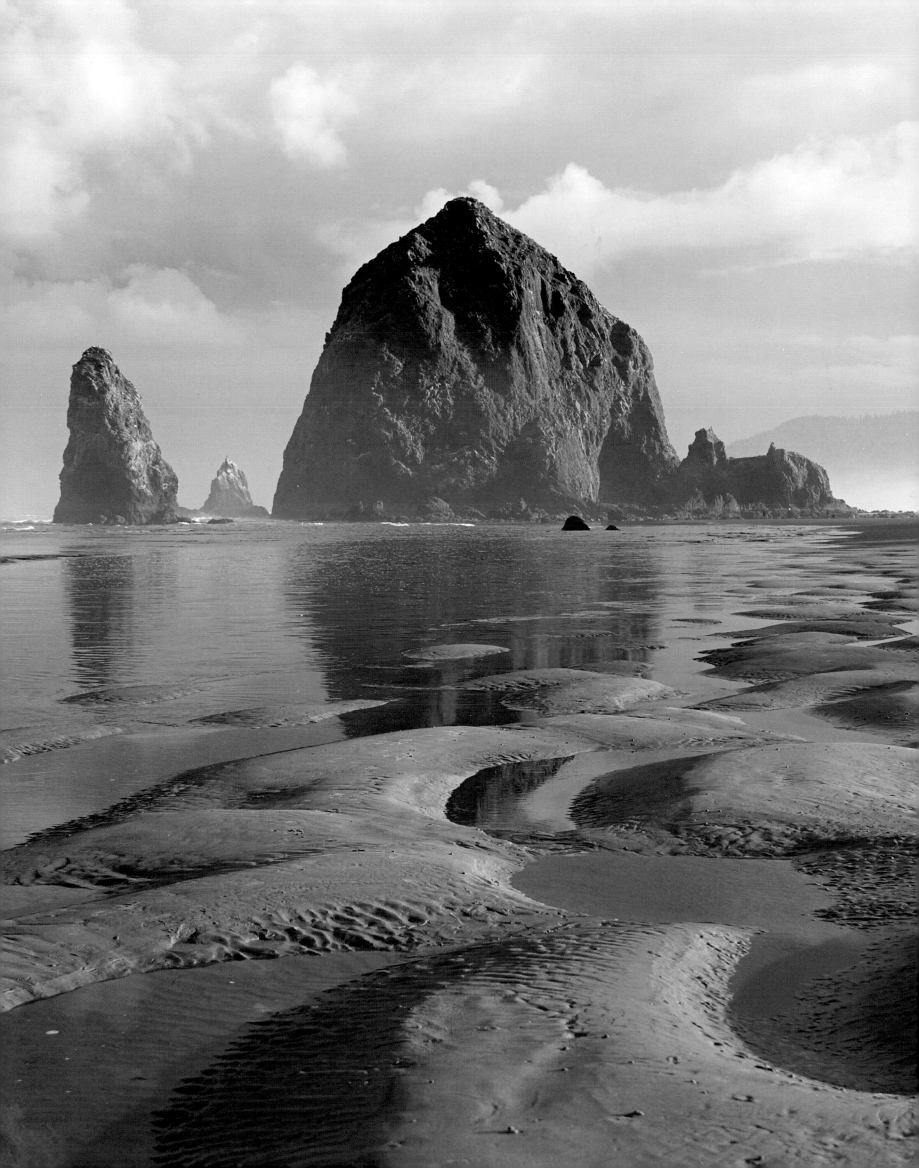

Florence

A crimson rhododendron bush brightens a private garden in Florence (opposite), which celebrates the flower with a boisterous festival every May. The town crowned its first Rhody Queen in 1908 on a barge in the Siuslaw River, which at that time could be crossed only by ferry. The Art Deco bridge (above), with its arched supports and tubular piers, opened to traffic in 1936.

Every morning the regulars gather in the cozy café in the shadow of the Siuslaw River Bridge to catch up on the news in Florence. It's a tradition, locals say, that pre-dates the transformation of this storefront at the end of Bay Street into a coffee place. These days the industrial-chic spot offers not only fresh roasted beans but also assorted home and garden items for sale. But it wasn't that long ago that the sign read Bill's Auto Service, and owner Bill Karnowsky kept a fire going winter and summer for friends to sit around while they sipped a cup of java.

At the rear of the shop a riverside deck has a com-manding view of the futuristic obelisks that punctuate the Art Deco-style span. The bridge, designed by Conde McCullough and funded by the WPA, opened in 1936, marking a turning point for the town.

Florence got its start with a few settlers in 1876. In its earliest days anyone who wanted to travel up or down the coast had to rely on a stagecoach – specially designed for running on sand – that made its way along the beach, captained by a driver attentive to the tides. As for the town's name, that came about, legend has it,

when a plank from a shipwreck washed ashore embla-zoned with the word "Florence." The relic was hung in a local hotel, and the moniker stuck.

The *Florence* wreck was not a rare occurrence. These were dangerous waters for ships: Breakers over the shifting sandbars at the river's mouth made naviga-tion treacherous, and offshore rocks posed additional hazards. Eventually new jetties helped traffic move in and out of the Siuslaw River and contributed to trade in lumber – and passengers – that extended to San Fran-cisco and Portland. Lighthouses, like the one lit in 1894 at Heceta Head, a dozen miles north, reduced the risk of ships running aground. But the lighthouse keeper, his assistants, and their families had a lonely existence tending the Fresnel lens and waiting for supplies that came by water or, occasionally, from Florence, seven hours away by beachside coach.

By the turn of the century, Florence was thriving, supported by a salmon cannery owned by the Kyle family, who also ran the post office and built an impos-ing mercantile in 1901. Photos from that era show a crossroads of one- and two-story false-front shops,

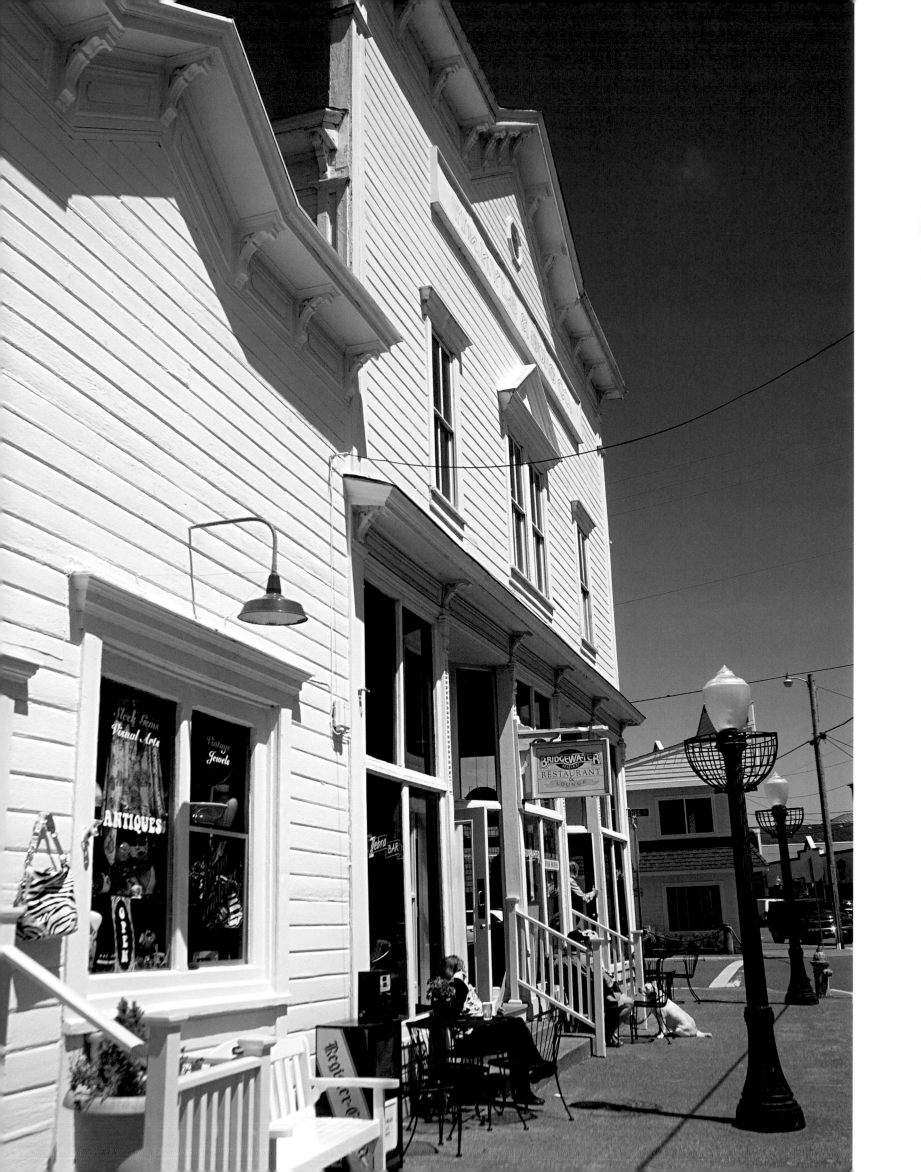

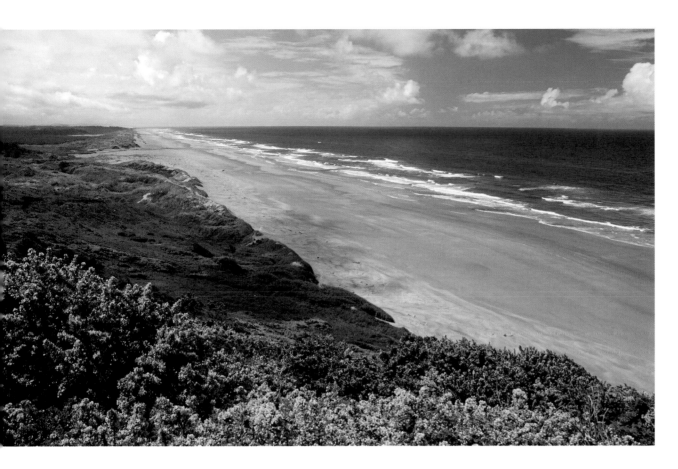

several gracious homes, and the Presbyterian church steeple. The town soon had its own newspaper, called *The West*, which was run by Florence's first mayor. The community was also developing its local traditions: Beginning in 1908, residents turned out every spring to celebrate the rhododendrons that bloomed in spectacular profusion in the surrounding woods. That first year Miss Laura Johnson was the Rhody Queen, crowned in great pomp aboard the queen's barge, which was moored in the river.

The floral monarch and her successors are remembered in the Siuslaw Pioneer Museum, which occupies the 1905 school building capped with a tiny bell tower. Other exhibits illustrate daily life in Florence over the years. Thanks to renovations over the last few decades, the old downtown has also regained the look of an earlier era. The Kyles' mercantile, listed on the historic register, is now a spacious restaurant; a drugstore from 1915 offers men's apparel; and the 1910 telephone office and the 1913 Masonic Lodge both house shops. Other old buildings – including a turn-of-the-century train depot that has been moved to a spot on Bay Street – are home to restaurants, while several centuries-old residences grace the side streets.

Although the cannery shut down in 1919, lumber barges plied the river for decades afterward, until the

last sawmill closed in 2005. Long before that, however, the riverfront district had gone downhill. By the late 1960s it was home to hippies and other offbeat characters, like the owner of a bait-and-tackle place jammed with wares but hung with a permanent "closed" sign, or the mysterious individual who claimed he knew the truth about the disappearance of D. B. Cooper and then disappeared himself, or Bill Karnowsky, who presided over his "Bay Street regulars."

Few buildings were torn down, however, and in the 1970s the historic structures began to be fixed up for shops, bars, eateries, and galleries. Craftsman houses were converted to bed-and-breakfast inns, and the old ferry landing, which had ceased to be used after the bridge opened, was transformed into a tiny city park.

The bridge now brings Florence thousands of visitors, especially during its Rhododendron Festival. They come, too, to explore the miles of beaches that make up the Oregon Dunes National Recreation Area. Trails lace the sandy hills that extend back from the ocean's edge in a succession of beaches, foredunes, hummocks, ridges, and stabilized vegetation. Hikers make their way down to the water; bikers ride the heights in noisy bursts of energy and speed. Although the process is pretty much invisible, the dunes themselves continue to evolve, subject to the natural forces of wind and waves.

The tall, false-front Kyle Building (opposite) *began as a mercantile in 1901, when it was built by one of Florence's leading entrepreneurial families. Restoration began in 1971, and the structure – now a restaurant – was listed on the historical register a decade later. Today many neighboring shops on Bay Street have also been renovated as chic boutiques and cafés. Beyond downtown, Bliss' Hot Rod Grill* (above) *puts its own twist on the classic drive-in restaurant. Above left: Flat white sands stretch for miles north of Florence. In the late 1800s this was the only thoroughfare on the coast, accessible to stagecoach drivers who had to time their schedules to Pacific tides.*

Hood River

The Roaring Twenties were just underway when the red-roofed Columbia Gorge Hotel (opposite) *welcomed its first guests to Hood River. Built by Simon Benson, the lumber magnate who had pushed for a highway from Portland, the stylish waterside accommodations were favored by movie stars and presidents. The area was already known for its orchards. Early crops of apples gave way to the pears that still bring fame to the valley* (above).

On a late summer's day with a stiff wind blowing, it seems everyone in Hood River is down at the Town Beach, where a spit of land hooks into the wide, swift-flowing Columbia. Families have brought lawn chairs and picnic coolers. Children and dogs are playing on the grass. Hundreds of people of all ages – from teens to gray-haired seniors – are wriggling into wetsuits, toting windsurfers and kiteboards to their launch spots, and skimming out into the river.

With all the activity on the water, it's amazing that there aren't any collisions, especially when a flotilla of tiny sailboats emerges from behind the bridge that links Oregon to Washington State. The boats parade through the swarm of athletes who zip back and forth, taking advantage of the breezes that have made the Columbia Gorge a windsurfers' mecca for more than 25 years.

The scene has its roots in geology, beginning with the two volcanic Cascades peaks that define the region:

12,276-foot-high Mount Adams, 40 miles north in Washington; and 11,239-foot-high Mount Hood, 30 miles to the south. Lava from their eruptions was gradually sliced away by the Columbia River, leaving the scenic cliffs and plentiful waterfalls that line the narrow gorge, while differences in air pressure east and west of the Cascades account for the notable winds that blow through.

In the past the river was rich with salmon, which sustained the Native Americans who had lodges and trading centers in the area. The Indians were numerous when Lewis and Clark followed the Columbia to the Pacific in 1805, but the tribes' population began to dwindle as whites claimed the land in the 1850s.

Mary and Nathanial Coe were among the earliest pioneers in what was originally called Dog River, and they soon planted fruit trees in the fertile soil – a harbinger of what was to come. Their home was a gath-

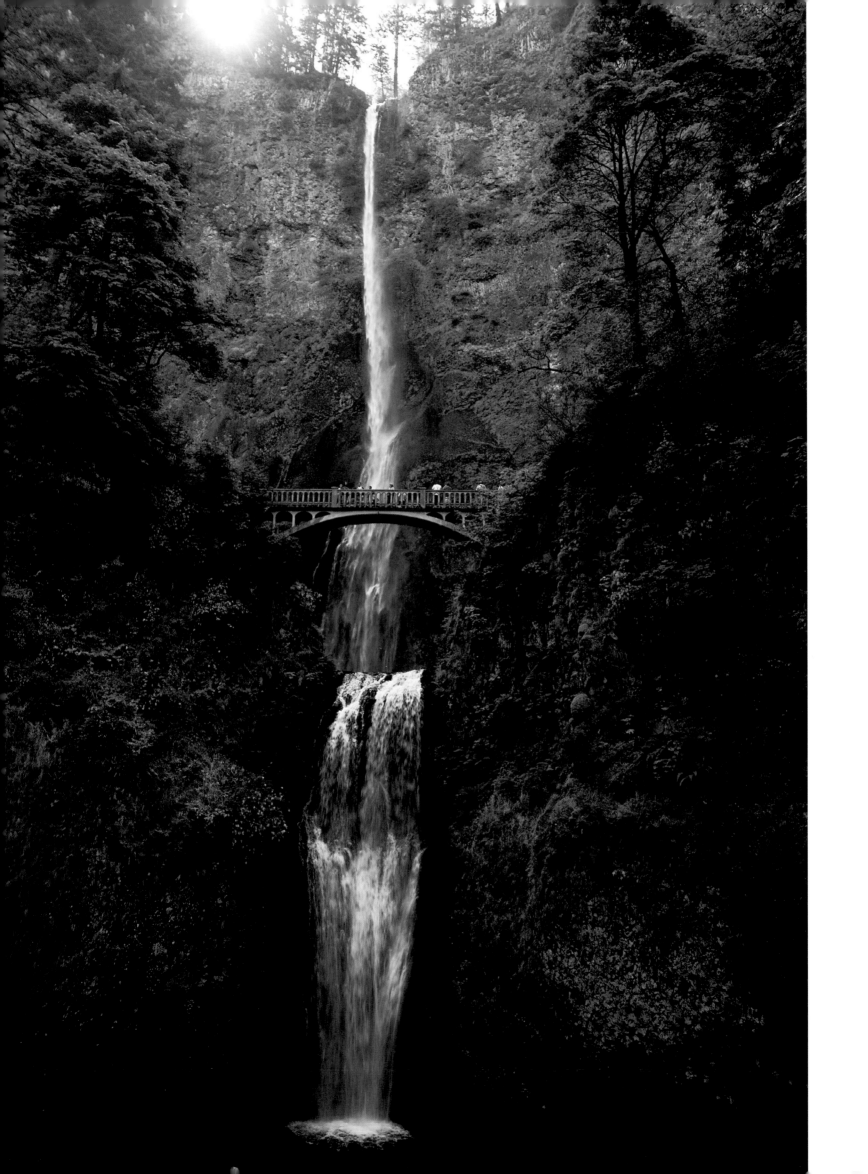

ering place for the little community, which changed its name to the more pleasant Hood River before long.

Transportation in those days was by riverboat, with short portages where rapids or waterfalls made passage impossible. The use of sternwheelers persisted even after the railroad came through the gorge in 1882. In anticipation of that event, Coe had already platted a town, offering free lots to anyone who would start a business. The first store opened at Oak and First Streets, just a block from the train depot, and a small commercial district grew up from there.

Within a few years the Hood River Valley was abloom with orchards. Growers organized a fruit fair, a cannery followed, and eventually a railway line transported produce and lumber to the warehouses in town. Hood River apples became famous, but a freeze in 1919 encouraged a shift to frost-tolerant pears, and recently wine grapes have also made an appearance. The Hood

River County Historical Museum has a wall lined with graphic fruit-crate labels that reflect the valley's varied crops, along with rooms full of other artifacts ranging from an apple-polishing machine and homesteaders' furniture to memorabilia of the Japanese families who worked in and developed the area's orchards.

The valley remains an agricultural center, with roads named Gravenstein and Peachtree and fruit stands and farm stores that invite "fruit loop" auto tours. The Mount Hood Railroad also continues to carry freight, despite being better known for scenic tourist rides through the countryside.

Meanwhile, the town of Hood River grew modestly, replacing its initial wooden buildings with the stately brick structures that line the streets of the downtown. A Craftsman-style train depot was built in 1911, and the Hood River Hotel, which dates to 1912, has been restored to reflect its early Edwardian style. City Hall

Thin ribbons of spray descend in tiers at Multnomah Falls (opposite), *one of the reasons the Historic Columbia River Highway is known as a scenic drive. Sightseers can also ride the Mount Hood Railroad* (above left) *in the shadow of its namesake peak, a winter sports destination. At other times of the year, kite-surfing enthusiasts* (above) *tote their rainbow-hued gear in and out of the water at Hood River's Town Beach; windsurfers launch from a different spot in the park. Over the last 30 years, these athletes have invested the 19th-century town with 21st-century energy.*

A Hood River shop issues a multicolored invitation to relax (opposite) and smell the flowers. Gladioli bloom in the garden of the Gorge White House (above right), a historic home and wine-tasting venue south of downtown. An easygoing drive through the "fruit loop" of the valley (above) brings visitors to a country store. Below: The Columbia Gorge sternwheeler offers cruises that evoke the past – complete with bewhiskered staff.

stands where it went up in 1921, while turn-of-the-century banks, fraternal halls, and mercantiles of all kinds are now occupied by offices upstairs and a variety of boutiques, galleries, and restaurants at ground level.

There are also onetime garages and automobile dealerships from the 1920s, monuments to an important change in the community during that decade. Cars appeared on the roads of Hood River and were driving into town on the recently completed Columbia River Highway from Portland. To accommodate the new visitors, Simon Benson, a lumber baron who had helped to fund the highway, envisioned a grand hotel overlooking the gorge. He hired Italian artisans who had worked on the road's stone walls and bridges, and in 1921 the opulent inn opened its doors, eventually welcoming silent-film stars such as Rudolph Valentino and Clara Bow and politicians such as the former President Taft.

A decade later, the Depression took its toll, but the construction of the Bonneville and other dams on the Columbia helped to keep the local economy going with jobs and hydroelectric power.

The dams tamed the river, but not the winds, something windsurfing enthusiasts began to notice in the early 1980s. Skiers had flocked to the snowy slopes of Mount Hood since the 1960s, but the easygoing windsurfers would have an even greater impact on the local lifestyle. As they moved to town, they infused it with a new energy that has given rise to fine restaurants, arts events, and wine-tasting venues.

Yet the scene remains mellow, welcoming to locals and visitors alike. Witness the crowd at The Pines, an art-gallery-cum-wine-bar that hosts a weekly musical jam session in the evening. What starts as a jazzy quartet of guitars, trumpet, and sax expands to include a harmonica, a keyboard, and an electric ukulele, while the spectators – whom you've probably met in the last few days – greet you like an old friend blown in by the wind.

Jacksonville

In his vintage barbershop on California Street, Ed McBee cuts hair and good-naturedly ribs a customer, who good-naturedly kids him back. This is the surely the same kind of lively "discussion" that has taken place in this tonsorial parlor since it first opened in 1884.

A pleasant time-warp feeling pervades all of Jacksonville, which was declared a National Historic District in 1966. The town's two main streets – Oregon is the other – are lined with the gussied-up one- and two-story brick façades of the late 1800s, adorned with fancy cornices, arches, false fronts, balconies, and awnings, in hues that range from terra-cotta and white to green and tan. Although the 19th-century butcher's, gunsmith's, blacksmith's, and general store now house a very up-to-date ladies' apparel boutique, a gelato shop, a gourmet foods store, and a restaurant, the contemporary proprietors are nevertheless eager to recount their building's history, often taking time to show off photos from the early days. The same pride in preservation is evident on the tree-shaded residential streets, where

A window on the past, Jacksonville's National Historic District exudes mid-1800s atmosphere (right). *The United States Hotel, built in 1880, played host to President Rutherford B. Hayes. Beyond it, the Jacksonville Inn, which dates to 1861, continues to welcome guests. The Jacksonville Barber Shop* (above), *a natural gathering spot for locals for more than a century, has also served as a post office.*

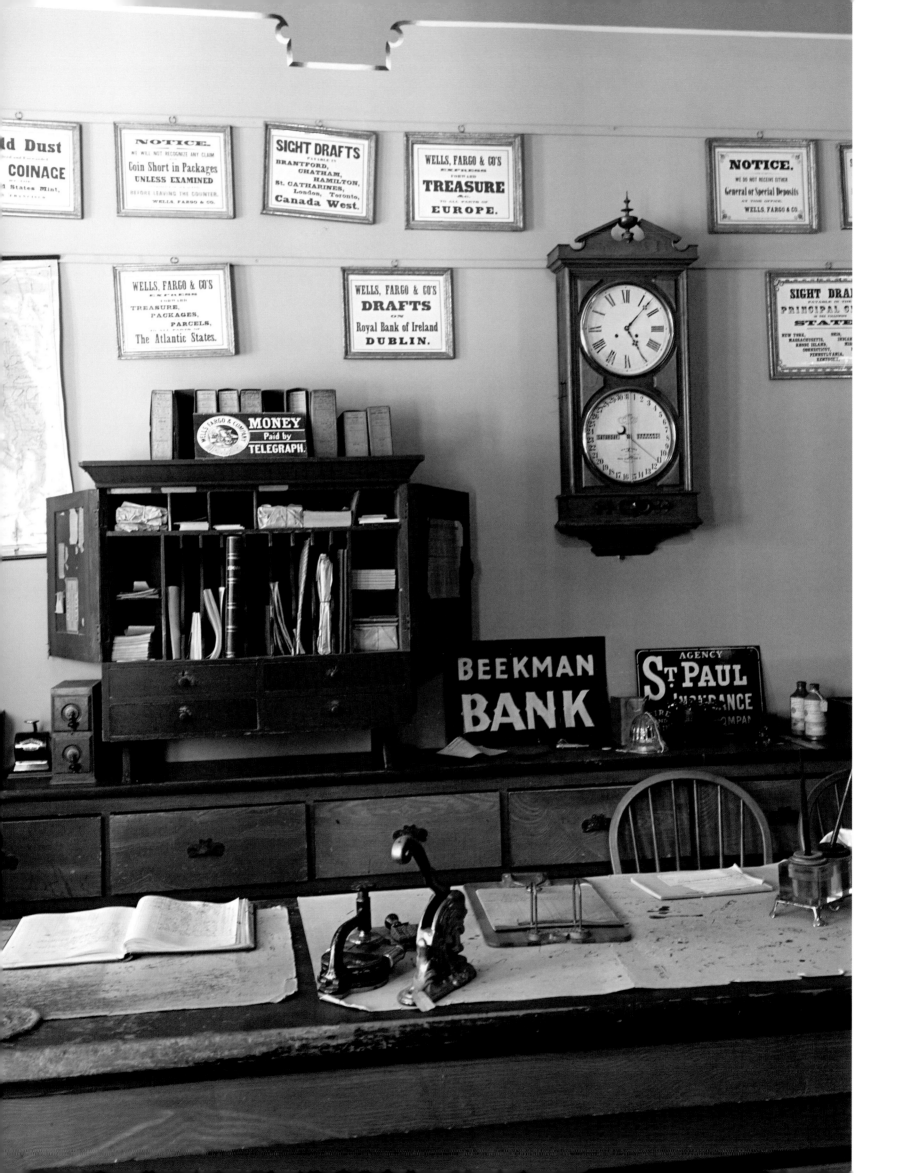

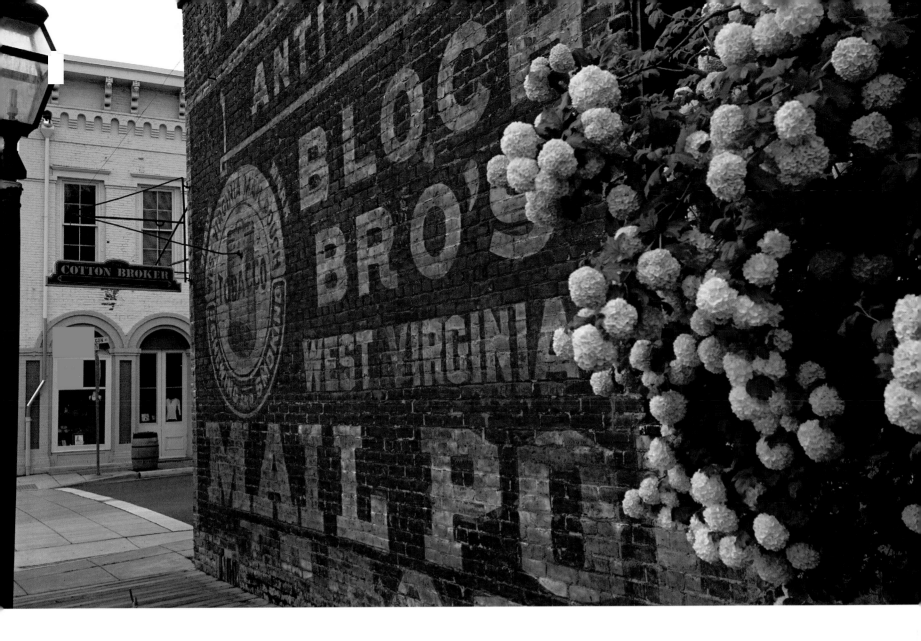

dozens of houses from the 1860s to the early 1900s have been meticulously restored.

It's an amazing transformation from half a century ago, when – locals are fond of pointing out – Jacksonville was without water or sewer services and so run down that banks refused to loan money to anyone who wanted to buy and restore a home. The interstate highway was slated to go through town, obliterating the old properties. A resident named Robbie Collins, an avid fan of architectural restoration, successfully lobbied for the historic district designation, ending the highway threat. He bought and preserved the 1861 Catholic Rectory (which had also been a home for wayward boys), and an 1865 brick dwelling that had served as a hotel, butcher shop, ice cream parlor, and saloon. Before long other residents would follow his lead.

The restorers had great material to work with. Jacksonville's roots reach back to 1852, when a pair of pack-train operators found gold in a nearby gulch. A mining camp called Table Rock quickly sprang up, and fortune seekers flooded in to try their luck with gold pans, sluices, and rockers. Many of them found it more lucrative to pursue other businesses, however.

Ledgers, stamps, signs, and inkwells have barely moved since the doors of the Beekman Bank (opposite) closed in 1912. Bags of gold from Oregon mines passed through its vault on their way to the U.S. Mint, making owner Cornelius Beekman a rich man. The express agent-turned-banker contributed generously to build the town's Presbyterian church (left), an 1881 example of Victorian Gothic architecture. Gas lamps and a ghostly ad (above) contribute to the impression that time has stopped.

The oldest wood-frame building in Jacksonville – and perhaps the oldest house of worship in southern Oregon – belongs to the Methodist Episcopal Church (below), built in Classic Revival style in 1854. According to legend, funds for its construction were collected from miners in the surrounding gold camps. After the original congregation disbanded in 1928, the church served other denominations; it's now home to St. Andrew's Episcopal Church. The cottage next door is the parsonage.

Within three years, Jacksonville had a new name and boasted eight drygoods stores, three blacksmith shops, two livery stables, one hotel, several boarding houses, one brewery, one stove and tin shop, one boot and shoe store, one millinery shop, two bakeries, one market, two cabinet shops, at least two drugstores, one billiard salon, one tobacco and cigar store, four lawyers, and one physician, as well as saloons, schools, and churches.

Cornelius Beekman, who arrived in 1853, established an express company, followed by a highly profitable bank. The rich but hardly ostentatious residence he and his wife built in 1873 is now a prized Southern Oregon Historical Society property, preserved as it was in 1911 with the original spice boxes in the kitchen, a music box in the parlor, family china on the dining table, and Julia Beekman's dresses in the closets. Beekman's bank is also a museum, a turn-of the century establishment down to the ledgers at the teller's cages, assayer's weights, and stamps and inkwells at the ready.

Another notable citizen, Swiss immigrant Peter Britt, came to Jacksonville in 1852. After a brief attempt at prospecting, he returned to his earlier photographic career and shrewdly pursued other enterprises as well. He bought a string of pack mules to ferry supplies to the town, invested in real estate, and experimented with plantings – not only ornamental shrubs but also fruit trees and grapevines, inaugurating a wine industry with his Valley View Vineyard. In addition to the vines, he left a photographic record of southern Oregon's people and places, including the first pictures of Crater Lake, taken in 1874.

Britt's story and memorabilia are on display at the Jacksonville Museum in the cupola-topped former county courthouse, alongside other lively exhibits. The courthouse itself was started in 1883, during Jacksonville's boom times, as part of a campaign to attract the railroad to town. Unfortunately the train was routed to Medford, and in 1927, the county seat shifted there as well. By then Jacksonville's economy was already teetering, and the Depression only added to its decline.

Many residents departed. Some of those who stayed survived during the lean years by digging for gold in their backyards. The real treasure, however, turned out to be the town itself. After the Second World War, locals organized a historical society that eventually bought and restored the courthouse – which had stood abandoned for 20 years. Over the next several decades, the jail next door was turned into a children's museum, and the pioneer Hanley Farm, with its two 100-year-old barns, also was donated to the group.

Today preservation is a Jacksonville pastime. Costumed docents staff the house museums and sometimes

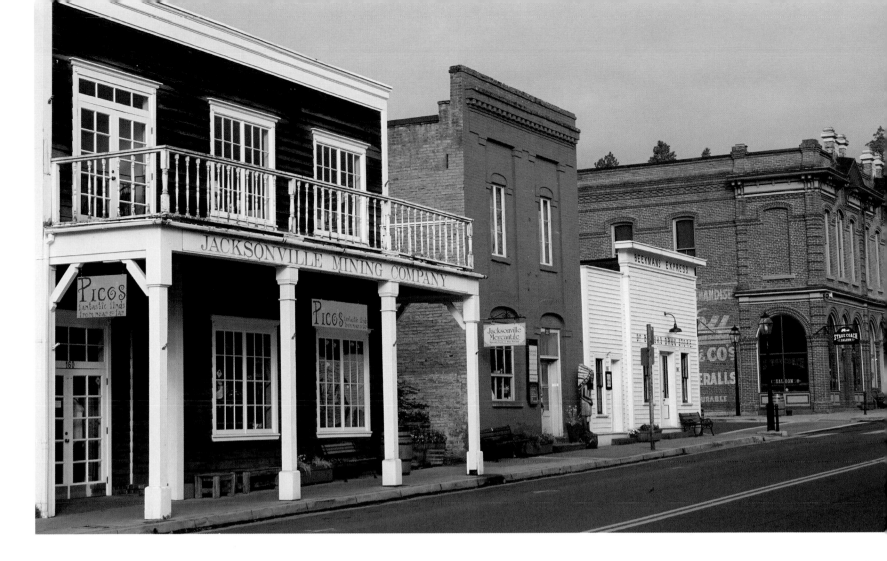

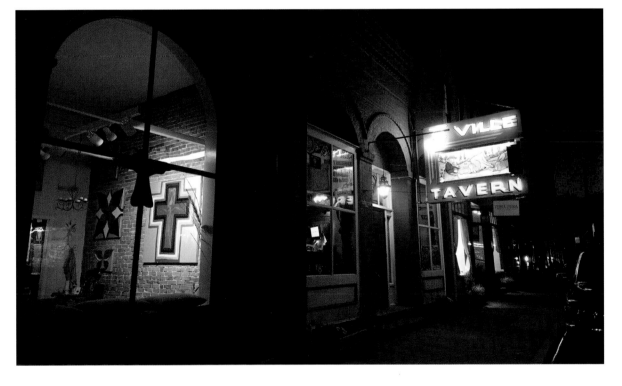

Built to impress, even small shops along California Avenue (above) boast false-front façades to boost their sense of importance. One of the main thoroughfares through Jacksonville, the street includes modest frame shops, two-story balconied structures, and grand brick buildings with ornamental touches. Inside, the old-time emporiums have been transformed into modern businesses selling eco-friendly products and gourmet foods or housing art galleries and bar-restaurants like the J'ville Tavern (left).

stroll the commercial district, adding to the old-time atmosphere that lures countless visitors. They come for the shops, restaurants, and romantic hotels, and for the annual Music Festival held on the lush grounds once owned by Peter Britt. Beyond the town, too, the wine industry he envisioned has taken on new life, with vineyards lining the green hills of the Rogue Valley and tasting rooms offering the opportunity to toast the power of history.

Joseph

With stirrups flying, the cowboy barely keeps his seat on the bucking bronco, whose back is arched while a hind leg kicks to the side. *Attitude Adjustment*, by sculptor Austin Barton, is a study in arrested motion, life-size and painstakingly worked in every detail, down to the texture of the buckaroo's fleece chaps. There are a dozen other monumental bronzes along Joseph's Main Street, but this one above all seems emblematic of the Western style of the town, which is flanked by forested mountains whose summits are still snowy at the end of summer.

This was not easy country for settlers to homestead, or even to find. Aside from the 9,000-foot-plus peaks guarding the Wallowa Valley to the south, the Snake River had carved out the treacherous Hell's Canyon, blocking easy passage from the east. The first white pioneers finally arrived here around 1872. But long before that, this was the heart of Nez Perce country, a place where the tribe summered and hunted abundant deer, bighorn sheep, and pronghorn. In winter, deep drifts covered the valley.

By the mid-19th century, the Indians' claim to these lands was being threatened, and in 1855 several tribal leaders, including Old Chief Joseph, agreed to treaties that defined a large reservation. But less than a decade after that, when the Nez Perce were asked to cede most of that land, he and several other elders refused. After the old chief died in 1871, his son, also called Chief Joseph, continued to attempt to maintain the tribe's territory peacefully. Nevertheless, in May 1877, the U.S. Army issued an ultimatum: The Nez Perce were to move to another reservation within 30 days. Instead the

A demonstration of horsemanship and a showing of the colors are all part of Chief Joseph Days (far right), the Old West celebration held every July in the tiny town of Joseph. Cowboys and cowgirls participate in the professional rodeo events – from riding and roping to steer wrestling and barrel racing – while Main Street businesses (right) show their spirit, too.

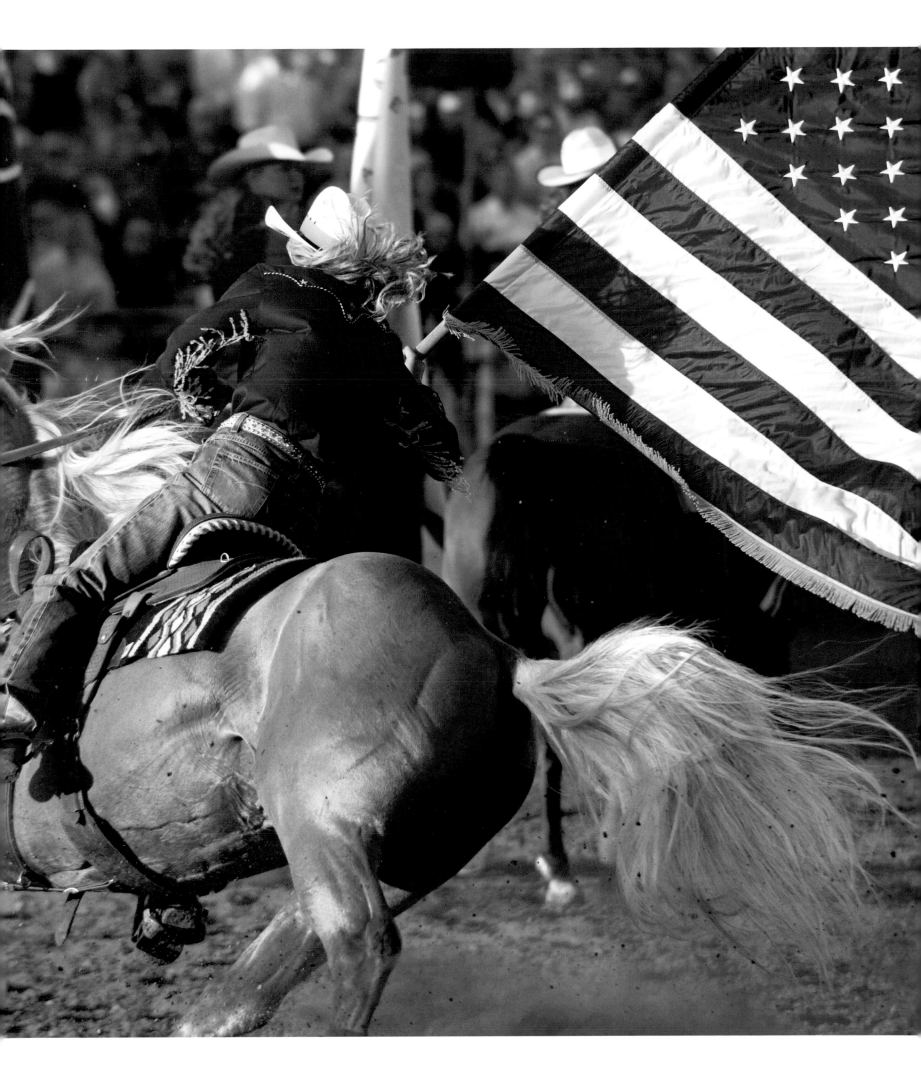

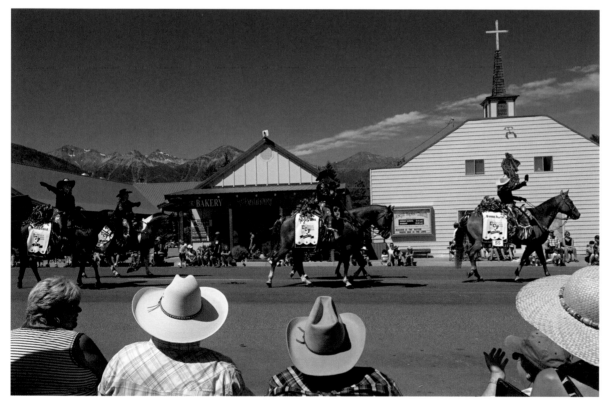

Everyone loves a parade, and Main Street is wide enough to accommodate spectators and contestants alike during Chief Joseph Days (above and above right). *The four-day celebration dates back to 1946. A newer tradition is the public display of large bronze sculptures crafted by the town's bronze foundries.* Attitude Adjustment, *by Austin Barton, catches a bronco mid-buck* (top). *The mountain setting is by Mother Nature.*

Indians fled, successfully crossing the Snake River and – after young warriors killed some settlers – beginning a run toward Canada. For several months the Indians eluded military pursuers, skirmishing and moving swiftly across Idaho and Montana. But the toll in lives was great, and in October Chief Joseph and the remains of his band surrendered. Chief Joseph was never allowed to return to the valley. He died on a reservation in Colville, Washington. His father's remains, however,

were moved to a gravesite overlooking Wallowa Lake, where contemporary visitors have left tokens, poems, and mementos to honor his memory. In town, the Wallowa Homeland Project also recalls the Indians' heritage – with photographs and exhibits as well as a grassroots movement for a place where the Nez Perce can celebrate their traditions and customs.

Meanwhile, during the 1870s and 1880s, settlers put down their own roots here, raising sheep and cattle

on scattered ranches. One enterprising homesteader named Frank McCully set his sights on a town. On his land claim – which encompasses today's Joseph – he established the first general store, presided over the first bank, set up the first public waterworks, built the first flour mill, was the town's first mayor, and was elected state representative for the county he helped create.

McCully also left his mark on the local architecture. The gracious mansion he constructed around 1915 is now a bed-and-breakfast on an expansive side-street lot. And his two-story bank, erected in 1888, remains the most impressive of Joseph's historic structures. Built of local brick in the Eastlake style, it has columns beside the angled entry and a hand-painted walk-in vault. The bank later was converted to a hospital and then housed city hall offices, but since 1977 it has been home to the Wallowa County Museum. Inside are photos, furniture – set up to re-create a kitchen, parlor, and bedroom – and curiosities such as local "buckskin bucks," deer-hide scrip used as money during the Depression.

Throughout those hard times, the ranchers and farmers persisted, though for the most part they raised horses and cattle instead of sheep. Sawmills – another source of local income – opened and closed. For outsiders, however, the attraction was always the setting and the outdoor sports: hunting, fishing, and camping, as well as boating on Wallowa Lake. More recently, adventure travelers have turned to the excitement of Hell's Canyon for hiking and white-water rafting.

Few people would have predicted Joseph's rise as a center for bronze art. In 1982 a small foundry opened in a former truck shop, and Valley Bronze began casting pieces for sculptors. Several other foundries have followed, producing both small artworks and gigantic statues, along with cathedral doors, and even national monuments. Visitors can tour a foundry to learn about the intricate process of transforming clay sculptures into wax models, then ceramic shells, and finally finished bronzes with impeccable patinas. Then they can see – and shop for – the results in Joseph's galleries. Main Street itself is an exhibit space, showcasing public sculptures that include a crouching cougar, a majestic eagle, and an Indian drummer, among others.

Many artists have since found the region a congenial place, not only painters and potters but also metal smiths and woodworkers, whose decorative crafts have turned restaurants and other buildings into environmental works of art.

And once a year, in July, the town becomes the scenic backdrop to an Old West party, as Chief Joseph Days bring together both cowboys and Indians. Over four days, there are parades, a Nez Perce encampment with traditional feasts and dancing, and dozens of rodeo events – including live bucking broncos that will send a chill down your spine.

Wind ruffles a field of grain around a Wallowa County barn (opposite), *a symbol of the persistence of ranch and farm life here in northeastern Oregon. Before the settlers claimed this land, Nez Perce Indians considered it their homeland. Though their current reservations are farther afield, members of the band return each year for the Chief Joseph Commemorative Encampment next to the rodeo grounds. Along with a friendship feast, traditional dances in tribal dress* (above) *are a highlight of the event.*

McMinnville

Everyone enjoys a bird's-eye view, and in McMinnville that means a ride up the elevator of the Hotel Oregon to the rooftop bar and restaurant. There's no better place to sip a glass of wine – Oregon pinot noir, undoubtedly – and look out over the leafy tips of trees that have grown unexpectedly tall. The hotel has stood here at Third Street since 1905, although it was originally a mere two stories high and called the Hotel Elberton. The top floors were optimistically added five years later, in anticipation of a wave of railway passengers. The visitors failed to arrive, however, and the top floors remained unfinished until a renovation in the late 1990s. Only then did the town's citizenry get a look at their cherished civic "living room" from above.

McMinnville's historic district, with its decorative century-old brick buildings, houses a third-generation-owned newspaper and a family-run sewing shop, banks, a shoe store, and beauty salons that serve locals, along with the restaurants, galleries, gourmet boutiques, and wine bars that catch the eye of travelers. The area also hosts lunchtime concerts and a weekly farmers' market where everyone mingles and catches up on the news.

McMinnville's sense of community can be traced back to its beginnings in 1853, when William Newby, who had traveled west on the Oregon Trail, decided to build a grist mill. There were enough other wheat farmers like him, he reasoned, who would welcome an alternative to transporting their crops to Oregon City, hours away on muddy, rutted roads. The mill flourished, and Newby soon invited a fellow pioneer, blacksmith Samuel Cozine, to move his smithy close by, and asked Solomon Beary to set up a store. In 1856, Newby and another associate laid out the town of McMinnville around these businesses, naming it in honor of McMinnville, Tennessee, Newby's hometown.

Over the next few decades, the community outstripped earlier Willamette Valley settlements such as Lafayette, attracting the railroad and a bank, and eventually capturing the county seat. McMinnville's Baptist academy had been chartered as a college in 1858; it later moved to the south edge of town, where today the 1882 Pioneer Hall, with its large white brick cupola, is the centerpiece of Linfield College's serene, green campus.

Rows of pinot noir grapes stripe the red soil of the Dundee Hills at Stoller Winery (opposite), *about 15 miles northeast of McMinnville. The fertility of the Willamette Valley brought countless pioneers over the Oregon Trail, including William Newby, who founded McMinnville around his grist mill in 1853. Third Street* (above) *has always been the community's commercial center. Its well-preserved brick and stone buildings are livened by shops and restaurants of all kinds and, in the last few years, more than one wine-tasting venue.*

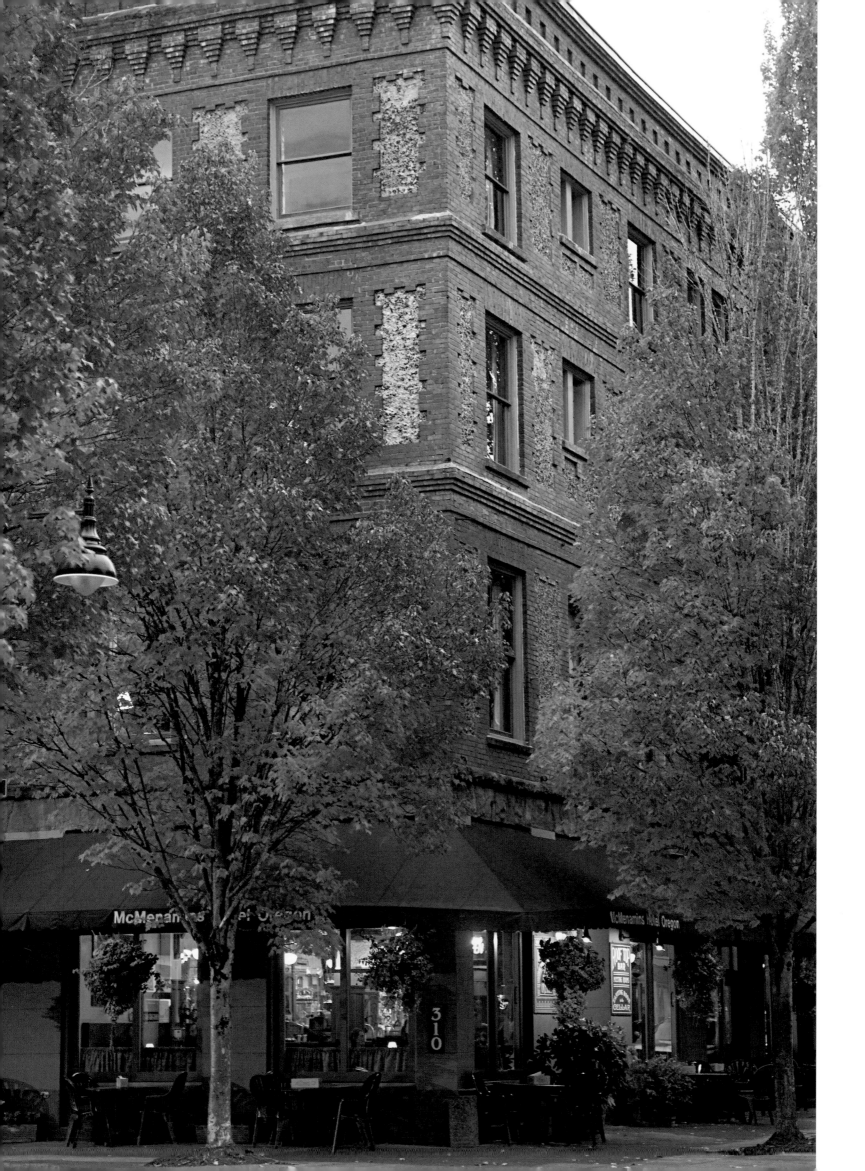

Meanwhile, downtown, Third Street's wooden structures were rebuilt in sturdy brick, like the narrow Schilling Building's saloon and the Wright Building, ornamented by scallops and sunbursts. Samuel Cozine and his wife, Mahala, constructed a Queen Anne-style residence with a large bay window, patterned shingles, and gingerbread trim. Now it houses the downtown visitor center, across from the city park where the grist mill once stood.

Around the turn of the century, some 1,400 people called McMinnville home. They sent their children to two public schools, read two newspapers, and supported five churches. And they cheered the opening of the elegant and modern Hotel Elberton with 26 gas-lit rooms, banqueting- and dining rooms, a ladies' parlor, and gentlemen's bar.

The Depression affected McMinnville as it did the rest of the nation. The Elberton was sold in 1932 and renamed the Hotel Oregon. When the economy began to pick up, various enterprises took advantage of the hotel's pivotal location. A beauty shop run by the Widness sisters moved into the ground-floor space. Coffee shops came and went. A restaurant and lounge called the Paragon Room attracted patrons to its steak dinners and Western band performances. In 1955 the Greyhound Bus depot joined a taxi stand in the lobby.

The event that garnered the most attention, though, was a local couple's sighting, in May 1950, of a silvery disc that they identified as a flying saucer. Their photos made the front page of McMinnville's *News-Register*.

Yet even extraterrestrial attention could not deter the slow decline of the downtown in the 1960s and 1970s, as businesses fled to shopping centers and strip malls. It took down-to-earth planning and cooperation to institute the redevelopment that began to turn things around in the late 1980s, aided by the splendid renovation of the Hotel Oregon. Today the building's corridors are graced by dozens of paintings that illustrate – with imagination and style – the UFO, the Widness sisters, the Paragon Room, and countless other colorful characters, while the rooms are named for the town's fabled personages.

Among those is a quartet of innovative winemakers who looked at the scenic hills northeast of town and thought the land had a lot in common with Bordeaux, France. David Lett, in particular, claimed the region could grow pinot noir grapes, and beginning in 1965 he was planting the vines that would earn him the nickname "Papa Pinot," as a founder of Oregon's wine industry.

Lett's Eyrie Vineyards' tasting room is still in the unprepossessing former turkey-processing plant that was the site of the original winery, which has gone on to garner many international awards. Another atmospheric in-town winery, Panther Creek, occupies the former Municipal Power Building. Meanwhile, scores of vineyards have sprung up along the county's winding roads, with tasting rooms that evoke Tuscan villas, Asian retreats, and contemporary Northwestern lodges. The emphasis on wine has gone hand-in-hand with a

A landmark since 1905, the Hotel Oregon (opposite) began as a two-story building. Later, floors were added on but never finished until a decade ago. Populated by memorable characters over the years, the hotel has been home to restaurants and lounges, beauty shops, coffee shops, a taxi stand, and a bus depot. Photographs in the lobby (above left) attest to the cavalcade of people and events, which also provide themes for the whimsical contemporary art that fills each floor. Above: *Fresh fruit at the weekly farmers' market sometimes comes with color-coordinated vendors.*

Columns distinguish the façade of the Classic Revival residence (opposite) *built in 1857 by Joel Palmer, an Oregon pioneer and founder of Dayton. Once a rival to nearby McMinnville, Dayton still boasts numerous 19th-century homes, while its surrounding hills are filled with wineries and vineyards* (right). *Some 150 aircraft are on display at the Evergreen Aviation & Space Museum* (above)*, but the prize exhibit is undoubtedly the wooden-framed* Spruce Goose, *whose wings span the immense hangar-like hall.*

developing taste for fine food and the birth of a number of gourmet restaurants in McMinnville and beyond.

If epicures find those offerings heavenly, well, others reach for the skies in other ways. In 1991, Delford Smith brought the *Spruce Goose* to McMinnville. Howard Hughes's monumental flying machine – nearly 80 feet tall and more than 200 feet long – is now the centerpiece of the Evergreen Aviation & Space Museum. Conceived as a way to ferry large numbers of men and supplies during the Second World War, the *Spruce Goose* never made it into commercial production. Still, it's a monumental artifact, along with other exhibits that range from a 1917 Sopwith Camel and a Second World War Spitfire to a Messerschmidt and a Flying Fortress, and even exploratory space vessels.

No, the 1950s flying saucer isn't on display. But if you crave out-of-this-world connections, visit McMinnville in May, during the three-day UFO Festival, when residents dress up as aliens and parade down Third Street in an exuberant, well-grounded demonstration of community spirit.

Vine to Wine

THE SUBTLE CHARMS OF NORTHWEST GRAPES

If you ask winemakers in Washington's Yakima Valley about their vine-yards, they might start by telling you what varieties of grapes they grow, when they started growing them, and how they cultivate the fruit to create their ideal wine. But it won't be long before you hear about geology: how the ancient Columbia River flowed through the area, leaving sediments of volcanic soil laid down with basalt and calcium carbonate. Or perhaps they'll mention how a steady breeze fans a certain warm southwestern slope where soils are deep.

In the end – or perhaps one should say in the beginning – it all comes down to the land, the *terroir* in winemaking parlance. Indeed, in the Pa-cific Northwest, the geologic force of volcanoes and rivers, coastal fog, and the rain shadow created by the north–south barrier of the Cascade Range have shaped the wines of Oregon, Washington, and British Columbia. In return, the rise of vineyards and wineries has transformed the region by attracting visitors and new residents in search of the good life.

The grapes have been in the area for almost 200 years. The first vines were planted around 1825 at Fort Vancouver, across the Columbia from modern-day Portland. John McLoughlin, who was in charge of the Hudson's Bay Company post, wanted the settlement to be self-sufficient, and traders and missionaries who came to the fort all noted the vines that draped his summerhouse.

In 1847 Henderson Luelling included grapevines along with the 700 fruit trees he carried in his wagon along the Oregon Trail. Within a year he had set up a nursery in the town of Milwaukie, south of Portland. Horticultural experimenter Peter Britt, who had an estate in Jacksonville, is said to have acquired his grape cuttings in 1854 from a peddler who brought them from California. Over the next 20 years, Britt, a Swiss-born photographer and entrepreneur, grew dozens of varieties and set up the region's first winery, Valley View Vineyard.

Gradually grapes made an appearance around Puget Sound and in Walla Walla, where Italian immigrants planted the fruit in the 1860s. Around that same time Father Charles Pandosy put in a vineyard at his Oblate Mission, near Kelowna, British Columbia, for a sacramental

Springtime green denotes an upcoming vintage at Sokol Blosser's organic vineyards (opposite) in Oregon's Willamette Valley. Wines from throughout the Northwest have commanded increasing respect in recent years and led to an explosion in the number of wineries not only in Oregon but also in Washington and British Columbia. In the Okanagan Valley of Canada, freshly harvested merlot grapes (above) are bound for the Quails' Gate winery.

vintage. Over the next several decades, growers continued to add grape varieties to their repertoire, until Prohibition (which had an early start in the region) put an end to winemaking. After alcohol was legal again, two Seattle companies turned to the berries and fruit for which the Northwest is famous and began distilling wine, but the industry didn't fully revive until the 1950s.

That's when the two Washington firms merged to form the American Wine Growers – the forerunner of Chateau Ste. Michelle – using grapes from eastern Washington. In the late 1960s, a few maverick winemakers moved to Oregon's Willamette Valley, which they believed resembled Bordeaux in France. Perhaps the hills around Dundee might be a place to grow pinot noir, they opined. Winemakers laughed, but David Lett (later known as "Papa Pinot"), Dick Erath, and others persisted until international awards proved them right. Two decades later, the lifting of import restrictions in Canada prompted growers in the Okanagan region of British Columbia to shift from sweet jug wines to better-quality vintages that could compete with U.S. bottles, and another wine area burst onto the scene.

Skaha Lake (below) *beckons beyond the orderly grapevines around Naramata. Here in the Okanagan Valley many fields once concentrated on berries and other fruit. At Blue Mountain Vineyard, co-owner Matt Mavety* (above) *conducts a barrel testing.*

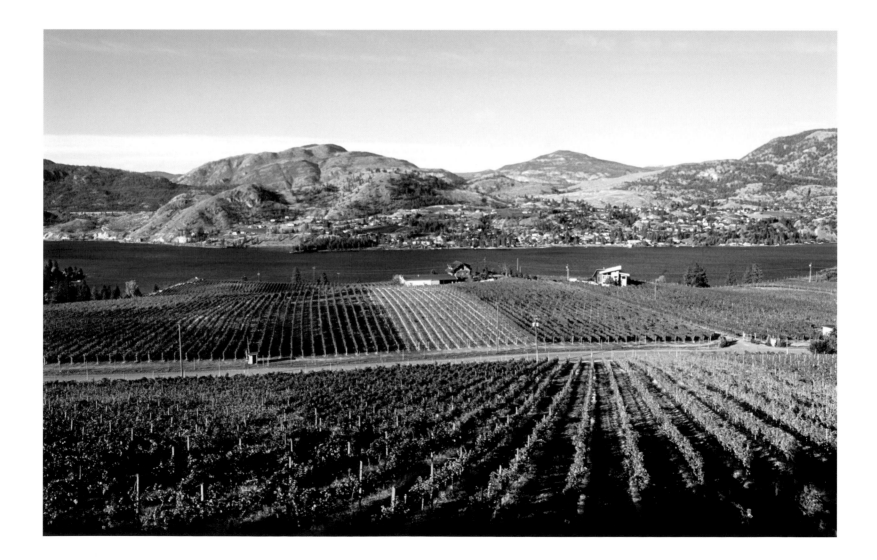

To say that Pacific Northwest wines have exploded since then would be an understatement. You can point to the number of wineries today: more than 400 in Oregon; 600-plus in Washington, second only to California; and almost 200 in British Columbia. Or to the amount of acres planted, perhaps 60,000 in all. Or to the number of appellations, geographical designations that can only be used by specific wine-growing areas: 24 and counting. The facts and figures merely underline what's obvious throughout the region. On the country roads around McMinnville, Oregon, signs direct you to wineries at every crossroads. Tasting rooms line the main street of once-sleepy Walla Walla. Even the lesser-known wine trails of the Okanagan are crowded with visitors who have had little opportunity to sample the products outside the province.

There are wineries from Vancouver Island to the Fraser River Valley, on both sides of the Columbia River, south to California and east to the Idaho border. You can find cranberry wine, pear wine, ice wine, and organic and biodynamic wines. Tasting rooms range from the former turkey-processing plant that still is home to David Lett's Eyrie Vineyards to the sophisticated European modernity of Col Solaire. Chateau Ste. Michelle now has a French-style chateau, while Nk'mip Cellars incorporates

Handle with care: A vineyard worker picks ripe roussanne grapes (top) *in the Red Mountain appellation of eastern Washington. The Yakima Valley is also home to Desert Wind, where winemaker Greg Fries* (above) *checks on the progress of one of his cuvées.*

Almost ready for picking, grapes ripen at DuBrul
Vineyard (right), near Prosser, Washington. The unique
properties of each field's location – the terroir – are
responsible for the signature qualities of its wine. It's often
not the lushest landscapes that make the finest vintages.
A winemaker's skill also plays an important role. Above:
Starling Lane Winery, on Vancouver Island, rolls out the
barrels as it welcomes wine-tasting visitors.

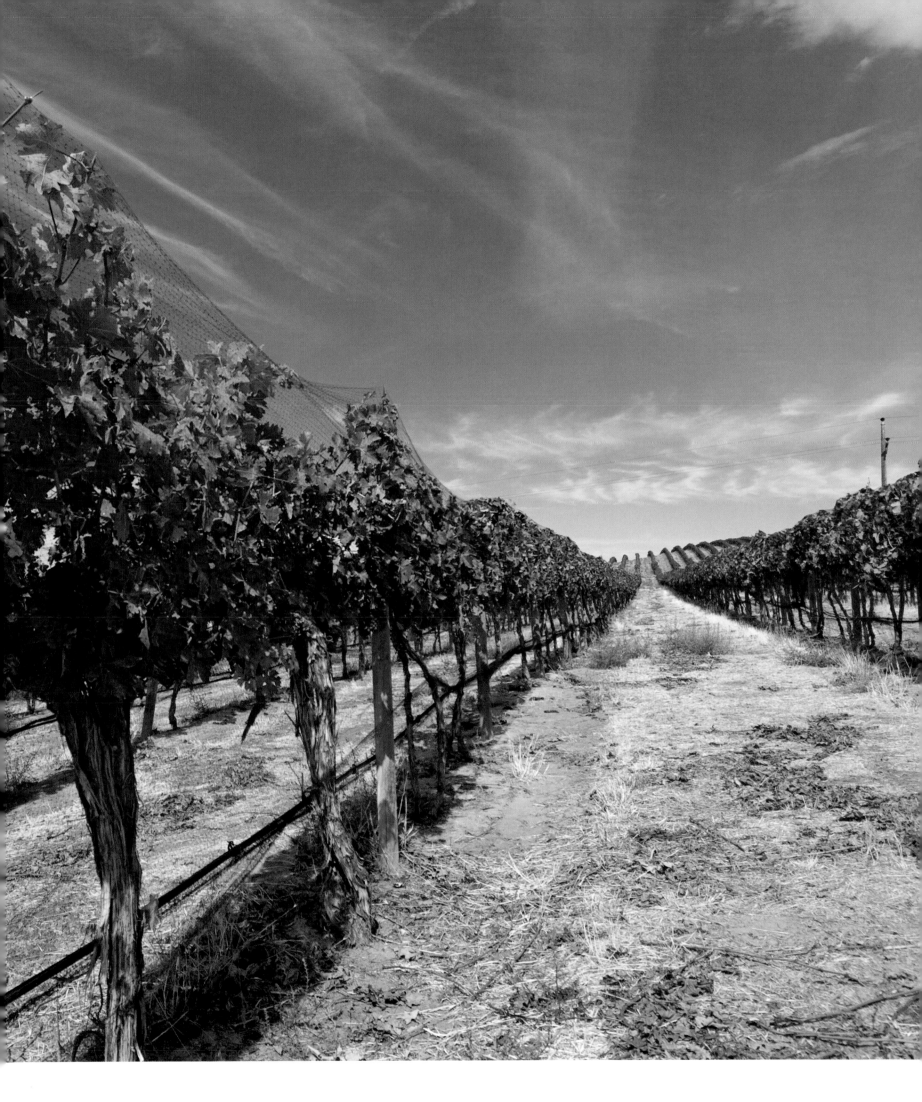

Dinner at the Old Vines Restaurant, at Quails' Gate winery (above), comes with a view of the surrounding vineyards as well as Okanagan Lake. Wine and fine food are a natural pairing, and the vintages of the Pacific Northwest have given rise to a host of noted restaurants in the grape-growing regions. Other culinary enterprises have sprung up nearby, allowing visitors to turn a vacation into a memorable epicurean journey.

Opposite: *Tulip fields outside La Conner.*

First Nations heritage into its decor. You can sip wines in century-old houses, oversize Tuscan estates, and industrial airport hangars. Of course, what really counts is the alchemy of sun, soil, water, and the imagination and skill of the winemaker.

With the growing taste for wines have come artisanal cheeses, heritage ciders, hand-crafted beers and ales, and organic fruits and vegetables. Not surprisingly, farmers' markets, fine restaurants, art galleries, and atmospheric bed-and-breakfasts have followed the rise of the wine industry in the region.

And so the pleasures of Pacific Northwest wines go far beyond the beverage in the glass. Regardless of whether you prefer a pinot noir or a pinot gris, you can savor the sunlight on rows of grapevines lining red-hued hills. Whatever the vintage, you may enjoy having it paired with a well-prepared meal. And after a day of visiting wineries, you can delight in spending the night in some stylish hostelry. Don't blame the wine if you dream that you, too, could find just the right piece of land, grow grapes, and never leave.

Washington

Coupeville

Some places are simply inspirational. Take Coupeville, midway down the zig-zagging coast of Whidbey Island. In 1932, local lawyer James Zylstra, who had never written a song before and apparently never would again, succumbed to the spirit of his home and penned a refrain extolling the region "Where the waves of Juan de Fuca/Kiss the sands of Whidbey Isle."

He struck a chord – literally. Even today, at gatherings in town, you might hear several generations of the 1,900 residents singing Zylstra's composition with affectionate gusto. But then Coupeville evidently can summon up incredible loyalty in its townspeople, who prize its history and natural beauty and fiercely defend them both.

The town faces the south shore of Penn Cove, a deep bay explored by the English Captain George Vancouver in 1792. Skagit Indians had long made their home here, but within 50 years, the Native American population had largely succumbed to smallpox, and a land act opened the fertile island to settlers from the east.

John Alexander came overland in 1851 and claimed the western portion of what is now the town. Thomas Coupe, a successful sea captain, and his wife, Maria, put down roots on the eastern half. Their simple bluff-top fishing cottage, built in 1854, still stands, though

it has been moved back from the edge more than once. The house is one of dozens of 19th-century homes and commercial buildings that account for Coupeville's designation as a National Register Historic District.

With straits and channels everywhere, this was a logical place for a seafaring man to settle. Coupe started a ferry service to Port Townsend, on the Olympic Peninsula. He was also involved in the "mosquito fleet," the assortment of small boats – first canoes, then sailing ships, then steamers – that provided freight, ferry, mail, and other transportation services around Puget Sound until the completion of the Deception Pass Bridge in 1937.

Other settlers soon joined the Coupes in the island community. An entrepreneur named John Robertson bought part of the Alexander claim and founded several businesses on Front Street, including a restaurant and a "cash-and-carry" mercantile, and put up a building that served as the courthouse.

By the turn of the century, Coupeville was bustling with law offices, groceries, a meat market, and a drugstore in small false-front clapboard or brick buildings. There was also a grand hotel, and, of course, a long busy wharf. In the quiet streets away from the water, prosperous merchants showed off with fine Victorian

The waters of Penn Cove (opposite) mirror the rear walls of historic downtown structures, constructed right onto the beach. After a decade or two of near abandonment, the turn-of-the-century shops and offices again beckon customers to dine, snack, and browse for gifts or antiques. The façades of Front Street (below) accentuate the town's old-time atmosphere. The flat-roofed building second from left, the oldest false-front in town, dates to 1883 and has been a saloon, drugstore, doctor's office, and post office. The narrow shop next store was originally a law office.

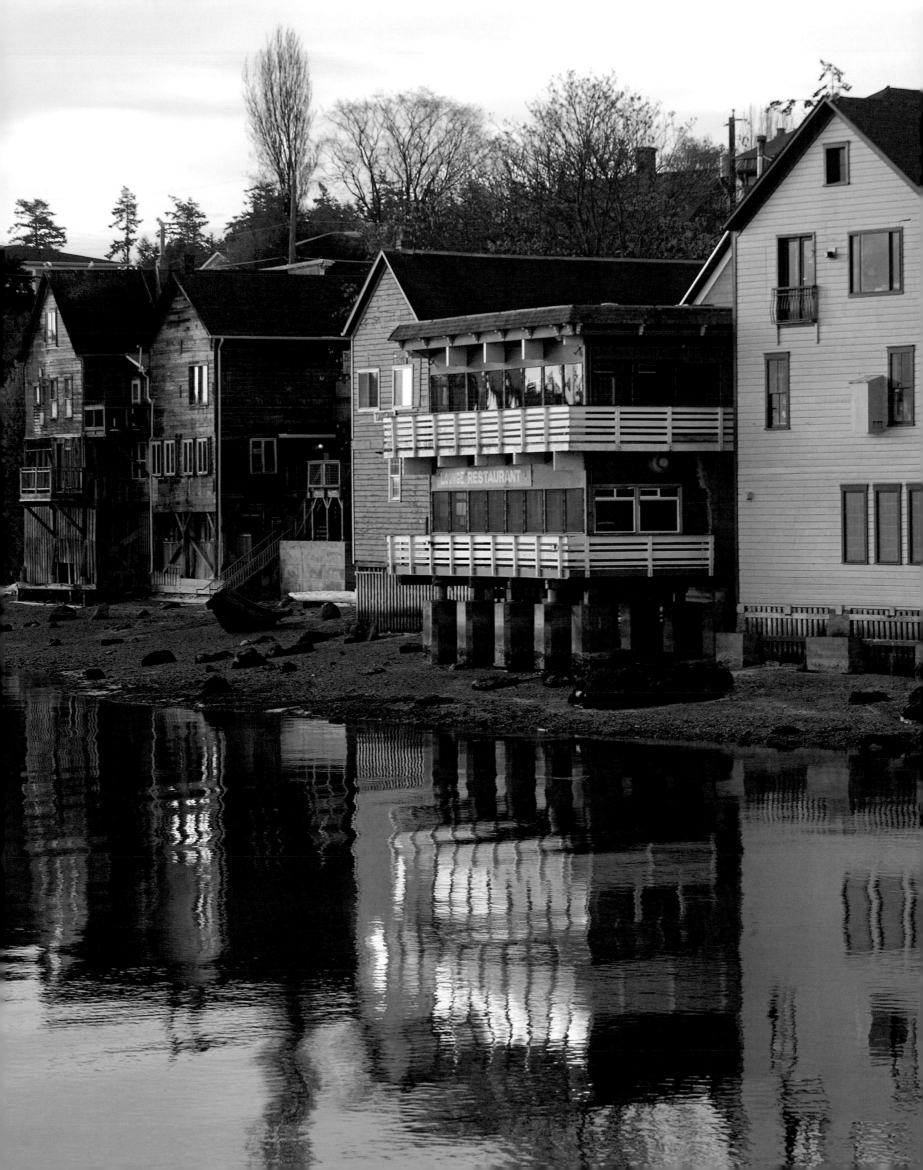

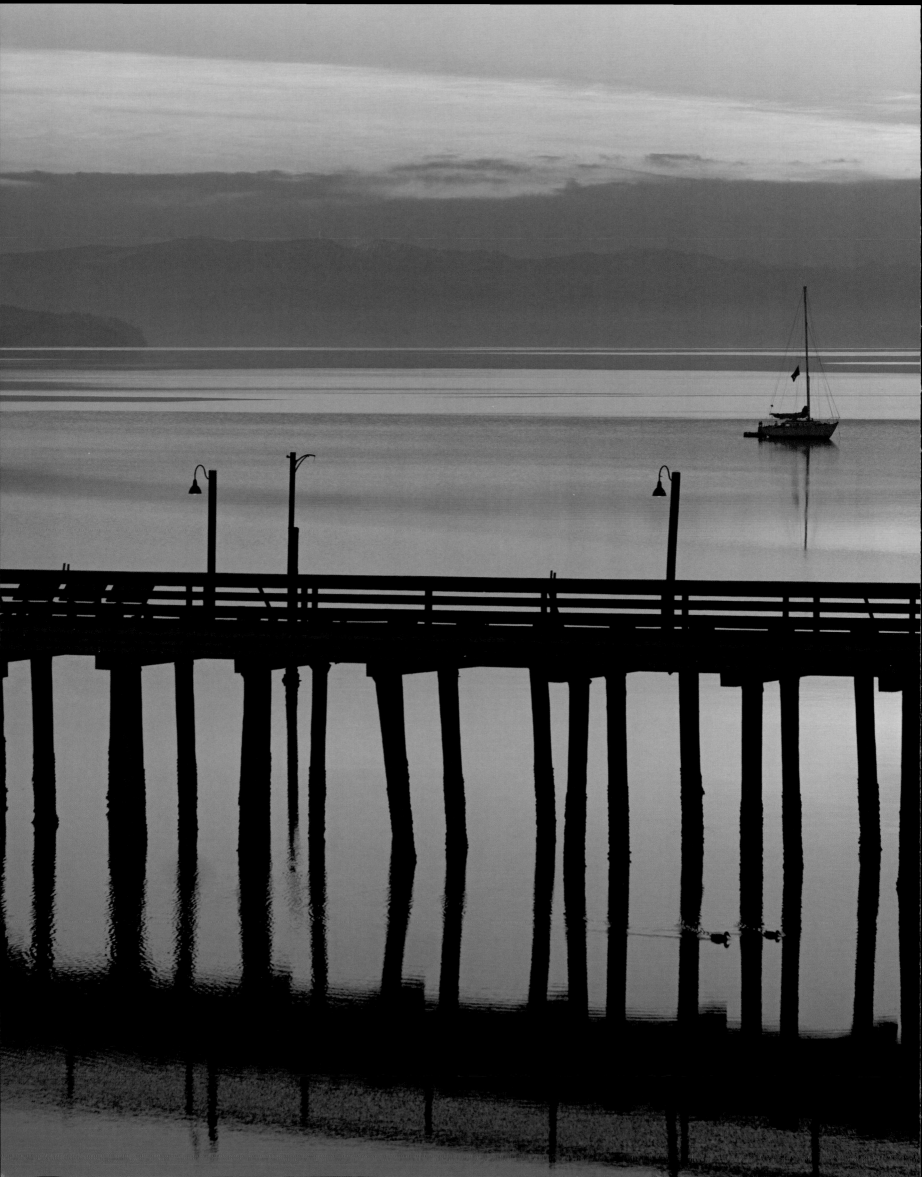

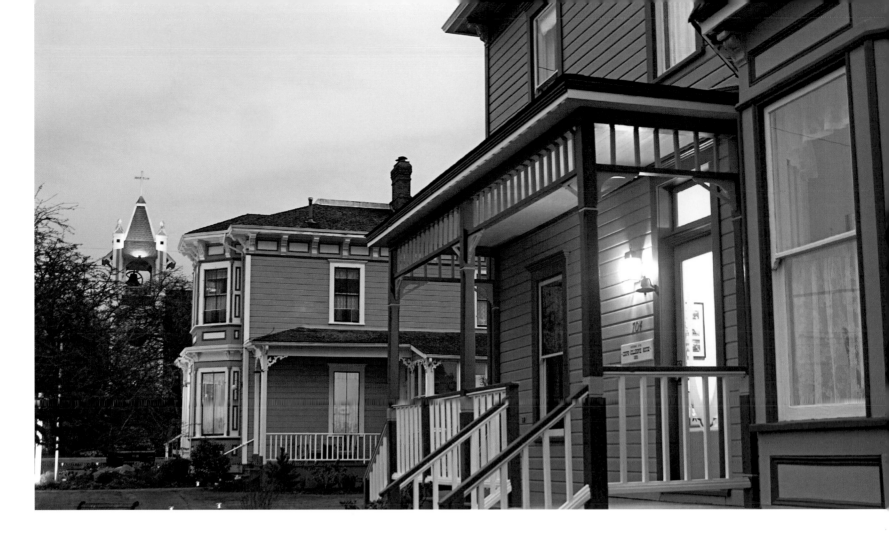

residences, some with French mansard roofs, others with Italianate bay windows, or Queen-Anne-style architectural details.

The town thrived as the commercial center for the farms that extended across central Whidbey Island. Isaac Ebey and Samuel Crockett had been among the first to homestead the inland prairie in 1851, fitting their claims between woodlands and rolling hills and building square blockhouses as refuges in case of Indian attack. Four of the little fortifications survive, but they did Ebey no good. He was killed in 1857 by members of a northern tribe, in retribution for their chief's death.

Ebey is remembered in Ebey's Landing National Historical Reserve, created to preserve the cultural landscape of a century ago. Coupeville lies within its boundaries, as do two state parks and several private farms passed down through generations. The bluff at Ebey's Landing offers a good vantage point to see just how varied – and lovely – this part of Whidbey is. Admiralty Inlet edges the pebbly beach below, while rectangular green fields extend to the west, dotted with old barns and farmhouses. Mount Rainier's summit and the peaks of the Cascade Range are visible on the distant mainland.

Also within the reserve is Fort Casey State Park, where the Admiralty Head lighthouse has stood since 1903. The beacon had outlived its usefulness within 20 years, and the batteries of Fort Casey, built in the 1890s, also are merely relics of the past. At the turn of the century, its artillery was part of a triangle of fire – along with Fort Worden on the Olympic Peninsula, and Fort Flagler on Marrowstone Island – meant to protect Puget Sound from attack by sea. As it happened, the fixed guns were never fired in war. But later the presence of the military would almost destroy Coupeville.

In 1942 the Navy set up an installation at Oak Harbor, to the north. It wasn't long before local merchants shifted their business to serve it. Though Coupeville residents often held on to their graceful Victorian homes, commercial Front Street soon resembled a ghost town.

Not until the 1970s did a few entrepreneurs eye the empty shops and begin to open antique stores or small galleries. Organizing a festival of the arts to draw visitors, and reviving a traditional water festival, the new arrivals gradually refurbished the false-front buildings. A mussel farm established in Penn Cove became known for the briny delicacies served up in a tavern that filled the spot of the old cash-and-carry store.

In 1989 the Historical Museum was founded on the site of an old inn near the wharf. It remains a repository for community artifacts, from the island's first car (a 1902 Holsman) to the original sheet music for lawyer Zylstra's song. On occasion it even gathers longtime residents to share stories about Coupeville in the old days. If those evenings invariably inspire a crowd, well, that's only natural.

Suspended animation: Only a pair of birds disrupt the utter calm around the Coupeville pier (opposite), suffused in delicate morning light. An evening glow illuminates old residences on Main Street (above) – the blue-trimmed 1891 Coupe Gillespie House and the 1887 Italianate Kineth House, both now part of a bed-and-breakfast inn. The Gothic-inspired steeple of the United Methodist Church, built in 1894, shines in the distance.

Once Coupeville central, the town wharf (right), from 1905, was built 500 feet into Penn Cove, so that boats could offload their cargo even at low tide. Water traffic was all-important here before the Deception Pass Bridge opened in 1937, as a busy fleet of ferries carried passengers and freight from here on Whidbey Island to towns along Puget Sound. Above: *Crockett's Blockhouse, on the prairie outside Coupeville, was put up by a pioneer family in the 1850s for shelter from Indians. Both the town and the surrounding area are part of Ebey's Landing National Historical Reserve, which protects the cultural as well as natural landscape of the area.*

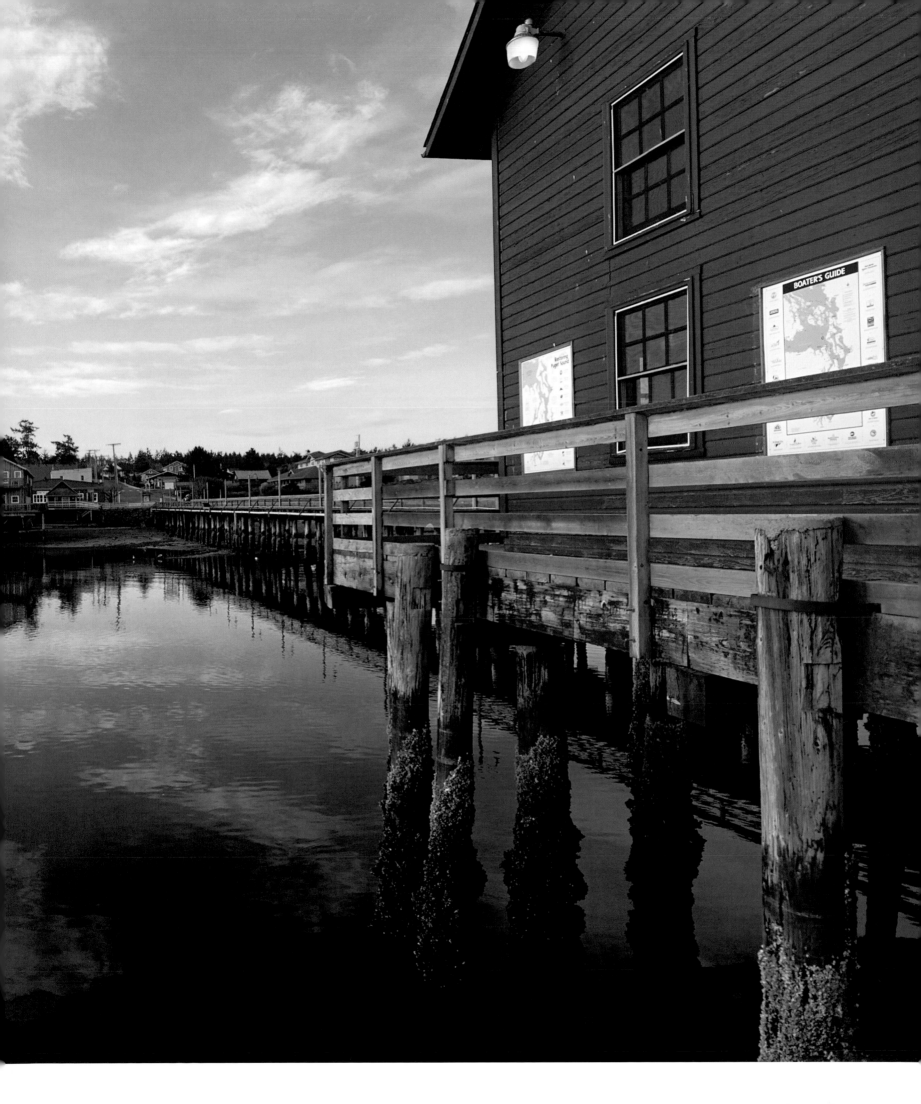

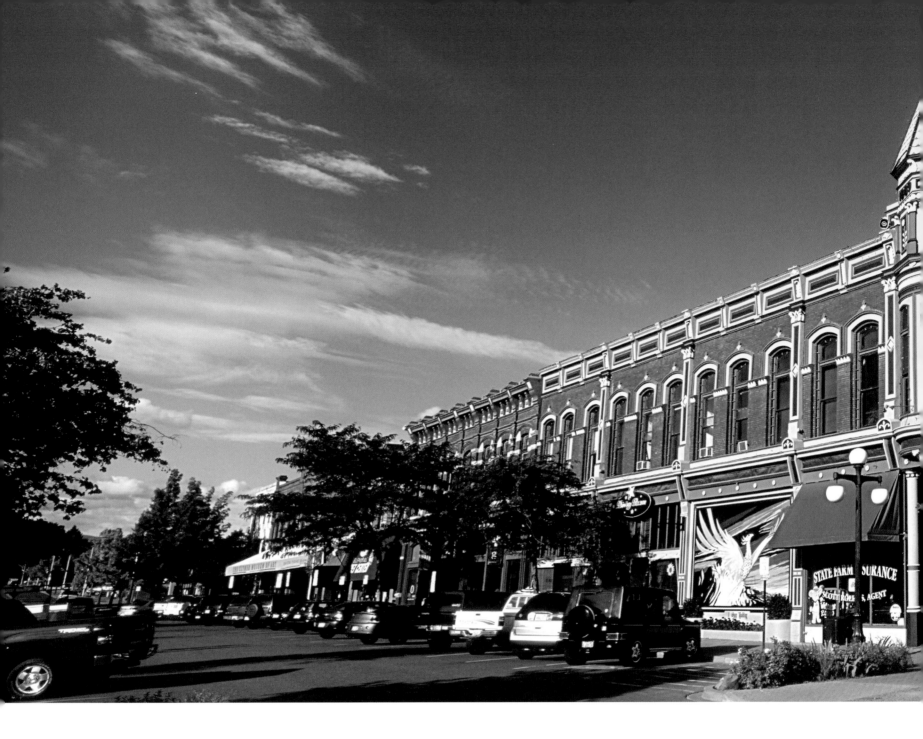

Ellensburg

A phoenix forever rises from the turret of the Davidson Building, which stands at the corner of Fourth Avenue and Pearl Street in downtown Ellensburg. The image of a bird reborn from ashes is, in fact, a tribute to the town's renewal after a devastating fire on July 4, 1889. Nearly a century afterward, the gloriously ornate edifice it crowns underwent its own transformation. Gutted and derelict in the 1970s, a decade later the building had been refurbished, its tinwork restored, its cast-iron columns uncovered, and the whole building extravagantly painted until it gleamed once again as a symbol of Ellensburg's heritage.

What a difference from the simple log cabin, a trading post known as Robber's Roost, that was the first structure built here in 1870. What the cabin lacked in stylish architecture it made up for in location. Indians and explorers traveling north–south and east–west had passed by for decades. Entrepreneur John Shoudy saw the possibilities. Within two years he had his own cabin and land claim and by 1875 had platted a town that he named after his wife, Mary Ellen.

For a glimpse of what life at the time might have been like, you can visit Olmstead Place State Park, where Samuel and Sarah Olmstead built a homestead in 1875. It's still a rural scene, despite the noise of the nearby freeway, with magpies hopping in the grass around the old cottonwood-log cabin. Across a pretty garden stands the more genteel house the couple built

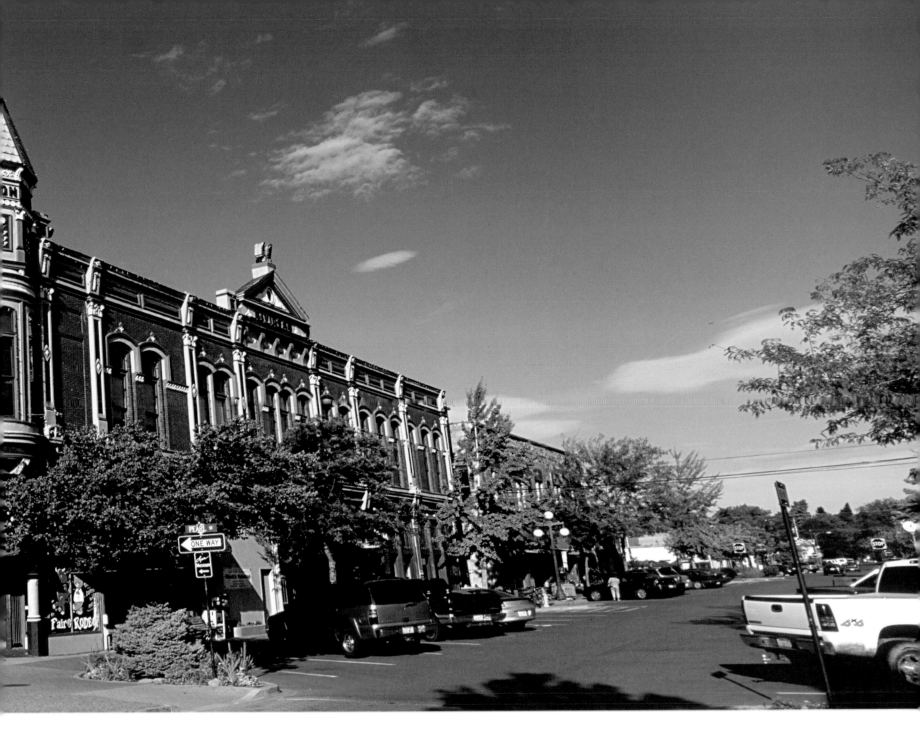

30 years later. Like the Olmstead children, you can follow a short trail to a prim red schoolhouse that's now also part of the park.

Another relic of those days is the grist mill in nearby Thorp. Farmers would haul their wheat, oats, and barley to the huge barnlike structure that has stood in that spot since 1883. In use until 1946, the mill was restored 20 years ago, and once again grinds grain for special demonstrations.

The town of Ellensburg got a boost in 1886, when Shoudy and other local businessmen pooled tracts of land to attract the Northern Pacific Railroad. It was part of a campaign to turn their community into a regional hub. In truth, the town fathers had something even bigger in mind. Envisioning a future city of 20,000, they set their sights on becoming Washington's capital after statehood was declared. Unfortunately, the summer of 1889 was hot and dry. The cataclysmic fire, which wiped out 200 homes and ten blocks of commercial buildings, put a crimp in their plans. Amazingly, within six months, the townsfolk had rebuilt nine blocks of downtown.

The merchants wanted their new stores to be modern, showy…and fireproof. The brick commercial blocks that line Pearl Street and nearby avenues largely reflect those efforts. The Kleinbergs housed their clothing business in an impressive three-story edifice with decorative pilasters. The Boss Bakery used cast-concrete panels, new technology for the time, while the Davidson Building's tinwork was fashioned to look like stone.

Attorney and entrepreneur Edward Cadwell requested a cast-iron cornice and unusual horseshoe-shaped windows on his new building's brick façade. That structure is now home to the Kittitas County

A symbol of urban renaissance then and now, the Davidson Building (above) presides with flair over the corner of Fourth Avenue and Pearl Street. The phoenix finial stood for Ellensburg's rebirth after a terrible fire in 1889. Thirty years ago a thorough renovation gave the then-derelict building new life; recent repainting keeps the splendid detailing fresh. Neoclassical columns and serious ornamentation underline the sober function of the Farmer's Bank building, built in 1911 (opposite).

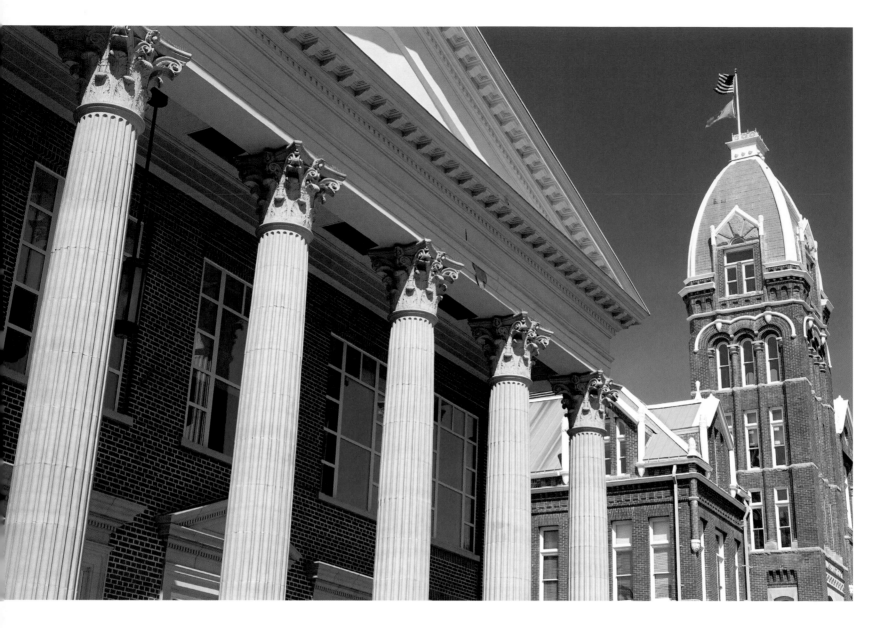

Water still flows under a bridge leading to the Thorp grist mill (opposite), which used the stream for power. Built in 1883 to serve the area's grain farmers, the mill also produced electricity for the agricultural town. Barge Hall (above) looms over the Central Washington University campus, which began as a state teachers' college. Right: Two of Ellensburg's distinctions come together in a downtown bookstore window, which reflects an impressive 19th-century commercial block and also pays heed to the town's deep passion for its annual rodeo.

Historical Museum, which details Ellensburg's development and showcases some large-scale local memorabilia, from a 1910 Flanders 20 automobile and a chair made of cow horns to newspaper printing presses and the safe and teller's cage from the Bank of Ellensburg.

Despite its best efforts, the town lost the contest to become the state capital, but it got a consolation prize: the state normal school. That title remains etched in stone over the arched entry of Barge Hall, on the campus of what is now Central Washington University. The college, the railroad, and hay- and sheep ranching continued to define life in Ellensburg for the next several decades, even through the Depression.

Other nearby county towns followed their own paths. Roslyn, in particular, was a coal-mining community from the 1880s to the 1960s. Its old company store is just one of the atmospheric and false-front emporiums on the community's main street, where a memorial pays tribute to generations of miners. The Brick Tavern, built in 1889, claims to be the oldest operating bar in Washington. Indeed, the whole town has a "lost-

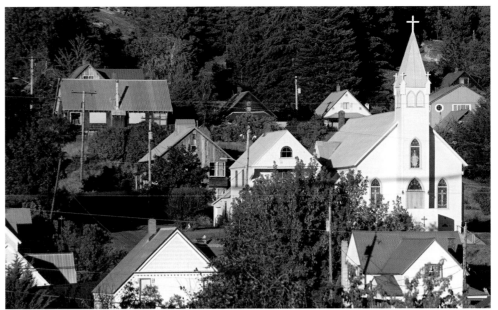

in-time" feel. If it seems to have a "lost-in-place" air, too, that's not surprising. Roslyn was the stand-in for the town of Cicely, Alaska, the fictional venue of the popular 1990s television series *Northern Exposure*.

Ellensburg itself is known for its Western personality, which takes center stage – or rather the center of Pearl Street – when a festive parade of cowboys, cowgirls, horses, and traditional Scottish pipers heralds the start of the annual rodeo, which dates back to the 1920s. Sustaining the Western theme for the rest of the year are a winter cowboy gathering and the Clymer Museum of Art. Housed in another turn-of-the-century building, the collection features paintings and prints by John Clymer, whose depictions of the West were frequent *Saturday Evening Post* covers.

Another local artist, Richard Elliott, turned his entire residence into a one-of-a-kind environmental sculpture, covering his house, fence, and yard with reflectors, bottle caps, and other found materials to convey the theme "art lives." Certainly Ellensburg's downtown lives on, with galleries, boutiques, and restaurants that welcome visitors and cater to college students and county residents. Even now, if you linger for a while, you just might find someone stripping 1950s veneer off a historic building, uncovering window details, or even making plans for a theater space or a café – carrying on the town's irrepressible spirit of rebirth.

An eastern exposure means the trio of old-style shops in Roslyn (left) *catches the morning light. The former mining community had a moment of fame when it substituted for an Alaskan outpost in a television series. With a few galleries and a popular tavern, its pretty, low-key village* (above) *continues to charm.*

Friday Harbor & Eastsound

Memorial Park is a tiny oval at the harbor end of Spring Street in busy Friday Harbor, a miniature islet complete with a stone memorial to war dead and two majestic elms that more than fill the space. For visitors, the park is only a puzzling detour in the town's traffic patterns, but for islanders this has always been a town center, a place for welcome embraces and teary goodbyes as loved ones stepped off or onto the docks that extend into the water.

Even today, lumbering Washington State Ferries ease in and out of one pier, while excursion boats, fishing craft, and pleasure vessels tie up at the adjoining dock. Autos, commuters, tourists, and excited whale-watchers pass through the area in a rhythmic flow on their way on and off San Juan Island.

The namesake island for a small archipelago between Vancouver Island and the Washington State mainland, San Juan Island actually played a brief role on the international stage. In 1846 the United States and Britain had set the border with Canada along the 49th Parallel, then through the Strait of Juan de Fuca to the Pacific. But the treaty was a little hazy about the desirable islands between Rosario and Haro Straits; both sides claimed them. In 1859, the British Hudson's Bay Company farm on San Juan had a contingent of Americans neighbors, including one Lyman Cutler, who didn't like the Company pig that dug up his garden. He shot the animal, prompting British authorities to threaten his arrest. Before long a company of U.S. infantry had landed on the island to protect the Americans, and three British warships were offshore.

Happily, cooler heads prevented further bloodshed in the so-called Pig War, and authorities worked out a temporary formal arrangement to share the territory. For the next dozen years Royal Marines maintained English Camp at Garrison Bay at the northwestern tip of San Juan, while American Camp was 13 miles away

Tranquil Roche Harbor (right) gives little hint of the limestone works that flourished here on San Juan Island in the late 1800s. Owner John McMillin established a company town around the factory, including a hotel, housing for his workers, his own home – now a restaurant (at far right) – and a small church. During weekdays the sanctuary served as a schoolhouse; in 1960 it became a privately owned Catholic chapel.

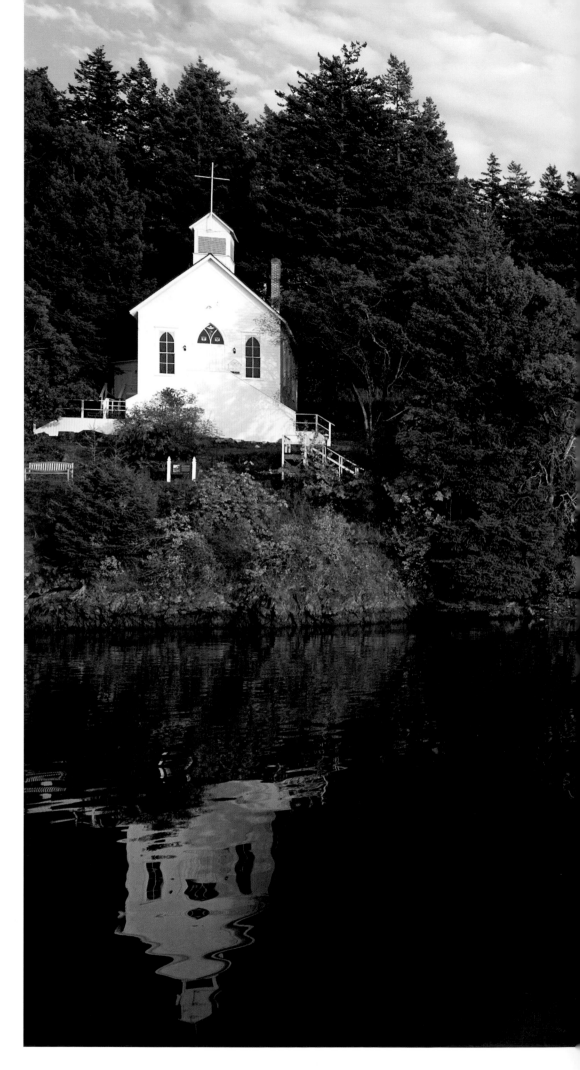

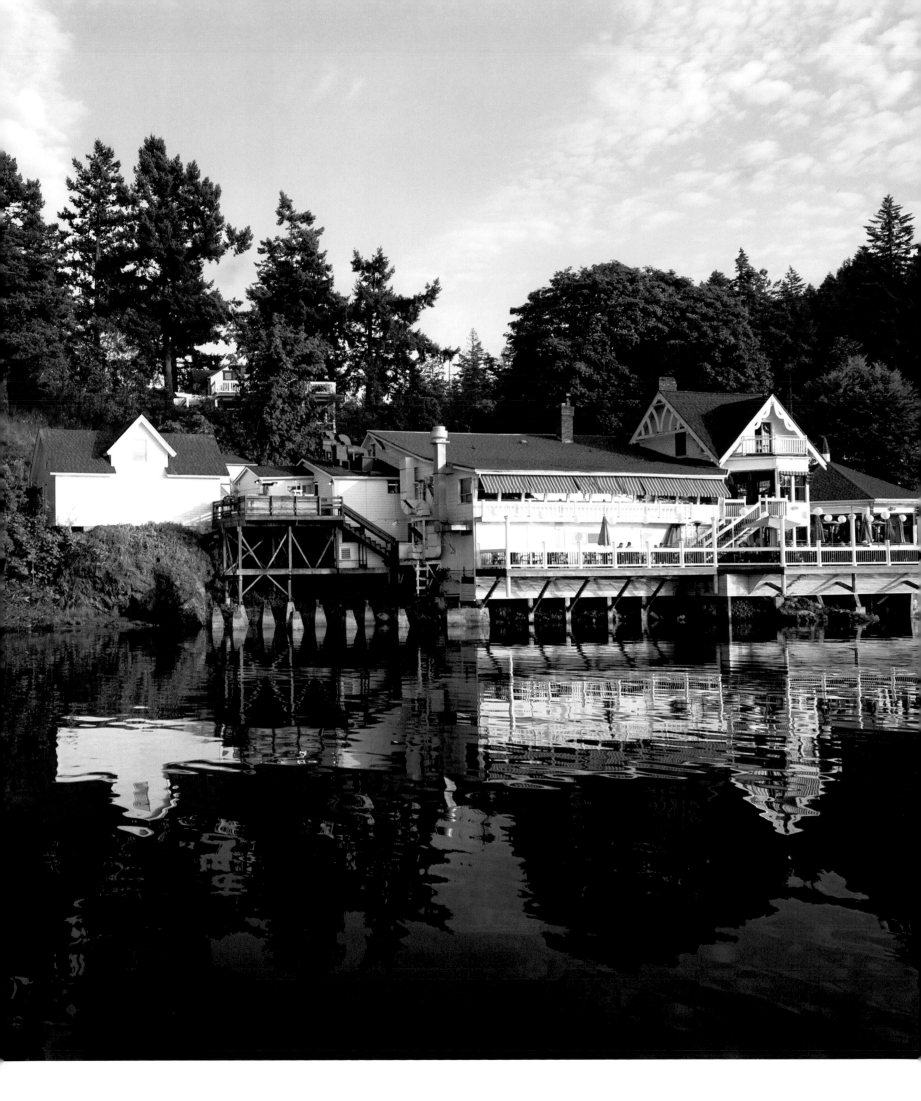

at South Beach. That lasted until 1872, when Kaiser Wilhelm I mediated the dispute and awarded the San Juan Islands to the U.S.

Today both camps are part of a national historical park that preserves a few buildings on each site – a blockhouse, barracks, and officers' quarters – along with a parade ground and the remains of a redoubt. They're pretty, tranquil spots where you can follow the park trails and imagine what it must have been like for a lonely soldier or marine in this remote island post.

Once the territorial dispute was settled, Friday Harbor flourished as a port, and many of the buildings on Spring Street date to the late 19th century, though their simple façades may have since been gussied up. A general store and saloon occupied the structure across from the dock, while a couple of hotels catered to visitors. The cannery that edged the harbor from the 1880s to the 1960s is gone, but the cannery manager's Victorian-style house is a favorite spot for a cup of coffee while waiting for the ferry.

Friday Harbor is still the commercial and administrative center for all the San Juan Islands, but the town is also a destination for day-trippers, especially whale-watchers, who can board a boat or just use their binoculars from the island's western shore. The surrounding waters are known for resident pods of orcas as well as other transient cetaceans. The Whale Museum, housed in Friday Harbor's 1892 Odd Fellows Hall, does a clever job of explaining the science and behavior of these fascinating marine mammals.

Beyond the harbor, the island was given over to sheep and dairy farms, fruit orchards, and fields of peas and other crops. One homestead has become the San Juan Historical Museum, whose centerpiece is an 1894 farmhouse, complete with family portraits, period furniture and clothing, and shelves of canned apples, pears, cherries, and plums from the Alaska–Yukon–Pacific Exposition of 1909. San Juan Island fruit was famous at the turn of the century; many of the venerable apple and plum trees still stand, providing a bounty for the birds.

The island's other product was lime, thanks to the huge lime kilns at Roche Harbor, where owner John McMillin eventually built an entire company town, including a store and cottages for his workers, and a large residence for himself. For visiting businessmen, he erected the Hotel de Haro in 1886. The inn continues to welcome guests to its historic accommodations and salutes each sundown by striking the colors with 19th-century fanfare.

Indeed it's tourism, not industry, that has sustained these islands since the 1960s, and nowhere is that more apparent than on Orcas, whose main town, Eastsound, resembles a chic New England village at the head of a deeply indented bay. Eastsound, like its neighboring communities, also has a long homesteading history, and the Orcas Island Historical Museum has arranged half a dozen early cabins to show what 19th-century life was like. Its rooms are full of artifacts, tools, photos, and profiles of the island's hardworking, intrepid settlers.

One notable resident came to the island not to work but to retire. Robert Moran, the Seattle shipbuilder and mayor, moved to Orcas for his health around the turn of the century and built a three-story mansion with nautically inspired bedrooms and a wood-paneled library

A brisk Orcas Island breeze keeps flags waving in Eastsound, next to the Emmanuel Church parish hall (opposite) *in the center of the village. Friday Harbor's heritage includes 19th-century buildings on Spring Street* (above left) *and a collection of historic structures* (above right) *at the San Juan Historical Museum. Below: alfresco dining with a water view at Roche Harbor.*

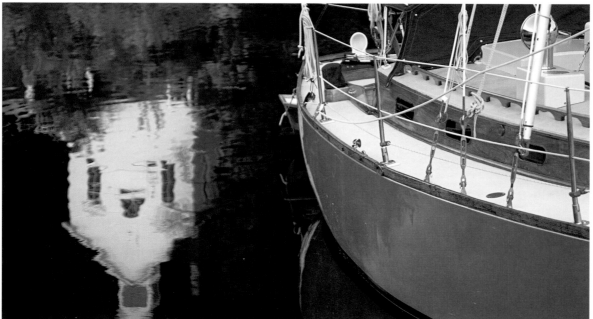

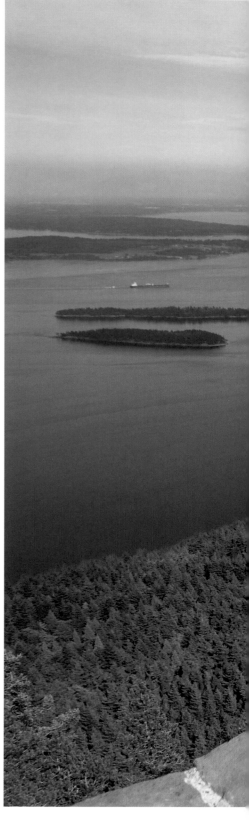

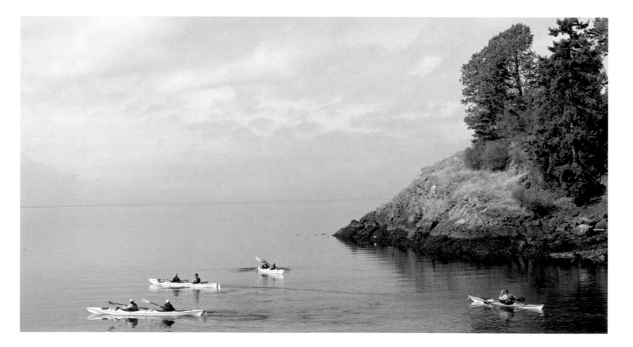

A visitor on Mount Constitution (above) charts the maze of landmasses within sight of the Orcas peak. There are 172 named islands in the San Juans. Public ferries serve the largest; otherwise residents travel by private boat. Sailing and kayaking are popular pastimes, with destinations (left, top to bottom) such as an inlet at Eastsound, the waterfront at Roche Harbor, or a cove off San Juan County Park.

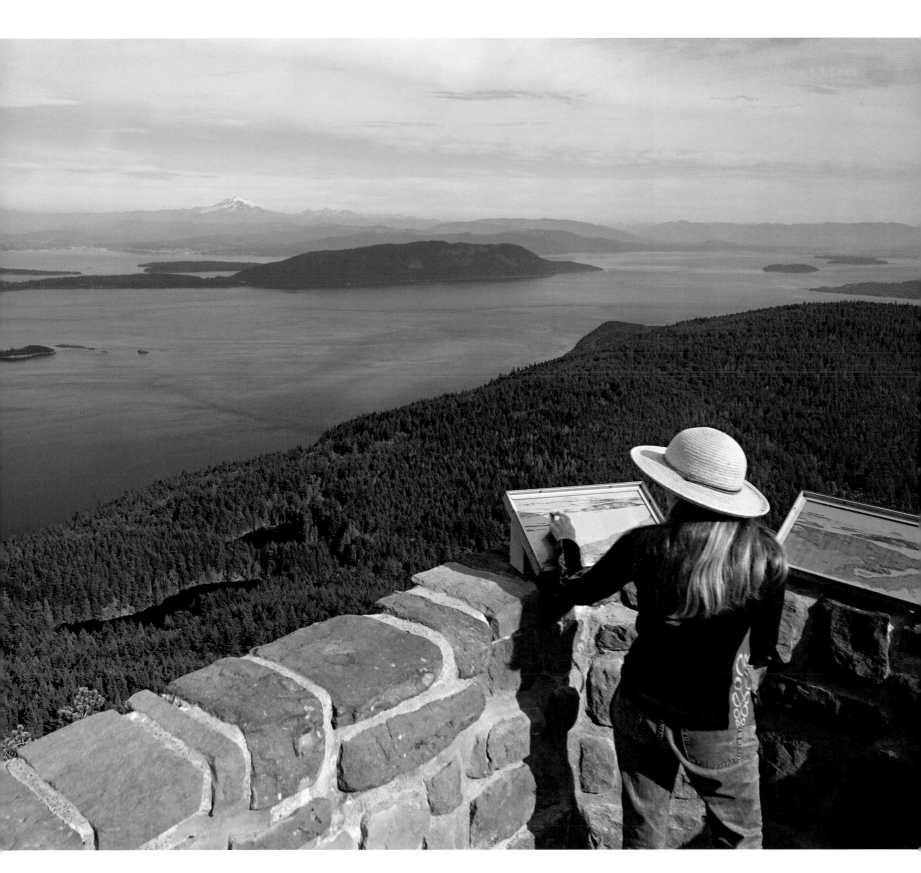

that houses a magnificent Aeolian pipe organ. Moran's real legacy on the island, however, is the almost 4,000 acres of land he deeded to the state as a park. There, from a stone tower atop Mount Constitution – the highest point on Orcas – you can take in a panorama that stretches from Canada's Coast Range past Mount Baker and Mount Rainier to the Olympic Mountains.

Grand as that view is, what really distinguishes Eastsound is its intimacy. The village includes a friendly gathering of boutiques, galleries, restaurants, and a few inns. Bed-and-breakfasts, artists' studios, potteries, and summer homes dot the rest of the island. At every turn the water beckons residents and tourists alike to board a sailboat or step into a kayak. If a network of connections and social ties binds the islanders together, you need only strike up a conversation to feel that you, too, can be seduced into the web of Orcas life.

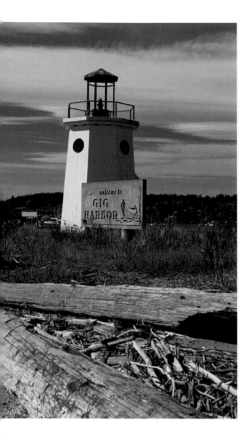

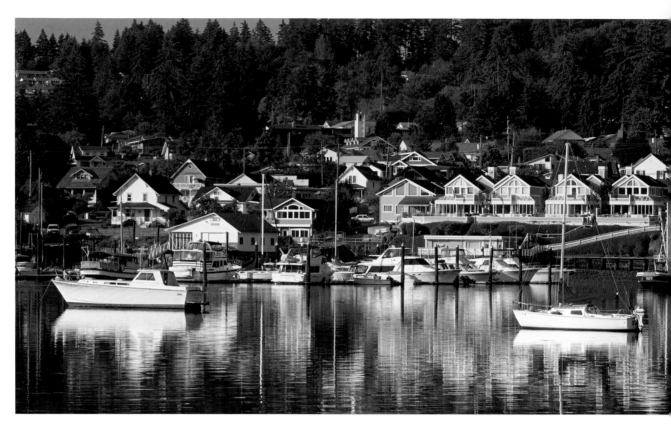

Gig Harbor

All-American spirit drapes the eaves of a turn-of-the-century house (opposite) across from the waterfront in Gig Harbor. Fishing, boatbuilding, and a sawmill fueled the initial economy of the settlement, whose residents largely immigrated from Croatia and Scandinavia. The original commercial district grew up at the head of the deeply indented harbor (above right), near one of the ferry landings. Later, steamers came in closer to the entrance to the bay, where a lighthouse (above) marks the way.

Like a graying monarch of the seas, the fishing boat *Shenandoah* is carefully shaded under an industrial-chic roof at Gig Harbor's history museum. Launched in 1925 from the nearby Skansie boatyard, the vessel was the last boat constructed in Gig Harbor to work local waters. Although its gracefully curved wooden hull and square, blue-trimmed pilothouse are in need of restoration – which the museum hopes to conduct on site – the *Shenandoah* remains a colorful reminder of the town's history and a vital part of the community's efforts to honor its fishing and boatbuilding heritage.

Not long ago, everyone growing up in Gig Harbor fished during the summer, just as teens in the Midwest might earn money by mowing lawns. Now pleasure craft have mostly replaced the working boats in the marinas, and visitors and locals alike enjoy the views – which often include sightings of stunning Mount Rainier – from parks along the inviting waterfront.

So it's no surprise that the town owes its very name to a boat. In 1841 an American naval expedition exploring southern Puget Sound sent its captain's "gig," or longboat, into the tiny anvil-shaped bay. Gig Harbor was written on the sea chart, and there it remained. At the time the only residents were Native Americans who lived by fishing and hunting on the wooded peninsula. They were still there when three white pioneers arrived in 1867. Only one of them, a fisherman from Montenegro named Sam Jeresich, stayed in the area, but within a few decades he had been joined by dozens of immigrants from Croatia and Scandinavia.

Some of the newcomers were stonemasons and carpenters; many others turned to agriculture, fishing, and logging. By 1887 they had built a sawmill on the shore, with a 450-foot wharf to accommodate ships waiting for lumber. Before long, the mill owners added boatbuilding to their operations, launching a steamer in 1888 and a schooner a few years later. Although hard times in the late 1890s forced the mill to close, others sprung up to fill the void, servicing a logging industry that continued into the 1950s. The boatbuilding went on, too, producing some 140 fishing vessels in the town's three boatyards between 1912 and 1931.

Gig Harbor's earliest settlers built their homes along the waterfront. One from 1884 still stands, a white, gingerbread-trimmed clapboard dwelling now almost swallowed up by a marina. A few other turn-of-the-century residences line the old town streets, but Gig Harbor's most unusual architectural features are its historic wharf-top net sheds where fishermen stored the essential gear for their trade. Built of hand-hewn fir, and with peaked roofs, the long, rectangular structures date back as far as 1910.

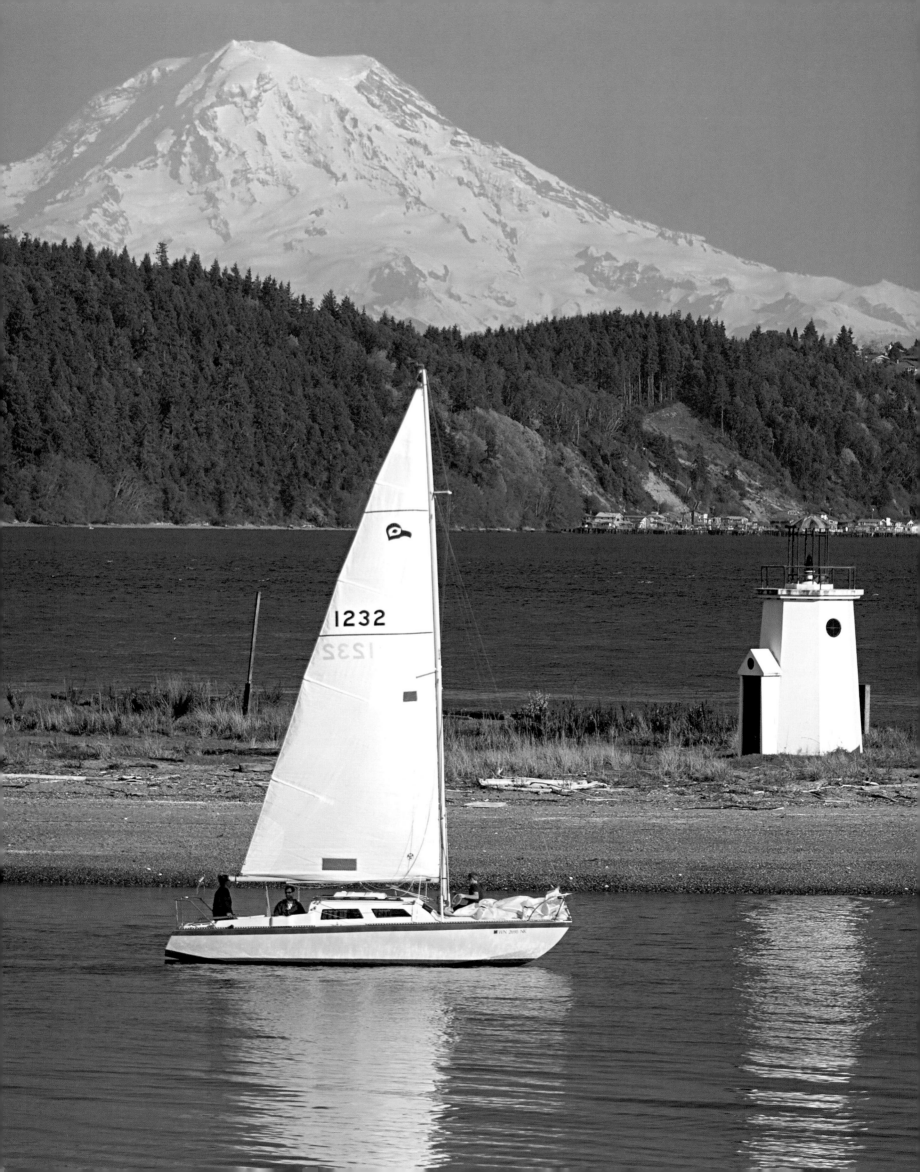

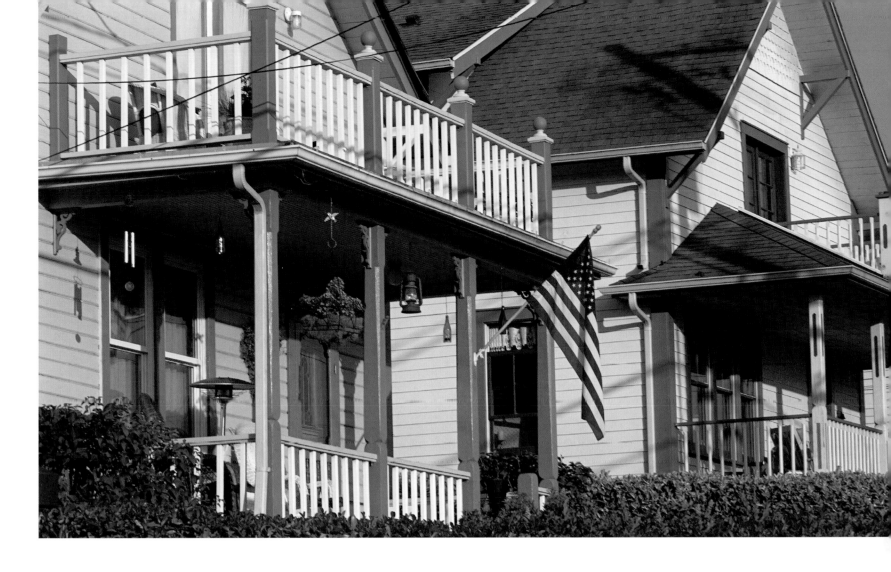

The harbor was part of a water highway that brought travelers and business to the head of the bay. The first downtown developed there, close to one of the steamboat landings. A general store, the post office, a butcher shop, and a baker, as well as several restaurants and an outdoor bandstand all clustered around the landings. A decade later, however, the center of town had shifted to the west side of the bay, and car ferries were replacing the passenger steamers.

Those ferries were the only connection to the outside world until 1940, when the first Narrows Bridge linked the peninsula to Tacoma. Unfortunately, the span, nicknamed "Galloping Gertie" for its wild vibrations, failed spectacularly after just four months in service when an engineering flaw precipitated its collapse in high winds. The ferries stayed in service for another ten years, until a second, safer bridge, nicknamed "Sturdy Gertie," was built.

Superior engineering also created another Gig Harbor nautical icon: the *Thunderbird*. In 1958, the American Plywood Association announced a contest for a plywood boat that could sleep four and race competitively. Ed Hoppen, then owner of the Eddon Boat Company, took a Ben Seaborn design and devised a kit for a 26-foot plywood sloop. His *Thunderbird* won the contest and went on to change hobby boating, giving do-it-yourselfers a chance at racing trophies. Over the last five decades, thousands of *Thunderbirds* have been

made, but the very first hull has come home to Gig Harbor and is on display, along with *Shenandoah*, at the Harbor History Museum.

Not all the exhibits in the museum have emerged from the water, however. The one-room Midway School – built in 1893 and in use until 1941– was recently moved to the grounds of the striking new museum building, where interactive galleries will allow visitors to experience a sense of the area's past – from Native American basket-making and European exploration to logging, boatbuilding, fishing, and community life.

To bring the maritime heritage into the future, the Gig Harbor community recently banded together to preserve the Eddon Boat Building site, which had been a local shipyard since 1920. There maritime enthusiasts young and old can watch and learn traditional and contemporary boatbuilding skills, as a way of keeping the working waterfront alive.

Of course, after the sailboats or yachts are safely moored, one more tradition must be preserved. Near the mouth of the harbor, across from the little lighthouse at Point Defiance Park, and not far from an old ferry dock, several restaurants offer waterside decks where patrons can raise a glass with friends within sight of the ever-changing tide.

A glorious backdrop to an afternoon sail, Mount Rainier dominates the horizon beyond Point Defiance Park and the route into Puget Sound (opposite). Porches and balconies add neighborly touches to Gig Harbor's frame cottages (above).

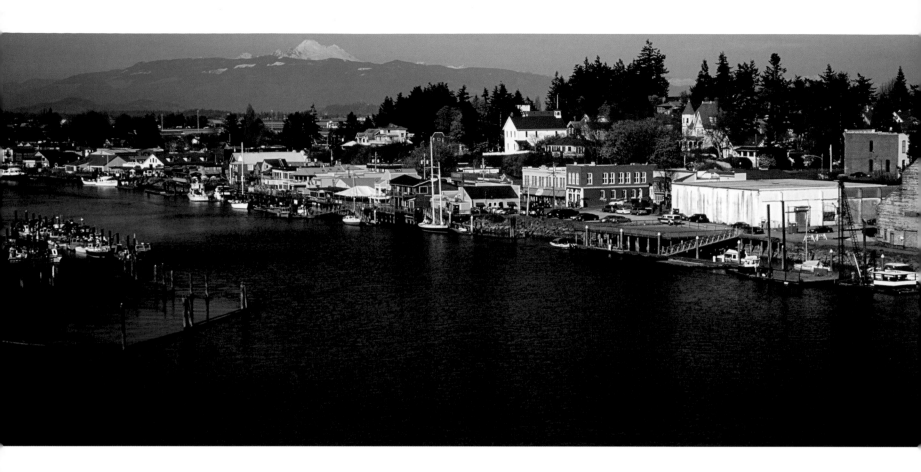

La Conner

The twin-steepled Sacred Heart
Catholic Church (opposite) was
established in 1899, thanks to
the efforts of Louisa Ann Conner,
wife of the town's founder, who
traveled the area by canoe to solicit
donations. The community grew
up on the tidal mudflats along
the Swinomish Channel (above).
Shipments of lime, lumber, produce,
and seeds made this a bustling
waterfront in the late 1800s.

Most of the time, if you gaze out to the Swinomish Channel that fronts the town of La Conner, you'll see pleasure vessels plying the waterway or anchored at the dock; perhaps a motorboat with a handcrafted kayak strapped to the roof, ready for an owner's afternoon paddling excursion. But every once in a while, a tugboat chugs through the channel, pulling a densely packed float of logs. It's a startling reminder of the days when this narrow waterway separating the Washington mainland from Fidalgo Island was an important commercial thoroughfare and La Conner a lively hub for shipments of lumber, lime, and agricultural produce.

At first the water actually hindered settlement. In the mid-1800s the area was largely marshy "flats," washed by high tides and given to annual flooding. Only when pioneers arrived after the Civil War and began to build dikes could they plant crops. Within a few years the fertile soil was growing oats, barley, and other grain, and by the turn of the century the region was known as a major seed-producing area – a reputation that continues to this day.

The town itself got its start when Alonzo Low set up a trading post in 1867. He didn't stay long. Within two years John S. Conner owned the store, along with a post office. Conner used his wife's initials – "L. A.," for Louisa Ann – to name the burgeoning settlement.

His mercantile business thrived, and in 1873 he sold it to the Gaches brothers and went on to run a hotel. In the next few decades other merchants set up shop in the clapboard and brick one- and two-story businesses that now make up the colorful storefronts of First Street. There was the Palace Meat Market, Harry Rocks's Harness Shop, a cobbler's workshop, the *Puget Mail* newspaper, warehouses, and, of course, a couple of watering holes: the Nevada Bar and Fletcher's Saloon.

With their profits, the new residents built fine houses on the heights above the channel. A spectacular Queen Anne mansion, complete with a grand veranda and a two-story turret, was constructed by George Gaches and his wife, Louisa, in 1891. It stood across the street from the white-frame 1875 grange hall that has been a courthouse, school, church, lodge, community center, and finally, today, a garden club.

La Conner prospered as a port early in the 20th century, and many gingerbread-trimmed cottages from those days still dot the quiet lanes of the town. Other reminders of local turn-of-the-century lifestyles are collected in the hilltop Skagit County Historical Museum, where the view takes in a panorama stretching from Mount Baker to the Skagit Valley.

Scenery couldn't sustain the economy, though. The Depression hit the region hard, and gradually the

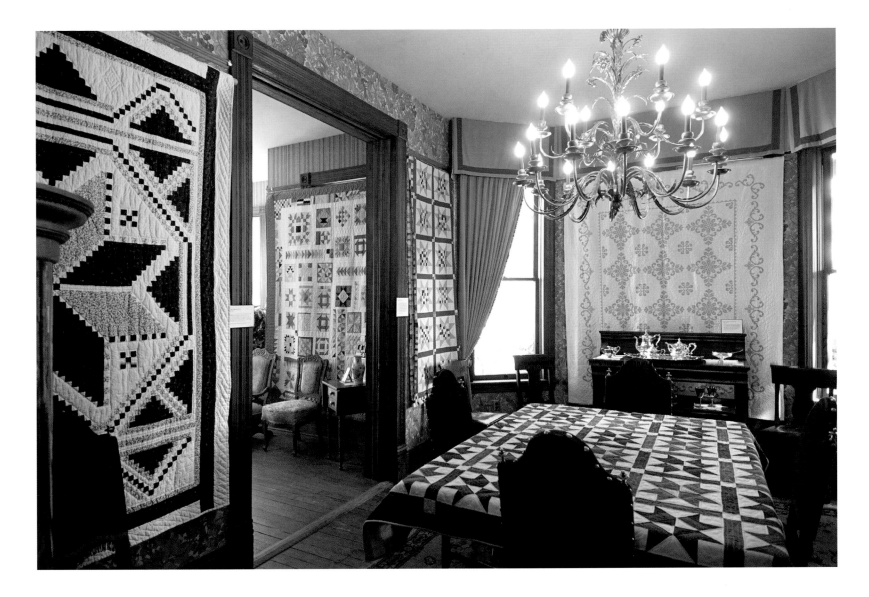

town's population dwindled and businesses shuttered. The elegant Gaches Mansion, which had been turned into a hospital, was auctioned in a sheriff's sale and eventually partitioned into a boarding house.

Empty buildings and cheap rents often attract artists, and La Conner caught the eye of painter Morris Graves, who moved to town in 1937, followed by painters and sculptors of what *Life Magazine* would dub the Northwest School. Guy Anderson, Mark Tobey, and others brought a bohemian air to La Conner, an attitude accentuated in the 1960s and early 1970s as hippies and countercultural writers like Tom Robbins also discovered the town.

Gradually La Conner's tide turned. When the Gaches Mansion was badly damaged in a fire in 1973, the community rallied to save it, and after five years of renovation, it was added to the National Register of Historic Places. In 1981 it became home to the Valley Museum of Northwest Art, the brainchild of acclaimed photographer Art Hupy, who had opened a gallery on First Street a few years before.

Since then, the 19th-century storefronts have reopened with boutiques and restaurants. A former bank – complete with its original vault – is now occupied by municipal offices. The dock where lime from the San Juan Islands used to be offloaded now hosts a wine-tasting venue, and a nearby turn-of-the-century hotel is again welcoming guests with a bit of Edwardian style.

La Conner's main street is home to a number of galleries, as well as the art museum, which moved to its larger quarters in 1995. The Gaches Mansion, with a spectacular restored Victorian interior on its lower floors, houses the Quilt and Textile Museum. Sculpture is on exhibit year-round on the downtown streets.

However, the raffish spirit of a few decades ago hasn't completely disappeared. It pops up now and then in the form of knit garments that appear on some of the public statues, and the town's embrace of almost a dozen wild turkeys as local mascots.

In the surrounding fields, nature adds its own art every spring. Among La Conner's notable crops are acres and acres of tulip and daffodil bulbs. Each April they draw thousands of visitors who come to marvel at the brilliant display, a sea of vivid yellow, red, and pink extending as far as the eye can see.

Urban turkey trot: La Conner's wild winged mascots (opposite) *take a morning stroll in front of the 1886 City Hall. Down the street, the Quilt and Textile Museum fills the interior of the restored Gaches Mansion* (top) *with handcrafted works of art. Old-style rockers are a feature of Katy's Inn* (above).

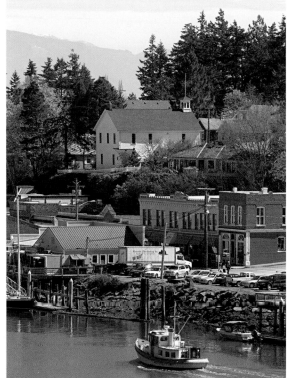

Every year, during a spring festival, Skagit Valley flower growers open their fields (left) to visitors who do, indeed, tiptoe through the tulips. La Conner's garden club has its home in the large, white, former grange hall, above downtown (top). Across the channel is the Swinomish Indian Tribal Community, where a church shrine (above) includes local decorative touches.

Oysterville, Ilwaco, Seaview & Long Beach

In a historic cannery building on Willapa Bay, a worker in a bright bib apron and rubber gauntlets is sorting piles of the bivalves that brought fame and fortune to little Oysterville 150 years ago. The last link to the town's initial *raison d'être*, Oysterville Sea Farms still raises its namesake delicacy in the tidelands beyond the dock, though the community itself has dwindled to a few dozen houses.

These brackish waters – on the inland side of the Long Beach Peninsula that reaches up like a thin finger from southwestern Washington – were a natural nursery for the oysters, which grow on reefs on the shallow sea bottom. The Chinook Indians of the area knew how to harvest the bounty, and they shared their knowledge with the first white pioneers, Robert Hamilton Espy and Isaac Alonzo Clark, who founded the town

in 1854. It didn't take the newcomers long to realize that oysters would command a high price in gold-rich California. The following year they shipped 50,000 baskets of the shellfish to San Francisco, increasing that amount threefold by 1858.

Their fledgling industry soon attracted other settlers, who drew lots for 5-acre parcels of land. Before long there were 500 inhabitants, and Oysterville was a county seat. The neat red cottage that served as the courthouse remains a residence, the oldest of a dozen structures dating from the late 1800s.

Today it's difficult to picture Oysterville as it was in its heyday, a bustling "sinners' boomtown" filled with restaurants and hotels, and schooners waiting at anchor to take on their tasty cargo. Since then, the sea

has reclaimed several bayside streets, leaving only grassy meadow. But if you stand near the water and look back toward the road, you'll notice a few sturdy dwellings facing the bay. Constructed out of redwood that came as ships' ballast, they've survived decades of storms and tides that washed away other buildings. The church, with its extravagant red-and-white steeple, is the centerpiece of the Oysterville National Historic District. Built in 1892 for a Baptist congregation, it has an exquisitely simple interior, with rows of wooden pews joined like a ship's keel.

Around the corner is the gray-shingled schoolhouse built in 1907, with an old-fashioned bell tower. Today its one-and-a-half schoolrooms belong to a community center. Another historic local meeting place is

Candy colors set the tone for fun on the main street in Long Beach (above). *The town has been a resort since early in the 20th century, when vacationers arrived on the "Clamshell Railroad," as the idiosyncratic Ilwaco Railway and Navigation Company was known.*

A relic of Oysterville's boomtown days (right), *the Ned Osborne House, from 1873, was intended for the owner's bride – until she jilted him. He left the upstairs bedrooms unfinished and died a bachelor. The tree-shaded lanes give little hint of the rollicking times in the mid-1800s when schooners waited to take on baskets of valuable bivalves bound for San Francisco. Today the town is a historic district that includes the 1892 Oysterville Church, with its patterned and painted steeple* (above). Above right: *tree-trunk sculpture in a private garden.*

the Oysterville Store and Post Office – established in 1858 – where the mail continues to be sorted into tiny decorative brass boxes. Further down the road, the tranquil cemetery is the final resting place not only for the town's founding families but also for the Chinook chief who greeted them.

By the late 1880s, the town was already fading, thanks to overharvesting of the oysters. (Later a parasite further damaged the beds, though scientists in the 1930s averted total collapse of the industry by importing a hardier species.) The final blow was struck when new train tracks stopped 4 miles short of the village. Businesses shifted to the end of the line, residents moved, and a rival town wrested away the county seat.

Oysterville's saga is brought to life – with stories of the entire peninsula – at the Pacific County Historical Society & Museum in Ilwaco at the base of the peninsula. That port town grew up in the 1870s, when steamers from Astoria docked to connect with stagecoaches and freight wagons that carried mail and other goods up the packed-sand beach to Oysterville.

Not shy about touting its attributes, a gateway to the sands in Long Beach (above) *beckons visitors. Steady winds over the Pacific strands have given rise to an annual kite festival here. The oysters grew on the leeward side of the long, thin peninsula, on Willapa Bay. The Chinook Chief Nahcati told Oysterville's white founders about the shellfish delicacy. He's buried in that town's historic cemetery* (right), *but his legacy lives on in a plate of raw oysters at the Shelburne Inn in Seaview* (opposite below).

A decade later entrepreneur Lewis Loomis, who ran the stagecoach line, envisioned a narrow-gauge rail line in its place. By 1889 his Ilwaco Railway and Navigation Company was chugging its way from Ilwaco's wharf to the Nahcotta depot 13 miles away. The IR&N was famous for its idiosyncrasies: Because ships could only cross the Columbia River at mid-flood, Loomis's "Clamshell Railroad" had to adhere to that timetable, pushing its schedule forward a half-hour each day, then moving it back two or three hours at the end of a week. The line's lackadaisical attitude – trains sometimes stopped so passengers could shoot geese or catch fish for dinner or even allow a fireman to gather flowers for his sweetheart – accounted for its other nickname: The Irregular, Rambling, and Never-Get-There Railroad. It may have been quirky, but the train was useful, carrying shipments of oysters and cranberries to market, and in warm weather bringing vacationers to the new resorts along the ocean beaches.

In Seaview, just north of Ilwaco, scores of 50-by-100-foot lots sold for $100 each, first accommodating tents and later sprouting little cottages. The community still has the air of a genteel 19th-century summer place, with a scattering of Victorian-era homes along

shady lanes and the historic Shelburne Inn, which dates from 1896. Even the diminutive railway depot has been turned into a cozy restaurant.

Long Beach, which began at Seaview's northern border, was a larger resort, with grand hotels, a natatorium, souvenir shops, and restaurants that contributed to a carnival atmosphere that lives on.

At the turn of the century the IR&N was sold to a more conventional operating firm, but within a few decades the appearance of automobiles on the roads signaled the eventual demise of the railroad, which made its last run in 1930.

Visitors have never stopped coming, however, drawn by unsullied ocean beaches, delicious oysters and clams, a relaxed atmosphere…and constant breezes. It turned out that the flat sands and reliable winds were perfect for kite aficionados, who for some 30 years have gathered in Long Beach by the thousands for their summer festival. The town also is home to the World Kite Museum, whose collection ranges from historic and scientific kites to colorful examples from around the world. Kite in hand or not, you can stroll the beach, breathe in the sea air, and let your spirit soar.

Ilwaco's seafront is a working harbor (above)*, continuing a tradition set in the 1870s, when ferries from Astoria, across the Columbia River, pulled up to the dock, their timetables governed by the changing tide. Fishing boats are berthed here, along with excursion vessels, while waterfront restaurants serve up their catch.*

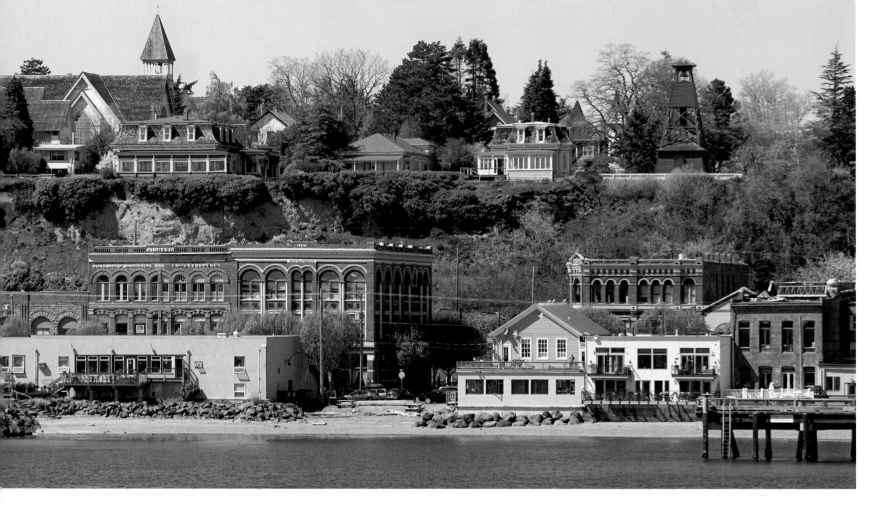

Port Townsend

A docent at the Commanding Officer's Quarters at Fort Worden, Steven Bailey – in turn-of-the-century army uniform – retires the flag for the evening (opposite). The fort, on the outskirts of Port Townsend, is now a state park, while the gracious farmhouse-style residence, which was home to 33 military families from 1904 to 1953, is a museum. From the water, Port Townsend itself (above) resembles a Victorian seaport. At sea level, the red-brick 1893 Customs House is now the local post office, while elaborate houses line the heights above. The triangular red bell tower, built in 1891, sounded the town's fire alarm, using different codes for different neighborhoods. It still rings on special civic occasions.

"Location, location, location," as they say, is the key to real estate. That was true even in 1851, when Alfred Plummer and Charles Bachelder, tired of searching for gold in California, built a cabin in the swampy flatland on the curved fingertip of a narrow peninsula guarding the entry to Puget Sound. To the north lay the Strait of Juan de Fuca, which opened into the Pacific Ocean. To the southwest, a vast wealth of forests was waiting to be harvested. For neighbors there were a few hundred Klallum Indians, who accommodated the newcomers without hostility.

Within a few months, two more entrepreneurs had arrived from Portland. The four pioneers platted a town and got to work, shipping timber to mining camps farther south. Wooden false-front shops, wharves, warehouses, and cabins soon lined the busy little harbor.

It was a logical place for a customs house. In 1854 Port Townsend was named an official port of entry where all foreign vessels had to stop to pay taxes on imported goods. The ships' captains often took the opportunity to buy supplies, make repairs, and hire the tugboats they needed to maneuver into mainland ports, while the sailors welcomed the chance to slake their thirst and enjoy lustier entertainments.

The merchants of Port Townsend were happy to answer all those needs. Over the next few decades, they built hotels, shops, banks, shipping agencies, ferries, saloons, theaters, gambling dens, and "female boarding houses," as bawdy houses were known. They profited not only from these ventures but also from occasional smuggling and the legal but nasty practice of shang-haiing sailors – getting them drunk and signing them on for a long sea voyage. Port Townsend's wide-open waterfront quickly became known as the rowdiest place north of San Francisco.

Meanwhile, Port Townsend's more genteel society was moving up – literally – to the bluffs above the harbor. German immigrant David Charles Henry Rothschild, for example, the proprietor of the thriving Kentucky Store (selling everything from "pins to anchors"), hired shipwright Horace Tucker to build a house on the heights in 1868. Today his Folk Greek Revival residence, the second-oldest home in Port Townsend, is a museum offering a time capsule of life before the turn of the century, furnished with the Rothschild family's belongings, down to toys in the nursery. Even now, the view from the front porch reveals a scene little changed from the late 1880s, thanks to the saga of boom and bust that followed.

The city fathers weren't content with Port Townsend's first incarnation. They had something much, much grander in mind. Dreaming of a city to rival New York, they filled in downtown's swampy ground and began erecting buildings that could serve 20,000 people, more than twice the actual population. They lobbied the Union Pacific Railroad to connect the town to Portland, and when they lost out to Tacoma in 1873, they pinned their hopes on a spur railroad line instead.

The fruits of their speculation still stand all along Water Street: three- and four-story edifices with decorative cornices, corner towers, jutting bays, and arched windows. A stately City Hall went up in 1892, causing civic consternation because it was located next to a "low resort." That same year the Jefferson County Courthouse was built with a magnificent clock tower, and in 1893 the Customs House got an impressive new stone home. Elsewhere in town, the building spree produced dozens of fabulous Victorian residences, including the lavishly turreted Frank Hastings House and the Ann Starrett Mansion, where an interior staircase curves up to a domed ceiling with pastel paintings of the Four Virtues and the Four Seasons.

And then, in 1893, a national depression stopped the railroads – and most other enterprises – in their tracks. Port Townsend's ambitious dreams evapo-rated, leaving downtown buildings unfinished shells. Two institutions saved the community from utter ruin. In 1896 Fort Worden was established just north of town as one of three batteries that formed a "triangle of fire" to protect Puget Sound from enemies by sea. The fort soon boasted artillery emplacements, dormitory-like barracks, a grassy parade ground, and stately Georgian Revival residences for the officers. Now a museum, the commanding officer's quarters are again comfortably appointed in 1910 style, complete with a 45-star flag over a roll-top desk.

The town's other lifesaver was a paper mill. Built in 1928, it bolstered the economy through the Depression and continued to sustain it after Fort Worden was shut down in 1953. Some Port Townsend old-timers look back on those lean days fondly, remembering a close-knit if dwindling community. The wharves crumbled, the office blocks stood empty, and squatters moved into the Queen Anne Victorians. Although only ghostly advertisements adorned their old brick walls, most of the commercial buildings remained, waiting for the next chapter in Port Townsend's story.

It was written by a few newcomers, with a penchant for architectural preservation and an interest in the arts, who formed a summer institute that now has a year-round home on the Fort Worden campus. They were joined by writers, artists, and devotees of alternative

The garden of an 1860s parish hall (left), now a wedding chapel, provides a panorama of Port Townsend's commercial district. From their bluff-side homes, merchants could keep an eye on their businesses but shield wives and children from the less-than-respectable shenanigans near the docks. Above: Re-creating 1910 decor, the commanding officer's study at Fort Worden hangs a 45-star flag, a reminder of the state of the Union then.

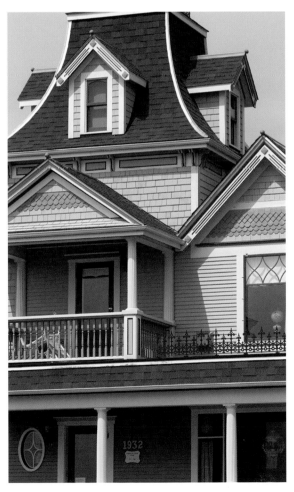

Among Port Townsend's treasures of Victorian architecture is the superbly renovated 1889 Starrett Mansion (far left), where rosettes in the door frames allude to family crests. The James and Hastings Building (above), also from 1889, was constructed on the site of the town's first log cabin. Left: gables galore at the O'Rear house, built in 1891.

lifestyles, including some who famously traded work at the Town Tavern, on the first floor of the 19th-century N. D. Hill Building, for room and board.

From the 1970s onward, dozens of historic homes were rescued and renovated, and Port Townsend was named a National Historic Landmark District. Quirky local institutions sprang up – such as Elevated Ice Cream, which initially sold its hand-made treats from an old elevator cubicle – and chain stores and fast-food eateries were banned. These days, galleries, restaurants, and boutiques fill the brightly painted Victorian buildings, while reviving Port Townsend's past has become a local hobby. Docents don period dress to tell stories and give tours. The 1907 Rose Theatre shows first-run movies, and City Hall, gorgeously renovated and expanded in 2006, houses the historical society museum, displaying artifacts, memorabilia, photos, and the old jail. But the best exhibit is the city itself: a Victorian seaport for the 21st century.

Walla Walla & Dayton

Heritage Park is a tiny green space on Walla Walla's Main Street, just steps from the shops and chic wine-tasting venues of downtown. On one side of the pocket park, a sepia-toned mural re-creates Walla Walla in all its turn-of-the-century architectural glory. Just opposite is the actual sandstone façade of the 1902 Odd Fellows Temple, complete with tall arched niches and a Dutch-style gabled roofline. Rescued when the rest of the building was torn down, the façade was re-installed here and then filled in with enameled panels depicting Walla Walla's varied residents between 1850 and 1950. A collaboration among local artists, sponsoring families, and the town's college students, the project demonstrates the community's strong ties and graphically depicts its saga of settlement.

That story begins 7 miles south of town, at the site of the mission run by Dr. Marcus Whitman and his wife, Narcissa, from 1836 to 1847. There, beside a millpond at the foot of a hill, Whitman put up a white-washed adobe house, planted a fruit orchard and wheat fields, and built a flour mill and blacksmith shop, while he strove to bring Christianity to the Cayuse Indians. After 1841 thousands of immigrants on the Oregon Trail passed by this mission, which must have been a welcome sight for the weary travelers. The ruts carved by their wagon wheels still dent the earth, all that's left of the mission except for a monument at the top of the hill.

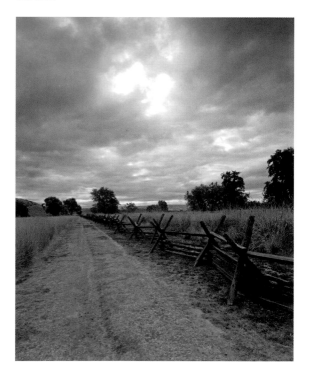

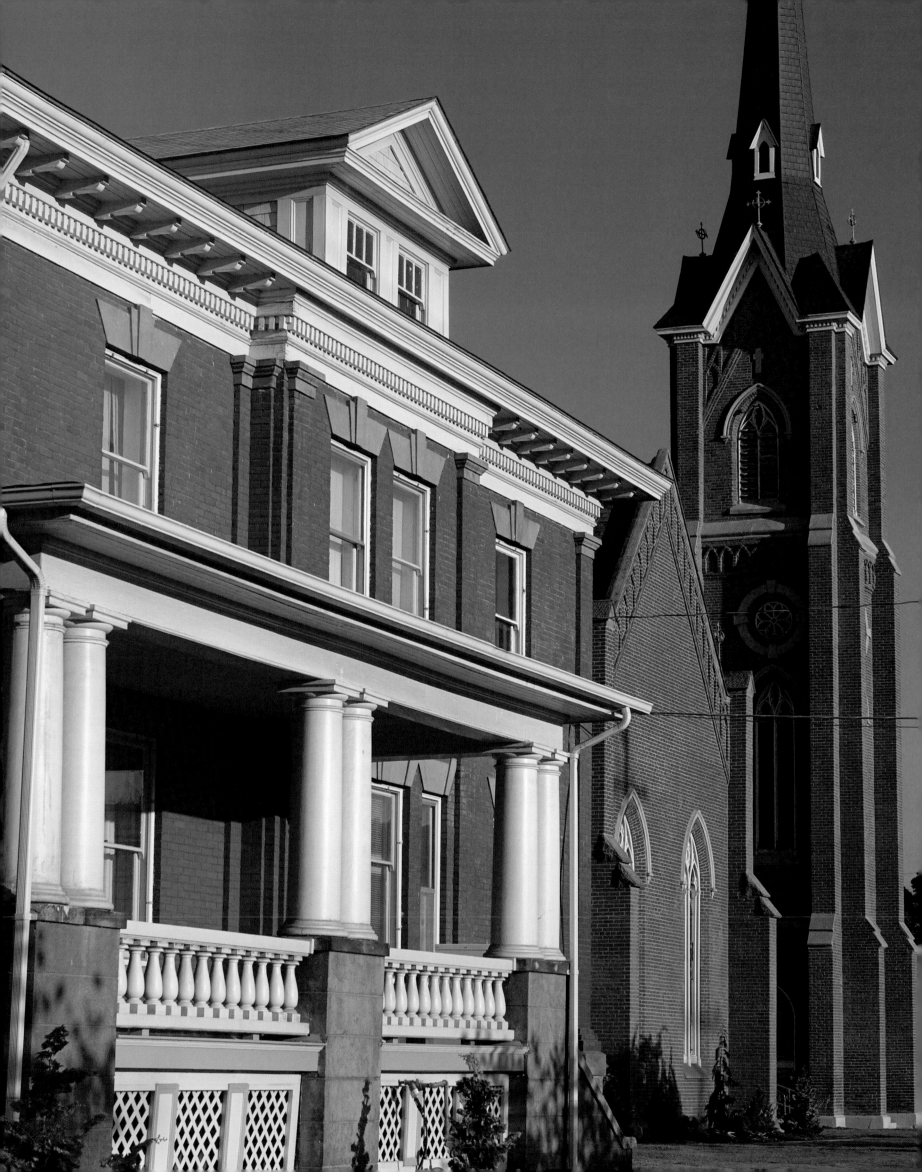

In 1847, despite Whitman's ministrations, a measles epidemic killed half of the Cayuse tribe. Angry and resentful, several warriors attacked the mission, killed both Whitmans and several others, and took 50 women and children captive. The hostages were eventually ransomed, but an Oregon militia pursued the Cayuse for three years, until five men were surrendered and executed. By then news of the massacre had prompted Congress to declare Oregon a territory.

Wars with the Indians continued until the mid-1850s, when the territorial governor negotiated a treaty and the army built a fort on Mill Creek, in the heart of Walla Walla. Although the military moved to a more easily defended site a few years later – the officers' quarters from 1858 and some other buildings today grace the grounds of the Veterans Affairs Medical Center – the reassuring presence of the army soon attracted new settlers.

One of those was entrepreneur William Kirkman, who owned cattle and wheat and became a booster of the growing town. His 1880 home, a grand Italianate residence made of local brick, with 14-foot-high ceilings and parquet floors, has been restored as a museum full of family furniture and memorabilia, including

a polished box piano in the music room, toys in the nursery, and his daughter's wedding dress hanging in her bedroom as it must have when she married in 1894.

More modest structures have been collected on the grounds of the Fort Walla Walla Museum. There you can peer into a double log cabin with a housewife's spinning wheel and loom on the hearth, as well as an early doctor's office, a barbershop and bathhouse, and a schoolhouse (where a teacher in 1908 earned $60 a month during her six-month contract). The museum's exhibit halls concentrate on agriculture, from the threshers that brought in the valley's wheat to the short-line railroad built in the 1870s to get that crop to market. In the late 19th century, wheat meant wealth, not only for Walla Walla but also for outlying communities such as Waitsburg, whose main street retains its vintage look, complete with a general store stocked with old-style bins of merchandise.

Dayton, roughly 30 miles from Walla Walla, has an extensive historic district with dozens of turn-of-the-century residences, including the 1880 Boldman House Museum and the gabled and turreted Queen Anne built by the son of the town's founder. A fifteen-room Victorian-style hotel occupies the saloon and lodge hall

A local landmark, St. Patrick's Catholic Church (opposite) *was constructed in Gothic Revival style in 1881, an era that left many historic structures in Walla Walla. The downtown Baumeister Building* (above) *made extravagant use of decorative moldings and cornices, accents highlighted in recent renovations.*

Preceding pages:
Furrows in the earth mark the passage of thousands of westward wagons on the Oregon Trail (left) *in the 1840s. Later, settlers built Dayton's railroad depot* (right) *the oldest surviving in Washington, which served its picturesque community from 1881 to 1972. As railroads extended across the area, transporting the local wheat crop to market, Walla Walla, 30 miles southwest of Dayton, eventually grew into a prosperous regional hub.*

On Dayton's Main Street, restored shopfronts reflect a interest in local heritage. The pink Dantzscher Building (above) *dates from 1895 and is now home to a chic contemporary restaurant. Walla Walla's 1917 Liberty Theater* (opposite top)*, took inspiration from Dutch architecture for its peaked columns. Erected on the site of the first Fort Walla Walla, the movie house has since been incorporated into a modern department store.*

established by Jacob Weinhard, a prosperous brewer. Down the street stands the oldest working courthouse in the state, a cream-colored Italianate edifice with a statue of Justice atop its pediment. Railway artifacts fill the restored Dayton Historic Depot, built by the Oregon Railroad and Navigation Company in Stick–Eastlake style, with accommodations for the stationmaster on the second floor.

As a regional hub, Walla Walla prospered, and it showed off its riches with impressive institutions and fine commercial real estate, from its own stately columned courthouse to monumental banks and hotels and opera houses with wedding-cake exteriors. The decorative façades add an ornamental air to downtown, while a public art program has placed sculpture both whimsical and serious on many downtown corners.

Meanwhile, the bankers, doctors, merchants, and wheat ranchers built elegant homes nearby, leaving a legacy of elaborate Queen Anne mansions, Carpenter Gothic creations, and Craftsman dwellings. Whitman College, which was chartered in 1883, 24 years after it began as a religious academy, stands among them in a gracious tree-shaded neighborhood.

Marcus Whitman was also the name of the luxurious hotel that opened its doors in 1928. Twelve stories high, and funded in part by local bonds, it welcomed dignitaries for decades, until it fell on hard times in the 1970s. Recently restored to its classic splendor, however, it once again shines as a source of civic pride.

The Depression stopped most construction in Walla Walla, but the region survived on agriculture: wheat, peas, and beans, as well as sweet onions. In the last few decades, local grapes have had all the attention, giving rise to scores of acclaimed wineries whose vintages have garnered a long list of prizes. Each year the new releases attract crowds of wine aficionados.

To welcome them, historic structures – from an old schoolhouse to a former mill – have been transformed into atmospheric tasting venues, alongside stunning new buildings. Lively cafés and fine restaurants have moved downtown, pairing their dishes with local wines, and adding their cheers to Walla Walla's future.

Traces of the past are visible in the wheel ruts of the Oregon Trail that passed by the Whitman Mission (left), a national historic site just outside Walla Walla. A century of contributions by the community's Native Americans and immigrant groups are remembered with tiled panels that fill the niches of the 1902 Odd Fellows Temple façade (opposite bottom).

Winthrop

Wooden sidewalks and covered arcades contribute to Winthrop's Old West flavor, which is playfully enhanced by a wooden Indian and a life-size cowgirl cutout (opposite). Centuries-old façades have been altered over time, but the Farmers State Bank (above) has occupied the same spot for decades. Next door, a school bell in the open tower once summoned young students to lessons, but today you have to be of lawful drinking age to enter the brewery restaurant inside.

From the horse corral on Sun Mountain, above the town of Winthrop, sagebrush-lined trails lead off in several directions, each one offering a slightly different perspective on this Methow Valley gateway to the northern Cascade Range. In the distance are a pair of peaks nearly 9,000 feet high, while closer at hand are panoramas of timber ridges, a hint of a river, and glimpses of a beaver pond through a glade of shimmering aspens. The best view, however, is from a horse's saddle, a seat that immediately confirms you're indeed in the West.

You'll get the same feeling as you drive down Winthrop's main street. Wooden sidewalks draw you past the row of false-front façades with overhanging balconies and atmospheric shop signs. Even the gas station has been redone in Old West style. Although many of the town's Western features were deliberately added in the 1970s, the town's roots genuinely go back to the late 19th century.

Until the 1880s, the confluence of the Methow and Chewuch Rivers was traditionally Indian territory. But the discovery of gold brought an influx of white prospectors, and the land was opened to homesteading in 1886. Five years later, when Guy Waring arrived in Winthrop, the settlement already had a name. But it lacked a general store, something the 32-year-old

Harvard graduate attended to immediately by starting the Methow Trading Company. He soon followed up with the Duck Brand Saloon and a year later added a post office. Although the stern Waring limited his bar patrons to only two drinks, his enterprises were all successful until the buildings burned in 1893, sparing only the saloon, which is Winthop's town hall today. Broke, Waring retreated to the East but returned a few years later with a bride, who followed him on the condition that he build her a fine house.

He obliged with "The Castle," as he styled the log cabin he handcrafted on the hill above town, a spot where he could keep an eye on his commercial interests. He and his wife also played host to Waring's college roommate, Owen Wister, who honeymooned in Winthrop and later incorporated the setting into his acclaimed novel *The Virginian*.

Ever the entrepreneur, Waring rebuilt his businesses and started others, including a sawmill. He planted orchards, though the valley needed irrigation and it was difficult to get the fruit to market. By the time Winthrop was actually platted in 1901, Waring owned every building on Main Street, except the town hall, and was catering to the needs of the surrounding ranching and mining communities. A drought in 1913 put a stop to his fruit-growing plans, however, and three

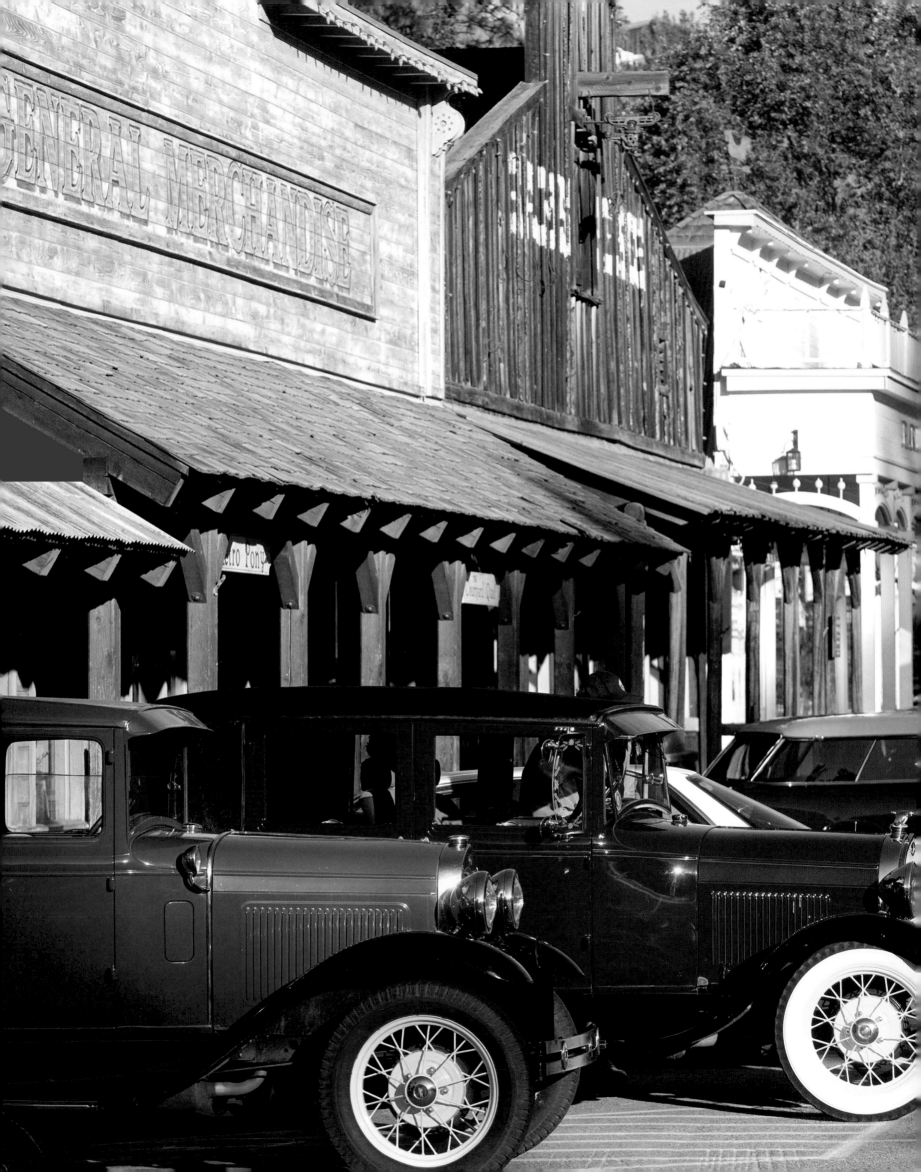

years later he was bankrupt. This time he left Winthrop for good.

The Castle has remained, first taken over by an Episcopal church and eventually passing into the hands of Simon Shafer, a merchant and collector of town artifacts. Today the long hand-hewn-log building is the centerpiece of the Shafer Museum. It's furnished as a house, with the Warings' piano in the living room. ("If

it doesn't make it to Winthrop, I won't either," Guy's bride supposedly insisted.)

Dotting the museum grounds are other structures that represent early 20th-century life. The Methow Trading Company cabin is furnished with cases filled with memorabilia; nearby is a dirt-floored cabin with a lean-to roof that was one of the area's earliest dwellings. There's a print shop, a ladies' drygoods shop, and the

Classic-car buffs bring their gleaming rides to town during Winthrop's annual Auto Rallye (opposite), *though visitors also arrive on two wheels* (above) *and on foot* (above left). *Venerable Three-Fingered Jack's, serving pizza and beer, claims to be the state's oldest legal saloon.*

A trail ride (above) *and dinner culminate in a congenial country barbecue* (opposite) *in the scenic hills of the Methow Valley. Paths that developed over decades of ranching, logging, and mining are now being used for year-round sports – mountain biking, fishing, and rafting in summer and skiing and snowmobiling in winter.*

entire office of the local doctor; as the docent will tell you, he brought most of Winthrop's old-timers into the world, including the docent himself. A simple assay office complements the sculptural collection of mine equipment, which features a stamp mill and a gigantic vibrating table.

After the initial gold boom, other minerals – from silver, tungsten, copper, and antimony to lead and zinc – kept the mines going until the late 1930s. After that, valley residents farmed and ranched, and logging operations had trucks rumbling down Main Street for decades. But Winthrop's out-of-the-way location, reinforced by its exceptionally snowy winters, meant that the community was always relatively isolated. The opening of the North Cascades Highway through the mountains in 1972 would change that.

Anticipating carloads of passing tourists, town merchants decided to embrace an Old West look by altering their old shop fronts. Indeed, visitors streamed in, including more than a few who stayed to buy second or

retirement homes. Today the false-front façades of Main Street house upscale clothing boutiques, chic home-decor galleries, fine restaurants, and easygoing cafés. The former schoolhouse is an atmospheric brewpub where musicians entertain on a riverfront deck in warm weather. The stagecoach stop is an internet business. Locals lament that they have to go to the next town for a hardware store, but they add that original bank is still a bank…and now has online service.

Step beyond downtown and you're likely to encounter several deer nibbling someone's lawn and looking longingly at a thoroughly fenced-in garden. Drive just a bit farther, and you're among the West's unmatched natural assets: bucolic lakes and spectacular mountains where you can hike and mountain bike, fish and hunt, raft in whitewater and ride horses. In winter, cross-country skiing and snowmobiling trails crisscross the snowy landscape. Or you can taste the flavor of an earlier age by riding in a horse-drawn sleigh, laughing all the way.

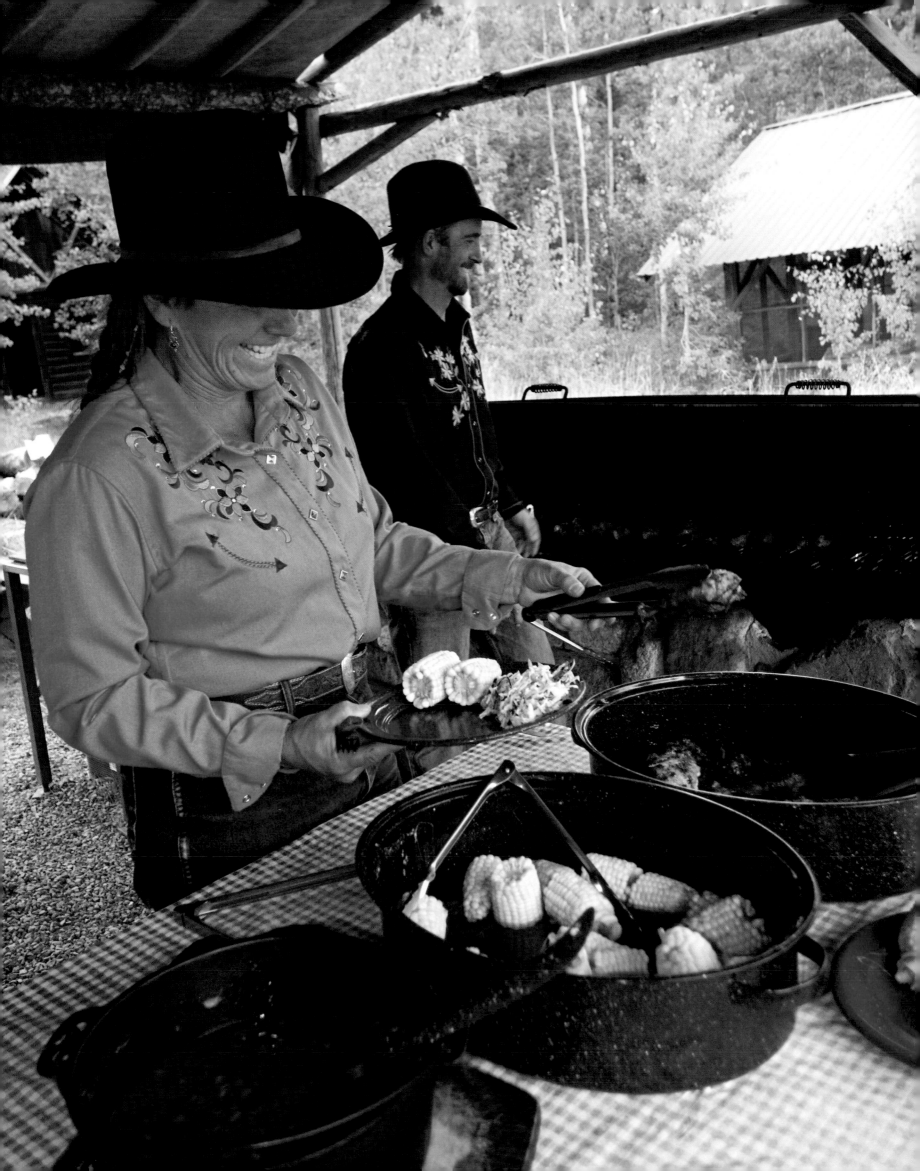

Gardens

SHAPING THE GIFTS OF NATURE

Gertrude Stein famously said "a rose is a rose is a rose," but she probably never set foot in Portland's International Rose Test Garden. Established in 1917, occupying more than 5 acres of a hillside overlooking downtown, the garden is a heady showcase for 550 varieties of the flower that has given the city its nickname.

Portland became the City of Roses early in the 20th century, after residents lined their streets with the blooms to focus attention on the Lewis & Clark Centennial Exposition in 1905. A decade later a local rose grower suggested building a public garden as a place to try new hybrids. Today that garden is filled with some 9,000 plants, including annual All-American Rose Selections going back to 1912–13. Climbing roses twine the street lamps, and florabundas and hybrid teas cover gentle slopes and frame fountains and sculptures. There are miniature roses, roses mentioned in Shakespeare's works, and roses in every imaginable hue, providing inspiration for Pacific Northwest gardeners.

Not that they seem to lack for inspiration. Thanks to the climate, the influence of Asian design, and the vision and resources of several individuals, the coastal regions of Oregon, Washington, and British Columbia have produced a wealth of horticultural gems.

Roses and rhododendrons are the highlights of Shore Acres Gardens, though spring bulbs and late summer dahlias extend the blooming season. Now a state park on the coast north of Bandon, Oregon, Shore Acres was originally part of a huge estate bought by lumber baron and shipbuilder Louis J. Simpson in 1905. Two years later Simpson built a bluff-top mansion for his first wife in 1907 and surrounded it with formal gardens; he later added a pond and a Japanese garden. His residence burned in 1921, and a second house was razed in 1948, long after Simpson and his second wife had given the land to the state for a park. But the gardens were renewed in the 1970s and come alive every April and May, when the rhododendrons and azaleas – some the size of small trees – are in full flower.

May is also when Florence, Oregon, holds its annual Rhododendron Festival. Since 1908 the town has celebrated the brilliantly blooming shrubs that line its roads and fill its yards by staging a parade and festively

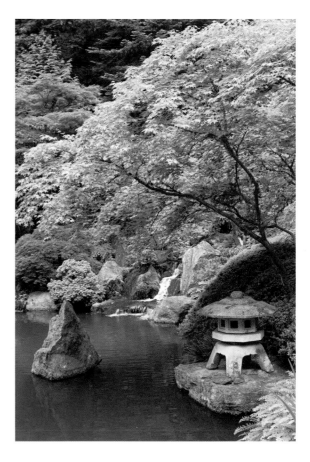

A symphony of greens: A corner of the Japanese Garden in Seattle's 230-acre Washington Park Arboretum (opposite) *is a brilliant demonstration of harmony in nature, with plants, rocks, and sculpture adding to a pleasing sense of balance. Similar principles apply in the Portland Japanese Garden* (above), *where paths take the visitor past ponds, pavilions, and waterfalls.*

A spring landscape in Butchart Gardens (right) *gives no sign that this Vancouver Island gem once was a worn-out limestone quarry. Now more than a century old, the horticultural riches encompass Japanese, Italian, Rose, and Mediterranean Gardens and a centerpiece Sunken Garden.* Above: *Weathered stones from Lake Tai, near Suzhou, China, are said to entice lucky spirits into the Sun Yat-Sen Chinese Garden in Vancouver.*

crowning a Rhododendron Queen. On Washington's Whidbey Island, Meerkerk Rhododendron Gardens is named for the couple who founded it in the early 1960s. Its unique and hybrid specimens are planted in a Pacific Northwest woodland setting and surrounded by a forest preserve that offers 5 miles of trails.

Across the road from the Rose Test Garden, Portland's Japanese Garden is a subtle masterpiece of green tones, sculptural trees, shrubs, rocks, and shimmering pools of water. Meandering paths lead visitors past a sea of raked sand, through a wisteria arbor abundant with blooms, over a moon bridge, and into a tea garden, as koi dart beneath a veil of waterfalls.

Seattle is home to several Japanese gardens. One is part of the expansive Washington Park Arboretum. Another is the work of Fujitaro Kubota, who emigrated from Japan, started a nursery company in 1923, and bought 5 acres of swampland, which he cleared, shaped, and planted by hand for the next five decades. Kubota Garden continues to be a tranquil series of intimate "rooms," including a miniature "walk into the mountains," traditional heart and moon bridges, and a small forest of cypress, among its many green delights.

Vancouver's Sun Yat-Sen Chinese Garden re-creates a Ming scholar's retreat. Built in 1985 by Chinese master craftsmen working with Canadian colleagues, the garden balances the four traditional Asian elements of rock, water, plants, and architecture. Weathered limestone rocks from

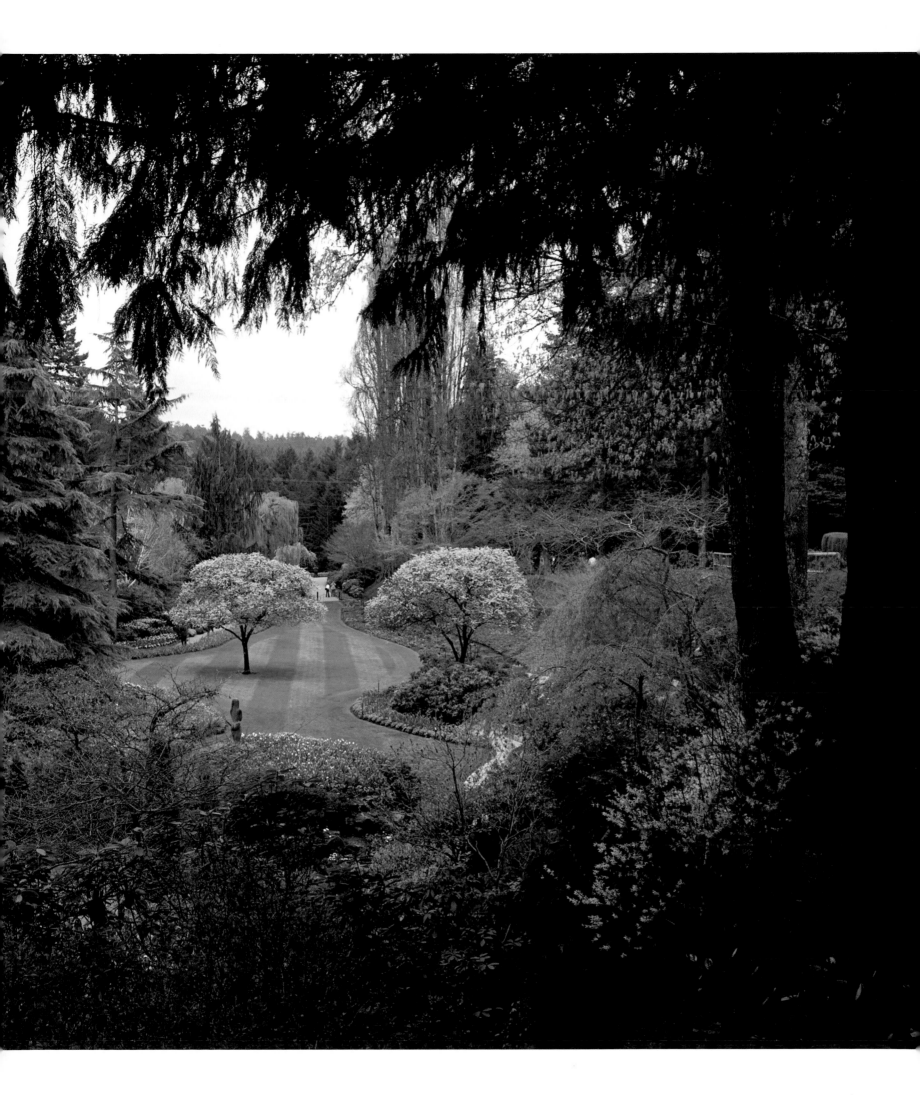

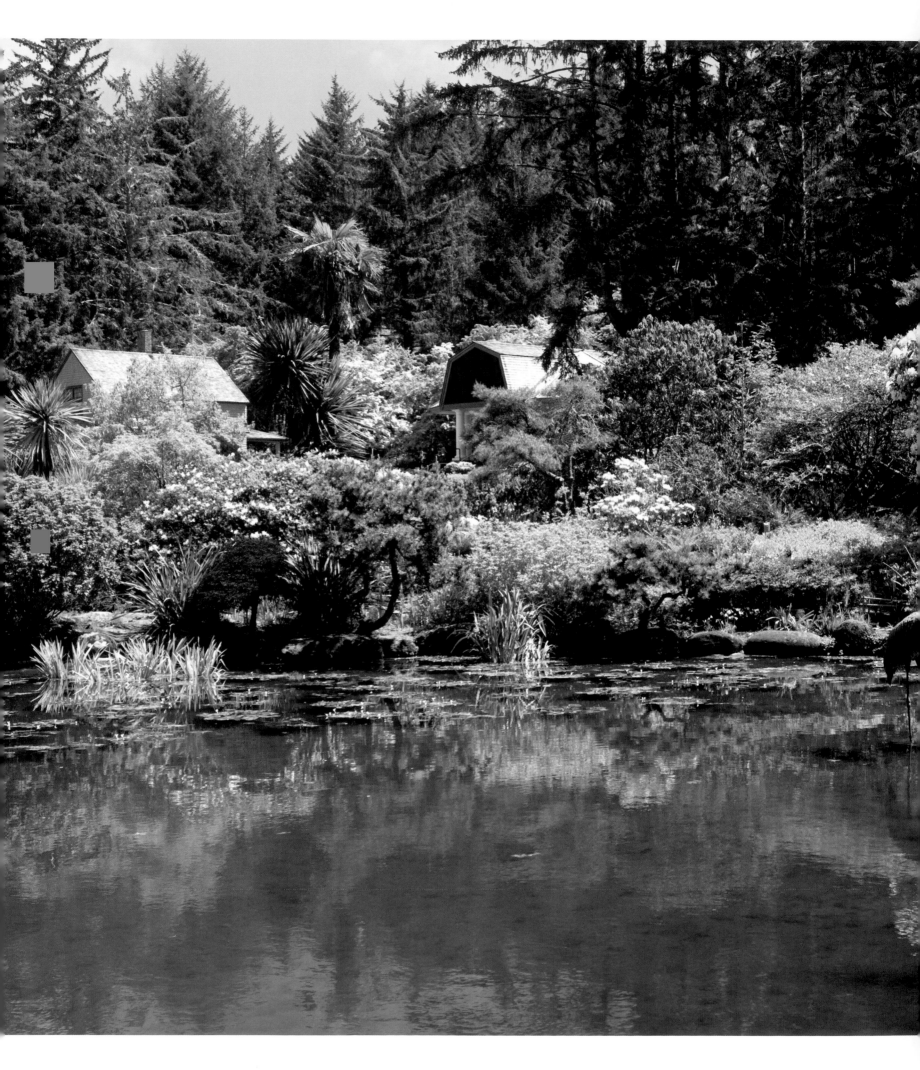

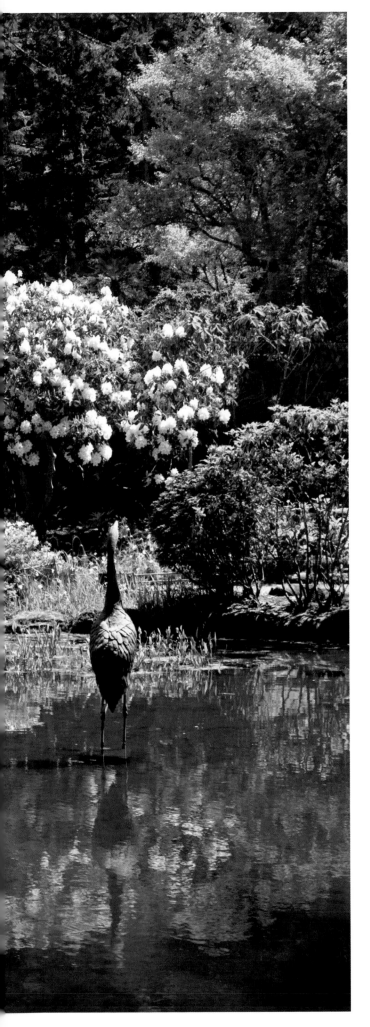

Shore Acres Gardens (far left), *part of a state park near Bandon, Oregon, comes alive with rhododendron and azalea blooms in April and May.* Left: *Architectural elements are important to the balance of yin and yang that underpins the Sun Yat-Sen Garden. The scene is meant to evoke the contemplative spaces cherished by 16th-century Chinese scholars.*

China; jade green ponds; and pine, cypress, bamboo, and miniature rhododendron are all artfully arranged in and around several pavilions to create an atmosphere of perfect harmony.

The Abkhazi Garden on Vancouver Island is a tiny jewel with its own romantic story. Nicholas Abkhazi, an exiled Georgian prince, met Peggy Pemberton-Carter in Paris in the 1920s. Separated by the Second World War – he was interned in a POW camp in Germany, she in a camp in Shanghai – the couple were reunited in 1946 and married in Victoria, where they built a house and designed the grounds with exquisite artistry. Peggy compared their garden to a Chinese scroll, which unrolls to reveal changing moods. A sinuous green lawn, known as the Yangtze River, flows past rock outcrops and ponds on one side and lush rhododendrons on the other. There are trees pruned to resemble waterfalls, minuscule plants clinging to boulders, and new perspectives at every turn.

Jenny Butchart had a much larger canvas to work with when she began the spectacular gardens that bear her family's name. In 1912, after the limestone quarry that fueled her husband's cement business had been played out, she decided to transform the massive hole in the ground into something beautiful. She had already landscaped several gardens around their home and added a Japanese Garden above a cove on Saanich Inlet. Now she began to clear the quarry of debris, turning the deepest section into a pond, transplanting ivy onto its steep rock walls, and hauling in topsoil for flowerbeds. The Sunken Garden was finished in 1921, but by

Solid meets liquid in a timelessly tranquil moment at the Japanese Garden (right) in Seattle. Roses are pink and no violets are in sight at the Portland International Rose Test Garden (above), while a display of snowy tulips announces that winter is over at Butchart Gardens (top).

Opposite: *the Three Sisters above the Elk River at Fernie.*

then the estate, dubbed Benvenuto, was already a showpiece, drawing thousands of visitors a year.

Butchart Gardens today are a stunning 55-acre horticultural display with formal Rose and Italian Gardens, a Bog Garden, and a Mediterranean Garden, as well as fountains, ponds, a piazza, and restaurants in the historic residence. On summer weekends, visits culminate with an evening fireworks show – a nice touch, and almost as brilliant as the riotous blooms of nature's own colorful creations.

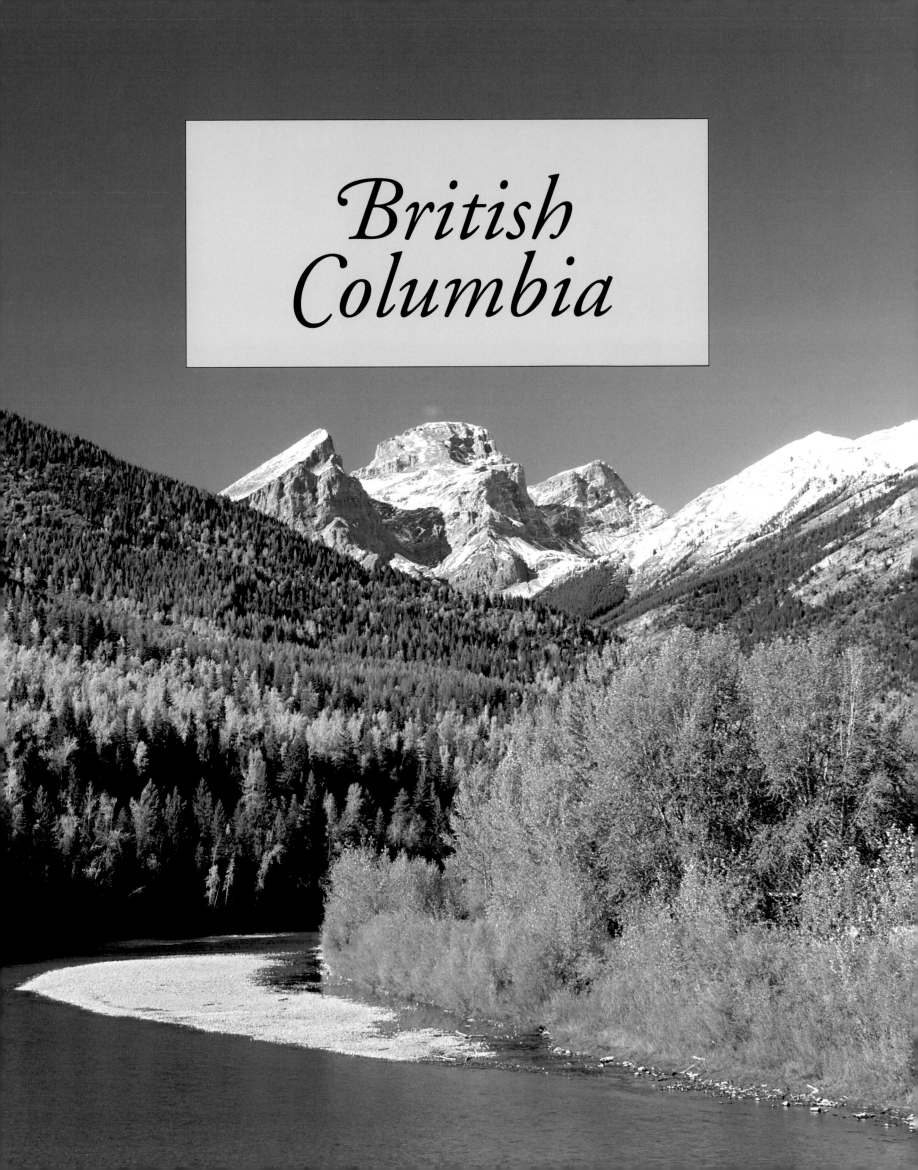

British Columbia

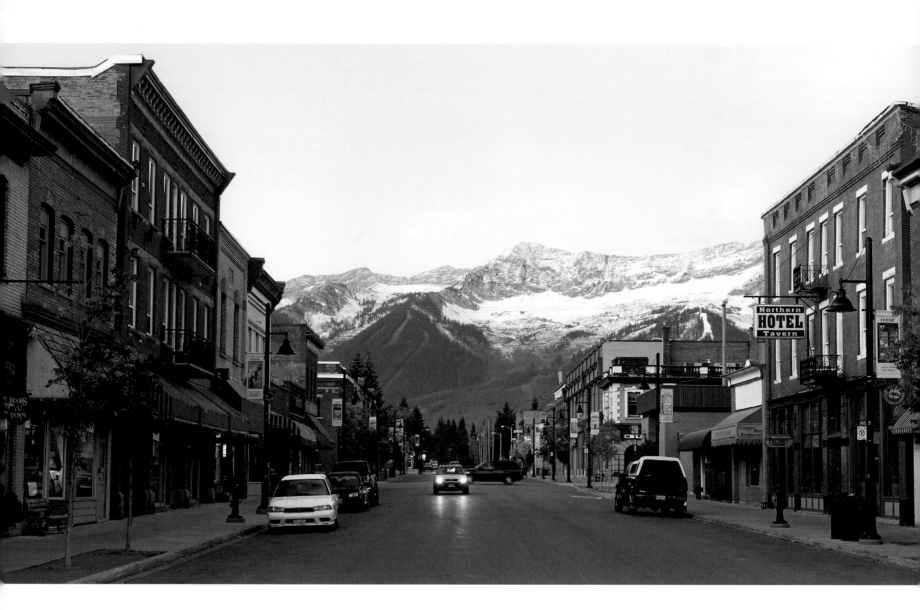

Fernie

With a slate roof and stepped gables that echo the peaks behind it, the Fernie Courthouse (opposite), built after the town's cataclysmic fire of 1908, resembles a chateau in the Alps. In fact, it's the Canadian Rockies that surround the coal-company town. The Lizard Range looms beyond Victoria Street's turn-of-the-century shops (above), in Fernie's historic downtown.

Picture the scene on August 1, 1908. After a summer of drought, 50-mph winds have whipped a rural brush fire into an inferno that is roaring toward the coal miners' town of Fernie. Hundreds of residents board the cars of the Canadian Pacific Railroad, which makes several successful passes through the flames to transport them to safety. Other townspeople take refuge in the Crow's Nest Pass Coal Company office, a stately Dutch Revival building made of cement and surrounded by a park-like lawn. Ninety minutes later, when the flames have run their course, they emerge to find the town in ashes.

This was the second time their community had burned. Just four years earlier a fire swept through the commercial district. But this time the conflagration leveled everything except the coal company's headquarters. Fernie would, of course, rise again – in brick and stone instead of wood. Decades later the redoubtable Crow's Nest Pass offices would be home to City Hall – fitting indeed, since in Fernie coal and civic life were intertwined from the start.

The earliest pioneers came to the area in the mid-1860s and 1870s to prospect for gold. Instead they found coal, itself a valuable commodity for the ore smelters farther west. But there was no way to market it until 1898, when, thanks to government subsidies, the C.P.R. laid tracks into Fernie and the Elk River Valley.

The downtown grew up near the train depot. After the fire of 1908, Fernie's main street took on the look it has today: two rows of flat-roofed two- and three-story brick buildings with ornamental windows and decorative cornices. Banks, a bakery, a meat market, a newspaper, the Miner's Hall, hotels and general stores, a barbershop, and pool hall all set up shop downtown. Those atmospheric buildings on Victoria Avenue now house restaurants, sports emporiums, a bookstore, a hardware store, and other contemporary businesses. Workingmen's boarding houses faced the railroad tracks, where the historic Canadian Pacific Depot has been transformed into a busy arts center that hosts concerts, crafts shows, historic exhibits, and a popular coffee shop.

A few blocks north was the post office – reincarnated today as the Fernie Heritage Library – and the Methodist church. The Roman Catholic church, with its octagonal tower and French stained glass, went up during a miners' strike in 1911, thanks to the pious wives who sent their idle husbands to work on it.

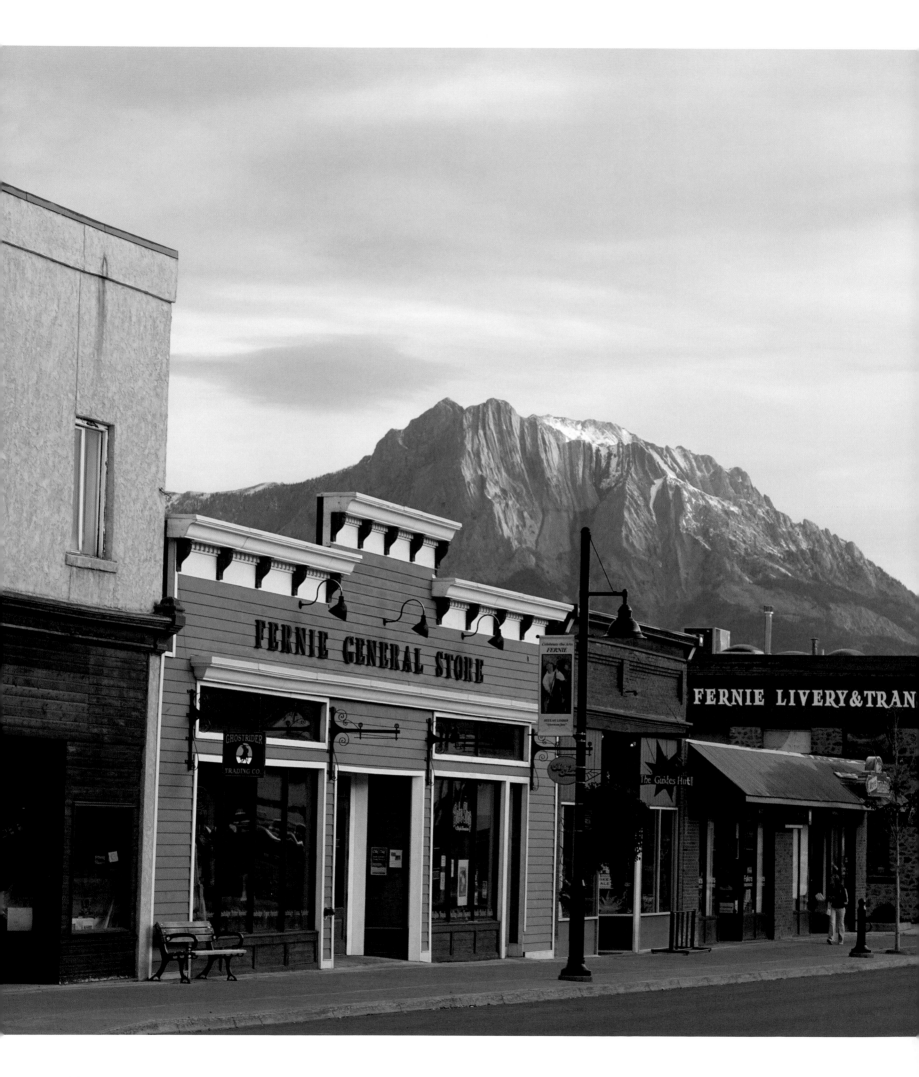

Mount Hosmer rises over the north end of Victoria Street (left), where even modern storefronts have to conform to low-rise period style. The livery building dates to just after the 1908 fire; its stone walls were quarried from the Elk River banks. Above: A road through old-growth forest leads to Island Lake Lodge and stunning mountain views – an inviting spot to hike and dine in summer but accessible only to cat-skiers in winter.

Not far away is the courthouse, an impressive red-brick chateau with a square stone entry, a slate mansard roof, and a slim cupola that looks as if it was a bit of an afterthought. The courtroom was clearly planned to be imposing. Native cedar forms the judge's bench and the high curved ceiling; the coats of arms of important personages and institutions decorate the dignified stained-glass windows.

More magnificent than Fernie's architecture, however, is its spectacular natural backdrop: the towering mountains that gleam golden-pink in the morning or evening, depending on which way you look. Mount Fernie has the slightly flattened top. The triple peaks are called the Three Sisters, while next to them stands Mount Proctor. Mount Hosmer has the added attraction of the Ghostrider, a rock formation that at sunset looks like a mounted Indian chief in pursuit. (He's supposed to be chasing town founder William Fernie, who jilted the chief's daughter.)

During the early years of the 20th century, the coal industry continued to grow, and in the 1920s the local economy was boosted by another, rather shady, enterprise as Fernie took advantage of its location to supply dry Alberta and Prohibition-era Montana and Idaho with bootleg whiskey. Rum-runners equipped themselves with McLaughlin Six Specials: fast Buicks with bumpers reinforced to go through barricades. Eventu-

ally, of course, that colorful era ended, and by the 1930s the Depression had brought hard times.

The mines closed, and the population dwindled, until the Second World War temporarily revived the coal industry. But the pits shut again in 1958. Seeking a new source of income, Fernie looked to an old pastime. Skiing had always been a popular form of recreation here, and the collections of the Historical Society Museum include hand-made skis from the turn of the century as well as ski-club memorabilia from the 1940s. Why not try for the 1968 Winter Olympics? In the early 1960s the town made its bid, and though it was unsuccessful, entrepreneurs went ahead and built a modest ski area on the slopes of Polar and Grizzly peaks, which opened in 1963.

Today, Fernie's mining industry again thrives, as its coal is now used in fabricating high-grade steel. But for visitors it's the skiing and other outdoor pursuits that are the main attraction. The ski resort has been improved and expanded; at the edge of town you can drive up through silent stands of old-growth forest to slopes that are incredible cat-skiing playgrounds in winter. In summer, sports enthusiasts enjoy mountain biking, whitewater rafting, world-class fly-fishing, and a web of hiking paths, which lead to alpine lakes or stunning vistas of the mountains that have shaped Fernie's past and now hold its promise for the future.

Fort Langley

Inside a log structure at Fort Langley National Historic Site, a shirt-sleeved cooper in corduroy pants and a vest is shaping slightly bowed pine staves for a wooden barrel. He keeps up a lively conversation with visitors, explaining the process and demonstrating his tools, all the while maintaining the pretense that the time is sometime in the mid-1800s when 2,000 such barrels, filled with salmon, were sent from this trading post to the Hawaiian Islands each year.

In the next building a hefty woman wearing a long skirt and a basket-like hat is pumping a large bellows, feeding the flame on the forge where she's heating metal spikes. She's preparing to turn them into candleholders or s-shaped hooks perfect for hanging clothes on a

19th-century cabin wall. Throughout the fort other costumed interpreters stroll across the grassy quadrangle or linger in doorways, helping visitors imagine what life was like here on the banks of the Fraser River more than 150 years ago.

This was thickly forested wilderness then, home to the Kwantlen band of the Sto:lo people, who lived by fishing and hunting, and who traded with the representatives of the Hudson's Bay Company, which erected a fort a few miles downstream in 1827. From there, goods could be shipped downriver to the coast and then around the world. A dozen years later, as their initial structure began to crumble, the Company moved to the historic site's present location. Its first

fort burned, but in 1840 the traders rebuilt, and the storehouse they constructed still stands, its rafters hung with pelts of beaver, fox, and other animals, while crates with plates, pipes, clothes, and other daily necessities are piled along the wall. Across the way, the reconstructed workers' quarters illustrate the lifestyle of the families of several employees of the Company: a Scottish boat-builder, a French-Canadian translator, and a Hawaiian laborer, his home complete with a chest of South Seas wares.

The grandest residence, though, is in the two-story Big House that served as the fort's office and the home of its chief trader, which has been carefully reconstructed from parlor to bedrooms. The most important room, however, is a simple downstairs chamber where a painting depicts the signing here – on November 19, 1858 – of the proclamation declaring British Columbia a crown colony of Britain.

It was a shrewd move by James Douglas, governor of the colony of Vancouver Island. Earlier that year thousands of miners had streamed into the Fraser River Valley, lured by the discovery of gold. Fearful that the United States might have its eye on the region, Douglas acted quickly, and in the process made Fort Langley the birthplace of British Columbia, which joined Canada as a province in 1871.

The onrush of prospectors actually breathed new life into the fort, whose fortunes had fallen with the decline of the fur trade and the rise of other more accessible trading posts. In the 1830s the Hudson's Bay Company started a large farm just beyond the fort to produce potatoes, barley, pears, and wheat that supplemented its shipments of salmon, pork, beef, and highly prized cranberries. During the Gold Rush, the farm's crops were in even greater demand, along with work clothes, shovels, pans, and coffee pots to outfit the

British Columbia in the mid-1800s comes to life in the re-creation of the Hudson's Bay Company outpost at Fort Langley National Historic Site (above), *as docents in period dress add to the illusion. The whitewashed building, the only original structure in the fort, is a storehouse built in the 1840s. Inside are bins, barrels, and crates of goods of the kind that passed through here more than 150 years ago. The bundles stacked against the next wooden building replicate heavy piles of valuable furs.*

Fort Langley • 159

Punctuating a corner of Fort Langley's palisade (right), *a bastion served both as a lookout station toward the Fraser River and as temporary housing. Inside one of the rebuilt workers' quarters* (above), *the table is set with simple utensils and the foods that would have been available in the 19th century. Families accompanied many of the employees, who came not only from across Canada but also from Europe and even the Hawaiian Islands.*

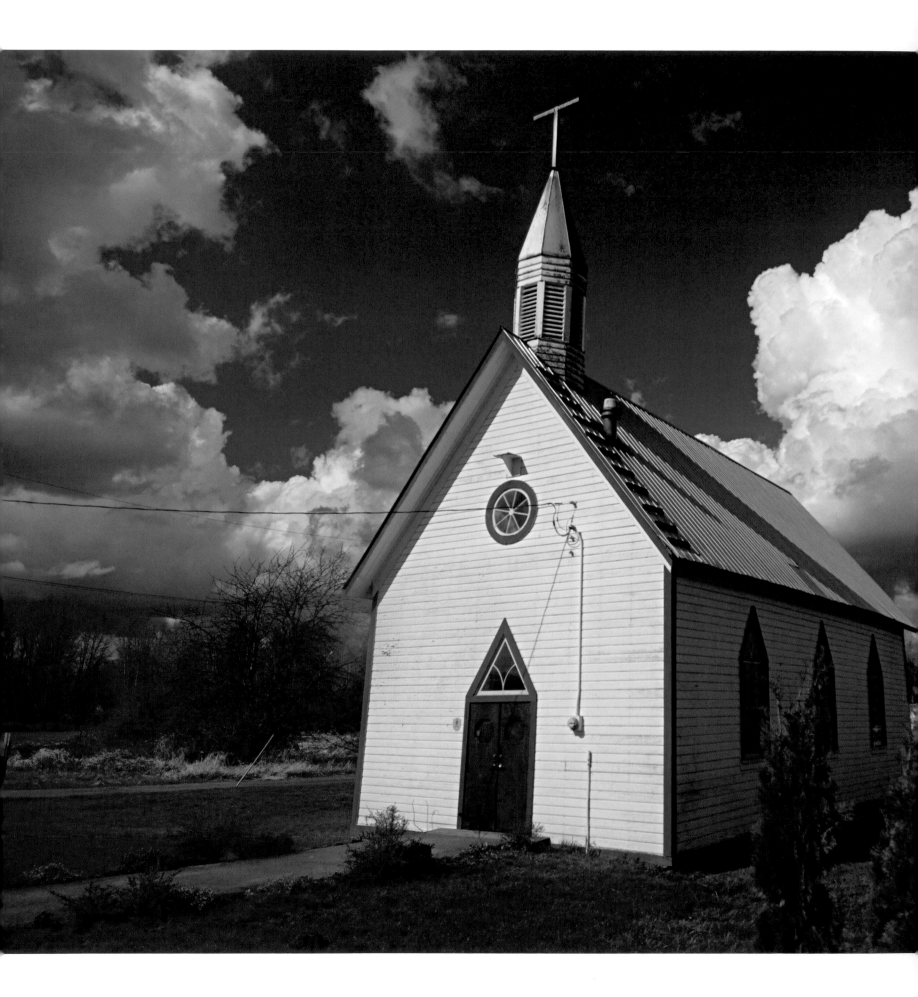

Spare in ornamentation, yet unsparingly graceful, the Church of the Holy Redeemer stands on McMillan Island (left), home to the Kwantlen band of Indians since long before the Hudson's Bay Company arrived. Above: Modern-day traders offer their wares in the shops along Glover Road, where twilight takes on a golden luster.

prospectors. But the good times faded again as the glint of gold disappeared, and by the late 1860s the fort was no longer needed. The Hudson's Bay Company sold off the farm and the land along the riverbank, and the stage was set for the next chapter of Fort Langley's story.

A little community sprang up, the core of today's picturesque village. A general store stood where its successor now offers fruit, vegetables, meat, and groceries; a hardware purveyor traded on the same spot as the current hardware store; and a saloon opened its doors close to where a contemporary watering hole slakes visitors' thirst. St. Andrew's church went up in 1885 near the tranquil cemetery, and twelve years later the Kwantlen band built a graceful, diminutive Roman Catholic sanctuary on their island just across the river channel.

Most of the town's other historic structures date to just after the turn of the 20th century, like the 1910 residence on Glover Road that belonged to the town's first doctor, which now houses a chic boutique, and the Coronation Block, whose 1911 façade arches over two

art galleries. The Canadian Northern Railway station, built in 1915, is home to the Langley Heritage Society, which uses the little baggage room as a venue for art exhibitions.

Fort Langley's evolution is the subject of two museums. The Langley Centennial Museum chronicles the First Nations and the early fur traders, as well as 19th-century home life, while the neighboring B.C. Farm Machinery and Agricultural Museum is jam-packed with everything from old tractors and a milk delivery wagon to a 1941 Tiger Moth crop sprayer.

The town today presents a congenial mix of the old and new. Galleries, cafés, clothing shops, and book-stores – many built in styles that match their antique neighbors – line Glover Road, and a riverside walking trail connects the re-created fort with the site of the first trading post. And harkening back to the cranber-ries harvested here 150 years ago, the local Fort Wine Company has a new use for the luscious crop – a very contemporary fruit wine.

Fort Steele

As a crowd gathers in front of the Wild Horse Theatre on Fort Steele's Main Street, a trim young woman in a dove gray skirt and jacket stands to one side and takes notes. Excitement buzzes from person to person, with word of a flim-flam artist on the scene. The woman – a journalist, as it turns out – asks a few questions, takes a few more notes…then heads inside the theater along with the rest of the actors portraying 1890s characters in a twist on an old-style comedic melodrama. It's all part of the experience of this heritage town, where visitors encounter modern reincarnations of the craftsmen, shopkeepers, and townspeople who once populated this historic corner of British Columbia.

Fort Steele owes its birth to the gold fever that swept through the area in 1864, after nuggets were found in Wild Horse Creek just to the south. The miners threw together a settlement called Fisherville, though within a year they would demolish or burn down the wooden cabins and shanties, trying to get at the gold that was literally in the streets.

A four-horsepower wagon rumbles down Riverside Avenue (right) in Fort Steele Heritage Town. The red-trimmed schoolhouse and St. Anthony's Roman Catholic Church were both part of the village in the 1890s, when Carlin & Durick (above) was the place for groceries.

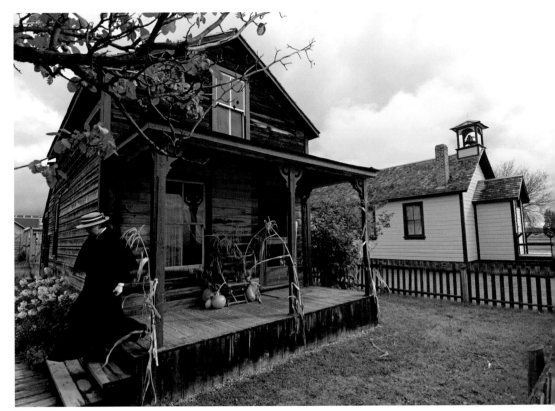

Meanwhile, a businessman named John Galbraith realized the need for a ferry service where Wild Horse Creek flowed into the Kootenay River. He built a log cabin for an office and charged a pretty penny for the crossing: $5 for one person, $25 for a wagon. His office still stands on that spot above the river, once again furnished with simple wooden chairs, clothes on hooks, and pulleys draped over the rafters. After half a dozen lucrative years, Galbraith sold the business to his brother, Robert, neglecting to mention that a bridge was planned. That didn't faze Robert, however, who stayed on to become a founder of the town soon known as Galbraith's Ferry.

Over the next two decades other pioneers joined him, and the growing white population began to threaten the traditional lands of the Ktunaxa Indians. When their chief peacefully but vehemently protested, the tribe was awarded a large reservation. Tensions continued nevertheless, until Superintendent Samuel Steele of the North West Mounted Police arrived with his troop in 1887 and worked out a more acceptable agreement. Steele and his men departed not long after, and the town was renamed in his honor. As for the Ktunaxa, they remained in the area and have renovated

the former mission school on their reservation into a chic contemporary resort.

The Mounties' post – with original and reconstructed barracks, a mess hall, and offices – is the first thing a visitor encounters upon entering Fort Steele. The town's historic structures blend with rebuilt and replica ones that depict the town in 1898, when it was a thriving regional center and home to several thousand souls. Often a local matron is on hand to show you around and pass along tidbits of gossip in the process. She might mention the astonishingly quick two-week mail service, point out the telephone wires that have recently been connected to the telegraph office, or tout the dentist's up-to-date painless anesthetic: cocaine. She'll probably tell you the price of a bath at the barber's – just 25 cents for first-used water, a nickel less for second – and whisper that Miss Bailey, the schoolteacher, is being courted by the superintendent, though the young lady is reluctant to marry and have to give up her job.

No guide is necessary at Barr & Comb's Blacksmith Shop, where the ironmonger demonstrates his skill with hammer and anvil. At the harness-maker's you can watch the craftsman cut and sew bridles and

Built not for defense but for water, a tower (opposite) *at a lonely edge of town is a replica of one constructed in 1897 by the Fort Steele Water Works Company. Elsewhere, "villagers" carry on daily chores and businesses. At the Cohn House* (above), *a matron steps off the "running veranda," where seasonal decorations complement the permanent gingerbread trim. And at Jack Corrigan's Harness Shop* (above left), *a master leatherworker turns out bridles and reins for horses, as well as belts and other souvenirs for visitors.*

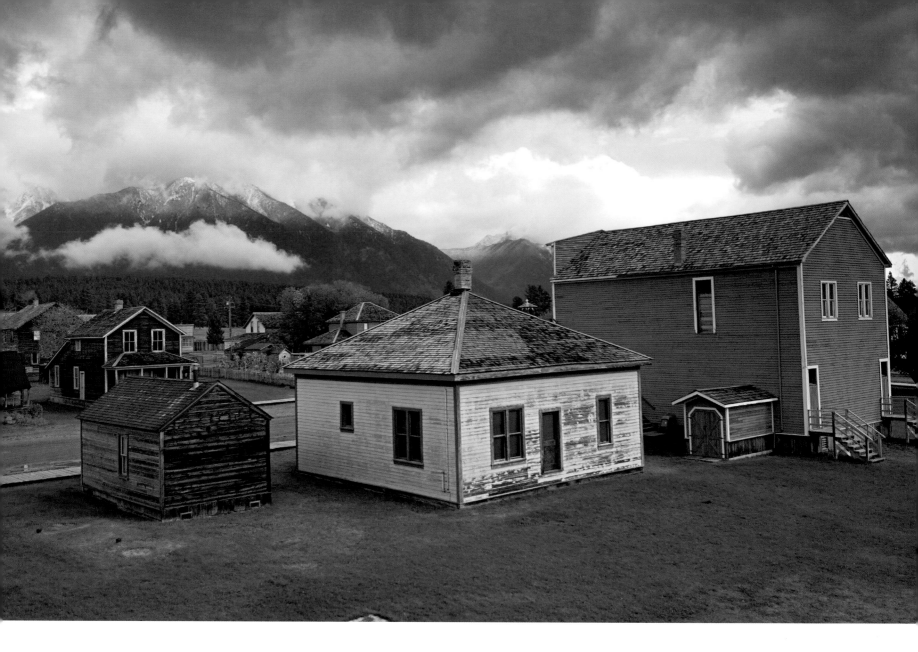

other essential equine gear for the nearby livery stable. The dressmakers are usually at work on aprons and bonnets next to the Carlin & Durick General Store, the oldest surviving commercial building in the Eastern Kootenays, where drygoods, haberdashery, rifles, and furniture fill one half of the establishment, while colorfully labeled cans, imported coffee and cheese, and sacks of produce jam the other.

The public institutions that were at the center of late-Victorian life occupy important places in town. The Government Building, which dates to 1897, is where the gold commissioner, the mining recorder, and the Appeals Court judge presided. Three houses of worship stand in close proximity to each other: St. Anthony's Catholic Church graced by a tall steeple, the fancier Presbyterian church, and the Anglican church with its vicarage across the street. The well-appointed 1894 Windsor Hotel welcomed only the finest guests to its 27 rooms, while the local *Prospector* newspaper reported all the comings and goings. Interspersed among the businesses are simple cottages, gingerbread-trimmed residences, barns, gardens, and pens for sheep

and chickens, all open to view and sometimes the sites of heritage demonstrations of turn-of-the-century housekeeping.

Amid the dozens of "townspeople" going about their daily business – and occasionally staging street entertainments – you will meet a local politician campaigning for an upcoming election. The election was an actual event. Unfortunately, when the votes were counted, it was Col. James Baker of rival Cranbrook who won the seat in the legislative assembly. He used his influence to see that the railway bypassed Fort Steele in favor of his own real estate holdings. It was the beginning of the end. Residents and merchants moved closer to the depot; government offices followed. By the 1930s Fort Steele was a ghost town.

The ghosts linger on, however. In 1961, Fort Steele became a historic park, and since then 60 buildings have been restored or rebuilt and furnished, and are inhabited – at least during visiting hours. This may be a place frozen in time, but it's also a warmly inviting portal to the past.

Ganges

Farmhouse chic, circa 1870s: Today the Salt Spring Island homestead (opposite) *built by Henry Ruckle is part of a heritage park that includes not only the pioneer house but also an array of outbuildings, and a later Queen Anne residence. The Ruckle family still works part of the land, though visitors can use its campsites and trails. A hilly interior separated early settlements, which sprang up where there was access to the water, like Fulford Harbour* (above) *in the south.*

For a tiny island town, Ganges has a festive bustling air. Residents drive in to shop and tend to business, while day-trippers and vacationers visiting Salt Spring Island browse the boutiques or stop for lunch. Water taxis drop passengers off at the dock, and sailboats moored in the marinas add to the mix of people coming and going.

At one corner of the central square stands Mouat's Store, housed in the same square white clapboard building with a green overhang that it has occupied since 1912. Four generations of one family have shepherded the business from a turn-of-century general store that provisioned homesteaders through Salt Spring Island's logging and fishing days, to the local fixture that still serves Ganges' modern community of artists, organic farmers, and retirees.

Although many of the structures on the square are relatively new, there are reminders here and there of what life was like here a hundred years ago – and how much it's changed. A red-and-white fire hall with a prominent clock tower, for example, displays a 1920 Bickle pump engine inside a glass wall. Not far away, the cute 1920s cottage that contained the island's first electric-light generator (and later served as

a smokehouse and a residence) is now a popular café. The general store that a group of businessmen started in 1912 to compete with Mouat's boasts a coffeehouse and other shops. Up the road, the bright barn-like Mahon Hall began as a gathering spot for the island's fruit growers around 1901 and today hosts frequent arts and craft exhibitions.

With its central location on the east side of Salt Spring Island, Ganges – named for the H.M.S. *Ganges* that explored these waters in the mid-1800s – now seems the obvious choice for an island hub. However, when the island was first opened to land claims in 1859, several other villages were more important. Salt Spring is shaped like a tilted stack of three saucers, with a deeply indented coast. Settlers put down roots in isolated communities separated by a forested interior and mountains in the south. They had to contend, too, with First Nations tribes who considered them interlopers.

The opportunity to own land nevertheless lured disenchanted gold miners, former Hudson's Bay Company employees – including a large number of Hawaiians – and free African-Americans who came from San Francisco in search of equal treatment. Other

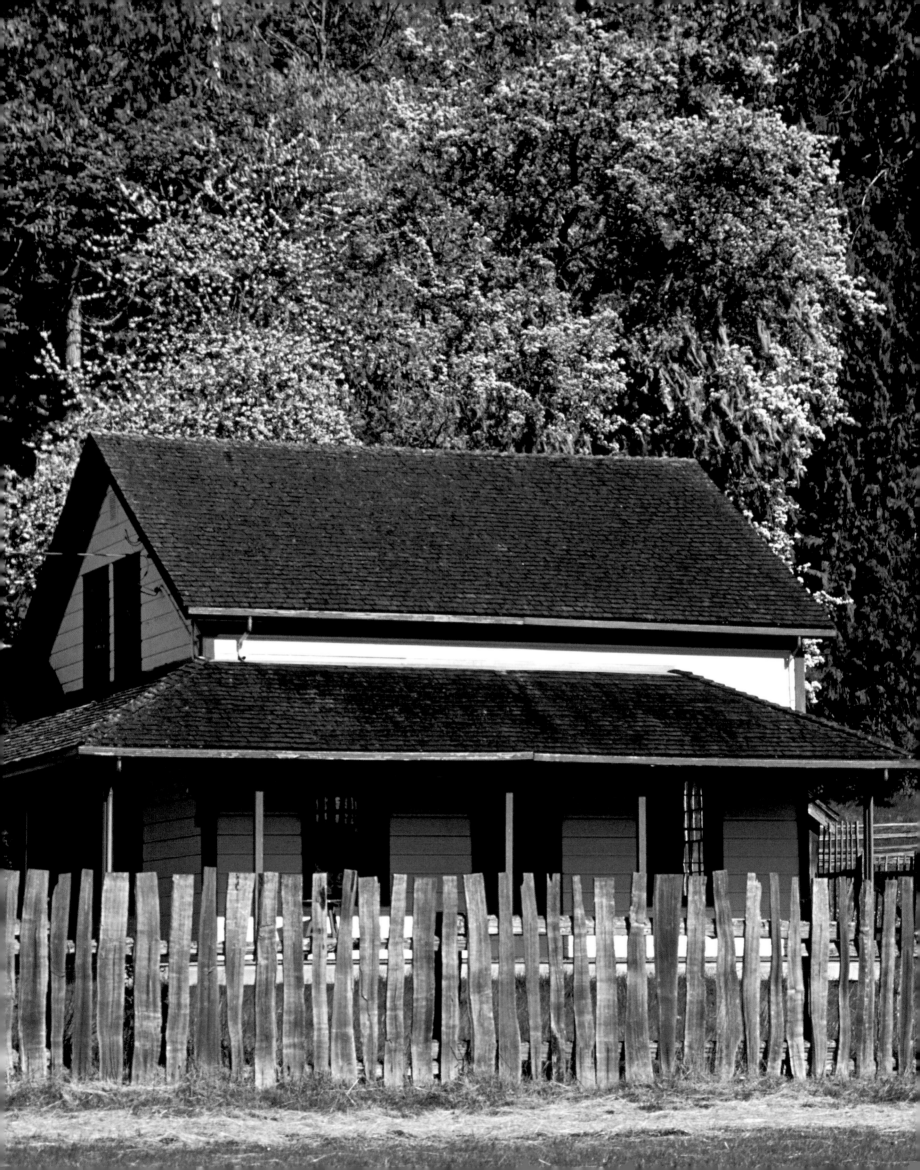

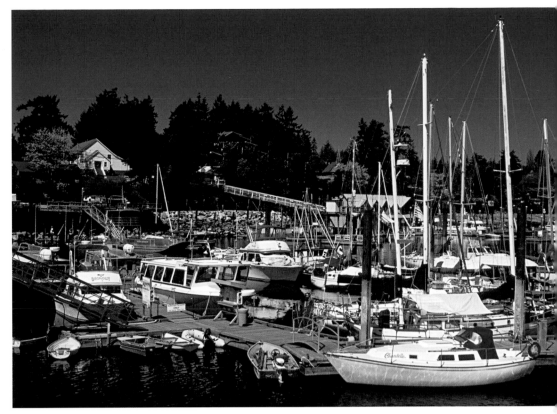

emigrants from the British Isles and from Japan soon followed. Some 450 settlers had arrived by 1895, most of them fiercely self-reliant, independent types quick to voice strong opinions – traits that many say still characterize Salt Spring islanders, who nurture good-natured rivalries between the different sections of their isle. The various groups gathered in churches and community halls still visible along the bucolic country roads. Catholics constructed the tiny stone sanctuary of St. Paul's in 1881. Burgoyne United Church, with its gothic windows and small steeple, went up in 1887 to accommodate worshipers of many different Protestant denominations. Two years later the Anglicans conse-crated sturdy St. Mary's, whose gated garden is carpeted with delicate white fawn lilies in the spring.

Looming above the town are the rocky heights of 1,985-foot Mount Maxwell. A narrow, twisting, and seemingly never-ending road leads up to a stunning viewpoint: To the west lies Vancouver Island's shore, while far to the south the San Juan Islands look like stepping stones across the Strait of Juan de Fuca. Closer at hand the Fulford Valley unrolls in a patchwork of green fields.

Throughout the last century, Salt Spring Island was known for its orchards, dairies, and sheep. Its very first family farm is still in operation, though most of the surrounding estate has been turned into a park. Visitors

may camp or hike the trails, while the homestead and outbuildings offer a glimpse of what the place looked like soon after Henry Ruckle arrived in 1872. Turkeys wander past his hand-hewn log forge. There's a pigsty and barn, the original one-and-a-half story farmhouse he built for his family a few years later, and a green-and-brown Queen Anne-style residence that a Ruckle grandson constructed for his fiancée in 1908 – though the couple never married.

Today the island's agricultural traditions live on in sheep and organic farms, cheese-making ventures, and wineries, which reflect, in part, the interests and lifestyle of the most recent arrivals. Since the 1960s, artists have flocked to Salt Spring, along with a few draft evaders from the Vietnam War. Fulford Village particularly prides itself on its laid-back hippie atmosphere. Signs for astrology and tarot readings liven its tiny crossroads, along with a free-trade coffee house and a fiber-arts boutique. Down virtually every lane on Salt Spring are studios and galleries displaying every kind of art and craft: ceramics and textile arts, woodworking and jewelry, painting and sculpture, glass and photography.

Some of those wares, along with produce and food, go on display every Saturday in the summer at the Ganges farmers' market, where the motto is "make it, bake it, grow it," and pretty much everyone turns out to enjoy it.

The gardens at Hastings House (opposite) *light up with spring bulbs and flowering trees. Built in the 1930s to match the owner's English estate, the property is now run as a country-style hotel. White fawn lilies are a rarer sign of the season in the churchyard at St. Mary's* (above left)*, established in 1889. Above:* Vessels of all shapes and sizes find a mooring in busy Ganges Harbour, a destination for day-trippers and a business hub for local residents.

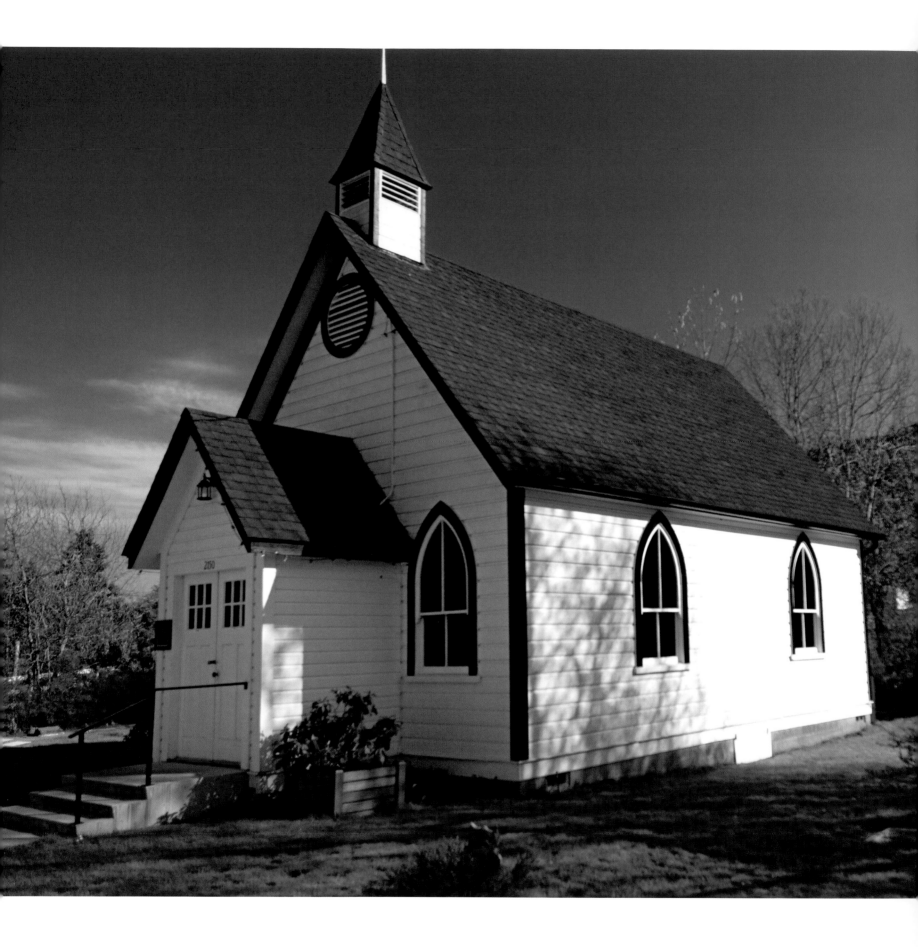

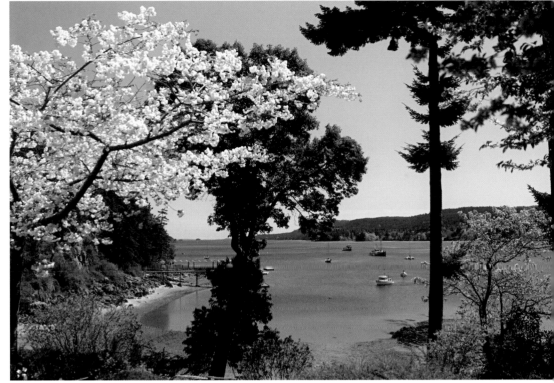

A place of country roads and quiet views, Ganges rewards visitors who venture beyond the main town. Near a bay on the island's west coast, Burgoyne United Church (far left) has welcomed Protestant worshipers since 1887. Ruckle Park's trails (left) lead to ponds and pebbled beaches. The view from a resort takes in a serene corner of Ganges Harbour (above).

Ladysmith & Chemainus

When it comes to displays of public art, Ladysmith takes an idiosyncratic approach, including among its "sculptures" a ship anchor, a "steam donkey" engine, and an ore car, as well as a montage of gears, chains, and tools. The pieces are a proud acknowledgment of the town's industrial heritage as well as artsy civic decoration.

Of course, Ladysmith also has an idiosyncratic history. It was founded by coal baron James Dunsmuir as a community for the miners who would work in his new Extension Mine. The coal from Dunsmuir's previous enterprises had been shipped from wharves in Nanaimo some 14 miles north, but a dispute over a railroad right of way prompted the tough businessman to create a new shipping port on the east coast of Vancouver Island in 1898, at a protected inlet then

called Oyster Harbor. He encouraged the miners to move nearby, and they responded by dismantling their small frame cottages, loading them onto railroad cars, and transferring them to the hill above the waterfront. Within a year the coal they mined was being shipped out from Dunsmuir's new port.

In naming his town, the patriotic Dunsmuir took inspiration from the Boer War in South Africa, where the four-month siege of Ladysmith was finally lifted in 1900. He continued the theme by naming streets after the generals.

Gradually Ladysmith's population grew to almost 5,000, with thriving businesses that ranged from a drugstore and a livery stable to cafés and bars. There were nineteen hostelries and boarding houses, including one called the Temperance Hotel, whose proprietor indeed

First Avenue façades: Ladysmith's row of sturdy turn-of-the-century buildings (opposite) *gets its moment in the sun. When the Island Hotel was built in 1900, it was one of 19 boarding houses and inns that served the coal-mining town of 5,000. At the marina, boat "garages"* (above) *provide shelter for the many pleasure craft that ply the waters around the 49th Parallel.*

served no liquor and would rent rooms only to miners. Why? Presumably her boarders cleaned up daily at the mine, allowing the hotel's sheets and towels to be washed less frequently.

A short-lived gold rush took place in 1908 outside another hotel, when someone found some promising-looking dust in the street. Citizens hurried to dig up their fortunes, only to discover that the gold had washed out from the building's barroom, where the mirrors were being gilded.

Ladysmith's colorful turn-of-the-century main street recalls those days, though the storefronts now cater to a contemporary – and undoubtedly more well-scrubbed – clientele who enjoy the bakeries, restaurants, and galleries. The solid stone former post office offers antiques and collectibles. And the original miners' dwellings, frequently enlarged and modernized, still dot the residential neighborhoods.

Life here wasn't always so easygoing, however. In 1909 an explosion at the Extension Mine killed 32 men, intensifying the workers' demands for better conditions and spurring their attempts to organize a union. Three years later their efforts culminated in a long, bitter, and violent strike that brought out the militia to restore order. The onset of the First World War in 1914 ended the work stoppage, and coal mining continued throughout the 1920s until falling

demand and the Great Depression ultimately closed the Extension Mine in 1931.

It was a windfall, literally, that rescued Ladysmith's economy. In 1933 a powerful storm toppled thousand of trees in the nearby hills. The logs were sold to a lumber company, and a new local industry was born, with several sawmills in town and room for the log booms in the harbor. The lumber business has greatly shrunk in recent years, but its traditions live on in annual celebrations at Transfer Beach Park, where two towering poles stand ever ready for lumberjack climbing competitions and a pool is on hand for log-rolling contests.

The park shows off Ladysmith's waterside charms, which increasingly beckon visitors to explore the area's inlets, coves, and tiny islands by boat, kayak, or perhaps aboard one of the Maritime Society's restored wooden vessels. The rewards are sightings of seals in the water and starfish clinging to rocks near shore, as well as myriad birds, from rare purple martins to plentiful bald eagles watching for prey from treetop perches.

If you follow the shoreline south a half-dozen miles, you arrive in little Chemainus, which got its start with a water-powered sawmill in 1862 and lived by logging and lumber for more than a century. In 1982, when the mill announced it would shut its doors, the community responded with artistic imagination. Spearheaded by local businessman Karl Schutz, a volunteer group com-

A couple of jaunty cottages on Roberts Street (above left) *in Ladysmith find new uses for old architecture – including serving pizza in an actual parlor. In Chemainus* (opposite), *the Anglican church carries on in traditional style. Above:* Larger than life, Billy Thomas, *the work of muralist Sandy Clark in 1984, depicting the first white male born in Chemainus, gazes out on Willow Street.*

The domed Chemainus Theatre (right) presents a year-round festival of dramatic offerings, but the town's best-known art form is undoubtedly its murals, which depict local history. The Telephone Exchange (above), painted by Cim MacDonald in 1992, remembers the operators and their office. Below: Stefan Junemann puts finishing touches on Emily's Beloved Trees.

missioned outdoor murals to depict vignettes from the town's past, beginning with an illustration of a steam donkey engine hauling logs from the forest. Since then, some 40 large-scale paintings have been added to walls all over town, including striking images of the area's First Nations tribes, 19th-century scenes, depictions of Chemainus's early settlers, and images of bygone pastimes, among many others. Some murals are connected to their locations, like the Letters from the Front mural on the side of the town's post office; others commemorate memorable characters, such as Chinese merchant Hong Hing, who ran a general store.

The most recently completed mural, on the side of the Chemainus Theatre, pays homage to Canadian artist Emily Carr with a trompe l'œil mural of five of her forest paintings in a gallery setting. Called Emily's Beloved Trees, the mural also subtly evokes the timber that sustained Chemainus for years. But the scene is so real – with painted steps leading into the exhibit – it seems the viewer could actually walk into the picture, forever fusing art and daily life.

Nelson & Kaslo

*Forever anchored on terra firma,
the S. S.* Nasookin *(opposite) – the
largest Canadian Pacific Railway
sternwheeler ever to haul passengers
and cargo on Kootenay Lake – now
stands out as an unusual private
residence just east of Nelson.
The lakeside town sprang up after
silver was discovered in the late
1800s and later prospered when the
railroad company laid tracks here
to transport ore received from
outlying camps around the lake.
Today, scenic hilly Nelson (above)
is a regional administrative center
with an easygoing lifestyle and a
penchant for the arts.*

All through the British Columbia summer, the open-air cafés of Baker Street throng with people eating, drinking, and schmoozing. Tourists mingle with residents; the youthful energy of the artists and students contrasts with the staid stone buildings of Nelson's downtown. In this isolated spot amid the Selkirk Mountains, halfway between Calgary and Vancouver, Nelson has managed to become a regional center, as well as a magnet for those with their own way of looking at the world.

Centuries ago, however, it was simply isolated. First Nations groups survived by hunting in the forests and fishing in Kootenay Lake, whose waters stretch 170 miles in an upside-down "Y." In the mid-1800s gold strikes to the east and west lured prospectors who set up camps in the surrounding granite peaks. Then in 1886 two brothers found the lucrative Silver King mine nearby. Before long the railroad claimed the land near the lake and began hauling ore to a smelter while town lots were sold.

Nelson, named for British Columbia's lieutenant governor, was incorporated in 1897. Within a year, the Hume brothers had opened a gabled and turreted grand hotel. City fathers showed off their boomtown's prosperity by commissioning a customs house and post office built in pink brick and marble. They followed that with a granite chateau of a courthouse, designed by no lesser an architect than Francis Rattenbury, famed for his Parliament Buildings in Victoria. The venerable edifices stand kitty-corner from each other. The post office is now home to the Touchstone Museum, which recounts Nelson's history in its innovative galleries.

As the town grew, real estate speculators turned their attention up the hill to Baker Street, where fire regulations ensured that buildings went up in brick or stone. Nevertheless, two earlier wooden structures remain, colorfully painted to complement their Victorian style. They have plenty of distinguished competition on the

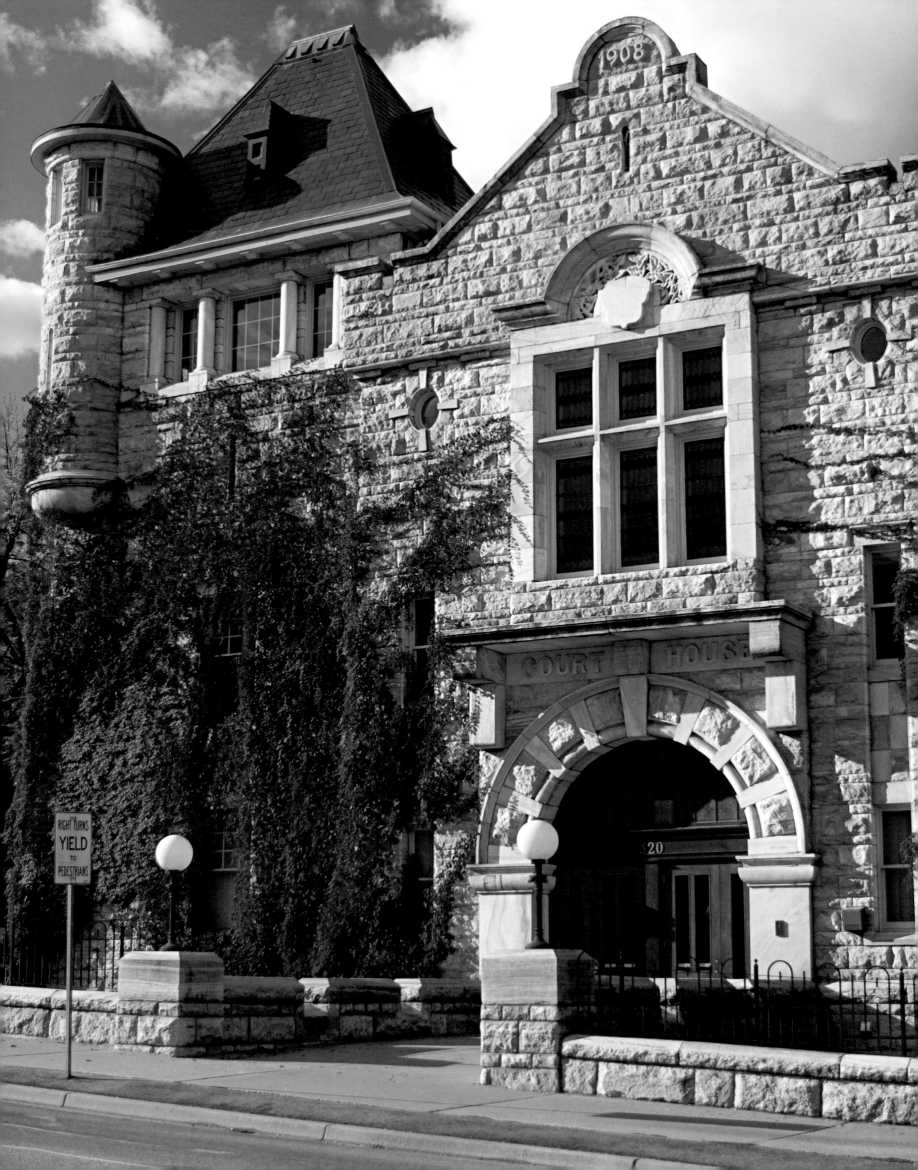

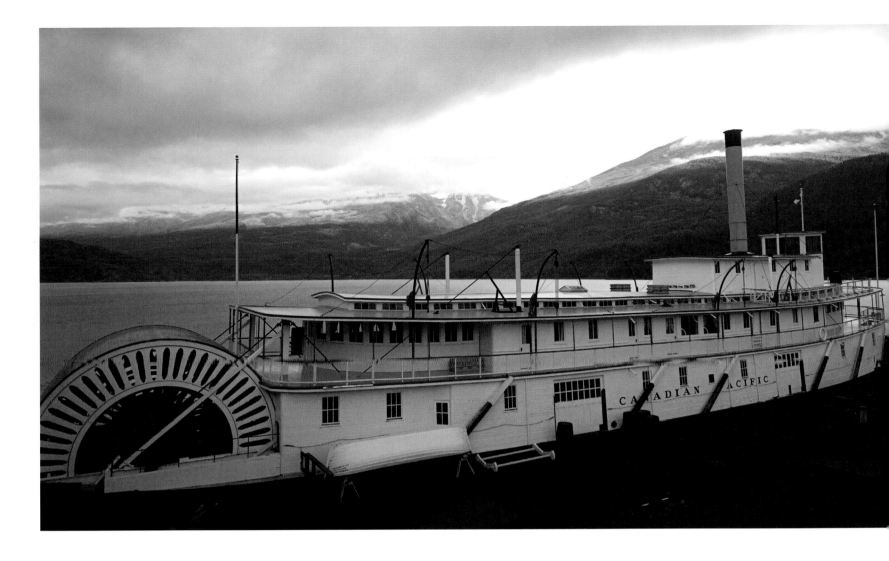

heritage front: the stone-and-brick Bank of Montreal, also designed by Rattenbury, a commercial block with a prominent corner turret, and another Rattenbury building constructed for a meat purveyor, with a cow's head above the portal, to list a few. All along Baker Street stand masterpieces of 19th-century architecture – with elaborate cornices, ornamental window treatments, and fanciful façades – that now house bustling boutiques, hip restaurants, galleries, and other shops.

Other interesting structures dot the town, which has hillside streets named Silica, Carbonate, and Mill, just in case you forget what industry was paramount here when the place was platted. The Capitol Theater, built in 1927, is a tiny Art Deco gem, lovingly restored and used for live performances, while the Nelson Firehall, built in 1912, has a copper cupola on its hose-drying tower. Like many Nelson landmarks, it had a cameo appearance in *Roxanne*, the updated movie version of *Cyrano de Bergerac* that was filmed in town.

Over the decades, the local economy gradually shifted away from mining. In the early 20th century fruit orchards thrived, only to collapse due to disease, overproduction, and high shipping costs. After the Second World War, lumber was the main industry, but the last large mill closed in 1984. By then most

of the town's glorious old buildings were covered by modern façades.

In the 1960s, draft resisters from the United States discovered Nelson. Artists drifted in, too, establishing a school that is now part of Selkirk College. Finally, a revitalization movement began to restore the town's architecture and develop its reputation for arts and crafts. New Age enthusiasts arrived, along with visitors and residents who savored the local energy and lifestyle. "I wish I'd come sooner," you'll hear them say.

Preservation took many forms. Streetcar enthusiasts discovered Tram #23 from 1906, which was serving as a chicken coop. With restored wooden benches, a refurbished exterior, and conductors in old-time uniforms, the streetcar now runs on a short scenic route, giving visitors a glimpse of the waterfront and a view of the bridge across Kootenay Lake.

From there, the road leads to the lakeside communities that were tied to the railroad depot in Nelson by steamboats, which regularly ferried people, mail, and ore. The little community of Kaslo, 30 miles north, rescued the S. S. *Moyie* – built in 1898 and now a National Historic Site – from the scrapheap after its last run in 1957. Today the vessel has been meticulously rebuilt down to its 17-foot stern paddle-wheel. The

A monumental house of the law, the Nelson Courthouse (opposite) combines chateau-style details with impressive granite. Francis Rattenbury, the noted architect behind Victoria's Parliament Buildings, also left his mark on several other edifices on Baker Street. Community spirit in Kaslo saved the S. S. Moyie (above), which steamed around Lake Kootenay from 1898 to 1957. Today the boat, with its intact salons, cabins, and stern paddle wheel, has been refurbished as a museum.

Tranquil B Street (opposite) *in Kaslo bursts with spots of color both manmade and natural. Almost deserted before the Second World War, the lakeside community now plays host to vacationers in summer. The Landmark Bakery on Front Street opens its arms to pastry fans all year round* (above).

Ladies' Saloon again boasts red-velvet seats and a flowered carpet, while the dining room, with its intricate parquet floor and gold-leaf stenciling on the walls, is set for an elegant dinner. Turn-of-the-century clothes are laid out on beds in the staterooms, and up in the Pilot House, where the windows frame a gorgeous panorama of water and mountains, children can sound the whistle by pulling a wooden handle.

Kaslo's industry actually began with a sawmill in 1889, but the town soon turned to mining and shipping silver ore. At first the community thrived, with 20 hotels and saloons and a bank that supported the district's many mines. But the silver panic of 1893 reduced the town to less than 1,000 people, and a quick trio of disasters – fire, hurricane, and flood – decimated the place, which somehow managed to hang on.

The Village Hall, from 1898, is one survivor. It's a wonderful white clapboard building, topped by a large open bell tower, with a double staircase curving down from its columned entry. A block away, the restored cream-colored false-front of the Langham Cultural

Centre harkens back its beginnings as a three-story hotel in 1893. Front Street has pretty turn-of-the-century façades, while quiet residential lanes are dotted with Queen Anne houses and quaint cottages.

By the start of the Second World War, Kaslo was considered a ghost community, empty enough to house a large contingent of Japanese-Canadian internees, who were crowded into the Langham and more than a dozen other locations. The bittersweet stories of those years – the community welcomed the newcomers, many of whom have fond memories of growing up there, despite the humiliation and hardship of internment – is recalled in displays at the cultural center.

A ghost town no longer, Kaslo today makes its living from timber and tourism, especially in the summer, when jazz fans pour in for a rollicking waterside festival. After the music dies down, though, the quiet returns, broken only by the *Moyie*'s whistle, summoning the shades of the past.

Revelstoke

Shadowed by Mount Revelstoke, Mackenzie Avenue (opposite) has been home to the Upper Town's businesses since early in the 20th century. A hardware store once occupied the building with the green-topped columns. Its Art Deco façade was added when the structure became a movie theater, as it is today. Farther up the street, the Classical Revival façade with its quartet of upstanding columns (above) was built in 1911 to house the Bank of Commerce.

The winding road that climbs to the summit of Mount Revelstoke passes through a rainforest of cedars and hemlock, enters a snow forest of spruce and fir, and finally arrives in a sub-alpine meadow where crimson Indian paintbrush, purple daisies, and pink pussytoes bloom in a great rush during the brief Canadian summer. Rising some 6,360 feet, this mountain was declared a national park in 1914, and its hiking trails lead out to viewpoints where you can look over to higher peaks: the rocky top of 8,058-foot-high Mount Mackenzie, or Mount Begbie with its distinctive triple pinnacles and double glaciers. Far below, the town of Revelstoke hugs a jog in the Columbia River, now tamed by dams and barely recognizable as the giant western waterway that pours into the Pacific a thousand miles away.

In the early 1800s – after explorer David Thompson finally traced its confusing hairpin course – the Columbia provided the best route to the coast, though the river was only navigable a few months of the year and fraught with rapids the rest of the time. Despite those difficulties, prospectors from the United States boarded paddle-wheelers to make the trip to the gold fields during a short-lived rush in 1865–66.

Things would change when Canada extended its confederation to the western colonies. British Columbia's condition for joining the union in 1871 was a railroad that spanned the country from the Atlantic to the Pacific. For more than a decade engineers evaluated routes, as the Canadian Pacific Railway (CPR) sought the shortest, southernmost path. They decided that the line would have to cross the Selkirk Mountains, which received

40 feet of avalanche-prone snow each winter. In 1881 Major A. B. Rogers finally surveyed the pass that, as the railway had promised, would be named for him.

Laying the tracks through tunnels and across gorges was a formidable engineering feat, which concluded on November 7, 1885, with the driving of Canada's Last Spike at Craigellachie, just 28 miles west of Revelstoke. Photos of that event, CPR artifacts, and tales of colorful characters are all part of the Revelstoke Railway Museum, designed to resemble a railroad backshop, complete with a powerful Mikado locomotive, other rolling stock, and a host of graphic exhibits.

Before the tracks were finished, however, Arthur Stanhope Farwell, an enterprising former surveyor, claimed more than 1,000 acres of land along the Columbia, where he guessed the railway would bridge the river. He platted a town there in 1884 and attracted general stores, a bakery, a barbershop, and a variety of saloons. Indeed, the CPR did have to cross Farwell's land, and it paid him for the privilege, but the railroad blocked the entrepreneur's real estate aspirations and set up its depot and building a mile east of his settlement. After several years of legal wrangling, banks and businesses saw where the future lay and moved closer to the depot. When England's Lord Revelstoke rescued the

A local – and heritage – landmark, the copper-domed, granite-and-brick Revelstoke Courthouse (right) *was designed by Thomas Hooper in 1912. The solid marble pillars came from Georgia.* Above: *On a nearby street, turn-of-the-century residences also sport a bit of decoration.*

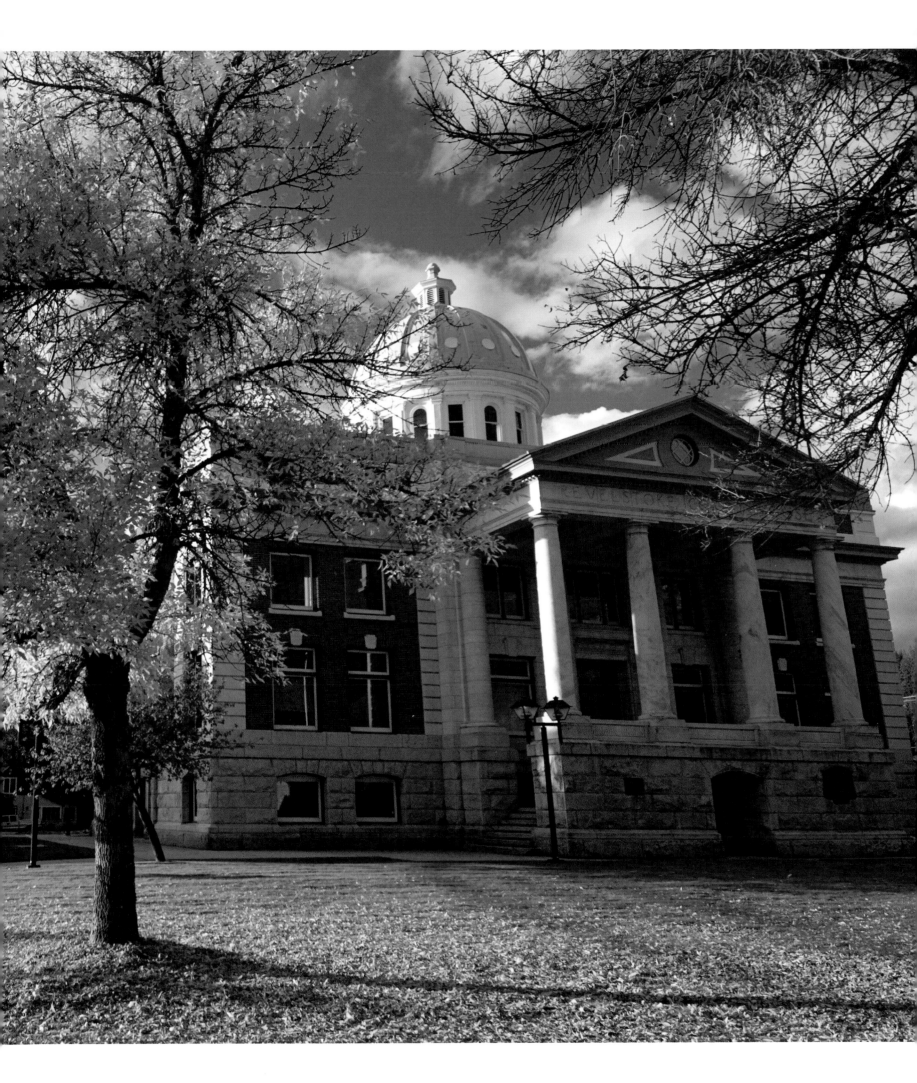

Gingerbread gone wild: Everything that can be trimmed is trimmed in the Queen Anne house built by Charles and Lyda Holten in 1897 (opposite), *close to Revelstoke's original Lower Town neighborhood. Now a bed-and-breakfast inn, the home's interior* (above right) *retains Victorian details of architecture and furnishings.* Above: *Marshlands border the mighty Columbia River, which keeps a low profile as it eases past Revelstoke.*

CPR from bankruptcy, the burgeoning railroad town was named for him.

Today Farwell's failed village has been absorbed into Revelstoke, forming part of the neighborhood around Front Street called Lower Town. The heart of downtown beats along Mackenzie Avenue, graced by a line of refurbished historical façades that date to the early 20th century. It's a lively, lived-in village center. The smell of popcorn emanates from the Roxy, which began life as a hardware store in 1905 and later was renovated as an Art Deco-style movie theater that continues to pull in patrons. Down the block a green-and-white façade denotes the Modern Bakery, the present-day successor to a shop that has been turning out pastries since 1903. One-time banks have the most ornate edifices, featuring classical columns or Beaux-Arts details. A few blocks west, the imposing brick former post office is home to Revelstoke's Museum and Archives, displaying a mind-boggling repository of town memorabilia, including instruments from the local band (founded 1892), steamship models, ladies' accessories, and even chocolate molds from Manning's Ice Cream and Candy Store, which gave employment to local teenagers for decades.

Revelstoke's grandest public building is its courthouse, built in 1912 at the edge of Lower Town, with solid Georgia marble columns in front and a copper-covered dome crowned by a lantern. Not far away is the Queen Anne residence of Charles Holten, a brewery

owner who brought a craftsman from Sweden to fashion its gingerbread decorations.

Most of the town's early civic leaders – the mayor, the railway superintendent, and other wealthy businessmen – chose to live at the far end of Mackenzie Avenue. Their gracious homes – such as the 1905 mansion built by a prosperous hardware-store owner on an entire city block and now a bed-and-breakfast – add elegant touches to the neighborhood. Working-class families favored the Selkirk District a few blocks east, where their modest cottages, detailed with porches and dormers, are also prized by preservationists.

The railroad – and a longtime lumber industry – sustained the town throughout the 20th century. By the time passenger train service was discontinued, the Trans-Canada Highway was bringing a new group of travelers, who discovered the area's outdoor offerings.

In summer, visitors can spend daylight hours glacier hiking, mountain biking, and river rafting, then join the locals at Grizzly Plaza, a popular gathering spot at the top of Mackenzie Avenue, for evening concerts in the gazebo.

In winter, though, it's all about snow: heli-skiing, cat-skiing, snowmobiling, and back-country ski touring. Winter sports aficionados praise the world-class slopes and snowboard terrain on Mount Mackenzie. In an ironic twist of fate, the annual 40 feet of snow that once gave headaches to 19th-century engineers makes 21st-century adventurers jump for joy.

Whistler

At seven in the evening on a spring day in Whistler, the tops of the snow-covered peaks are illuminated in pink-gold light, even as the village plaza, with its busy open-air cafés and bars, has receded into shadow. Take it as a subtle reminder that although this resort town has great charm and vitality, it's the mountains that are the starring attraction.

As well they should be, since the setting is simply stunning, especially if you ride the gondola up Whistler Mountain, where you'll see the zig-zag outlines of British Columbia's Coast Range extending in every direction like an unending field of meringue. Closer at hand are enough runs, bowls, and terrain to keep skiers and snowboarders happy winter after winter: 8,171 acres, the largest skiable area in North America. There isn't just one mountain to play on, but two: 7,160-foot-high Whistler is linked to 7,494-foot Blackcomb by a state-of-the-art peak-to-peak gondola that offers an eagle's-eye view of skiers and boarders carving their way through the snow (and occasionally a glimpse of four-legged wildlife, too).

Winter sports fans around the world got a close look at Whistler during the 2010 Winter Olympics and Paralympic Games, when it hosted the Alpine skiing,

Nordic, and sliding events. The resort's role in those competitions was the culmination of a dream for the entrepreneurs who opened the first ski lift on Whistler (then called London Mountain) in February 1966, and who tried five times to win the Olympic nod before the bid succeeded.

It's ironic, then, that the town actually had its beginnings as a summer resort, a rustic getaway for fishermen and their families. In 1911 this place was known as Alta Lake, and it was a remote, rugged valley on an old trading trail. When Alex and Myrtle Philips, who had moved to the Pacific coast from Maine, heard about Alta Lake, they were intrigued and embarked on a steamer trip from Vancouver to Squamish, then hired pack horses for a two-day hike into the wilderness. They liked the area so much that they bought land on the lake and by 1914 had opened Rainbow Lodge with just four bedrooms. Before long, the arrival of the railway made travel to Alta Lake less of an adventure. Rainbow Lodge expanded, adding cabins to accommodate a hundred guests, and other small resorts sprang up as well. Still, "rustic" remained the watchword, with no electricity, no water, and few other services. The landscape – and the biting fish – made up for the lack of amenities.

A rustic covered bridge over Fitzsimmons Creek (opposite) *connects Whistler's main and upper villages for visitors on foot. A gondola is needed, however, to get up Whistler Mountain, where Inuksuk* (above)*, the stone mascot of the 2010 Winter Olympics – with roots in Inuit lore – seems to embrace the spectacular surrounding peaks. To get back down, skis and snowboards are the method of choice.*

In the early 1960s a group of Vancouver businessmen had a different idea: Why not develop a ski resort? They concentrated on the south side of the mountain, which became today's Creekside area, and changed the name of the mountain to Whistler – recalling the sounds made by ever-present hoary marmots. Within a few years skiers were spreading the word about the mountain's miles and miles of uncrowded powder.

Among the first arrivals were a boisterous group of ski bums and flower children who lent a countercultural air to the community even as it grew into a serious resort. There were tales of unending parties and hijinks, such as those on St. Patrick's Day, when skiers spray-painted themselves green and glided down the mountain wearing nothing but skis.

By the mid-1970s Whistler's unbridled growth caught the attention of the provincial government, which created a resort municipality to install some political order just as adjacent Blackcomb was being developed. The new town fathers found a site for their

soon-to-be-built town center but rejected initial plans for a high-rise urban community. They pushed instead for a low-rise, pedestrian village with walkways that flowed like a river through plazas, past shops and hotels and that opened to views of the magnificent mountains.

In the decades since, Blackcomb and Whistler have been combined into a single resort, and lifts, gondolas, and tube and terrain parks have been added and expanded. Fine restaurants and upscale shops and hotels welcome leisure travelers, while the original ski bums have become artists, businessmen, and politicians. But the atmosphere remains youthful and energetic, with an international contingent of snow-sports enthusiasts in winter and mountain-bike adventurers in summer. It's not uncommon to meet a young woman who heads for one of the peaks with her snowboard first thing in the morning, then rides down the mountain to her office job. At the day's end, the skiers and boarders in their goofy hats and stiff boots gather in the village square and the bars at the lift base to toast another good day on the slopes.

Après-ski, Whistler's town plaza (below) glitters with possibilities for dining, drinking, or shopping. When the ski town was organized in the 1970s, residents rejected an urban design in favor of a low-rise streetscape that preserved mountain views. Pedestrian pathways like the "village stroll" (opposite top) border water features and include spots to sit and savor the scene.

Whistler's story – from pioneer outpost to Olympic venue – is illustrated in its recently renovated museum, which displays photos and artifacts from the early years alongside videos of some of the town's legendary characters.

It's worth remembering, though, that the First Nations were here before everyone else. Whistler was historically a meeting ground for the Squamish and Lil'wat peoples, whose traditional lands extended coastward and inland. The carved cedar doors of their stunning new joint cultural center now swing open to showcase the arts, crafts, and worldview of these two tribes. Magnificent cedar canoes are on display, along with woven hangings, intricate baskets, and songs and sayings that illustrate their traditional way of life, with its reverence for the natural world. To underscore that point, the center's long curving glass wall directs your gaze to the mountains, rising above the town in all their awesome glory.

With raised arms, a carved cedar figure (left) *signals a welcome to the Squamish Lil'wat Cultural Centre, which celebrates the heritages of the two First Nations tribes who traditionally shared the lands around Whistler. Inside, exhibits showcase not only their artifacts but also their coastal and inland ways of life.*

Powder perfect: The runs, bowls, and amphitheaters of Whistler (right) embrace a dazzling variety of mountain terrain — more than 8,000 acres, including Blackcomb, just a peak-to-peak gondola ride away. Snow blankets the topmost ridges all year long, but warm weather turns the grass green at Nicklaus North Golf Course (above), bringing out another contingent of sports fans.

Places to Stay and Eat

OREGON

For more information, Travel Oregon, 800-547-7842, www.traveloregon.com.

ALBANY & BROWNSVILLE

For more information, Albany Visitors Association, P.O. Box 965, 250 Broadalbin Street, SW, #110, Albany, OR 97321, 541-928-0911, or 800-526-2256, www.albanyvisitors.com.

Hotels:
The Pfeiffer Cottage Inn, 541-971-9557, www. ThePfeifferCottageInn.com. Charming bed-and-breakfast accommodations in a 1908 Craftsman-style bungalow in the Monteith Historic District.

Restaurants:
Clemenza's, 541-926-3353. Pasta and other Italian dishes in an upscale café on First Avenue.
Depot Restaurant, 541-926-7326. Seafood specialties in a casually atmospheric café.
Sybaris, 541-928-8157. Fine, creative Northwest cuisine in one of historic Albany's earliest commercial buildings.
Wine Depot and Deli, 541-967-9499. Fresh sandwiches and salads for lunch.

ASHLAND

For more information, Ashland Chamber of Commerce, 110 East Main Street, P.O. Box 1360, Ashland, OR 97520, 541-482-3486, www.ashlandchamber.com.

Oregon Shakespeare Festival, P.O. Box 158, 15 South Pioneer Street, Ashland, OR 97520, 541-482-2111, or 800-219-8161, www.osfashland.org

Hotels:
Albion Inn, 541-488-3905, or 888-246-8310, www.albion-inn.com. Five rooms in an art-filled Craftsman-style home with a garden near downtown.
Ashland Mountain House, 541-482-9296, or 866-899-2744, www.ashlandmountain house.com. Luxurious bed-and-breakfast in a meticulously restored historic stage stop ten minutes from Ashland.

Ashland Springs Hotel, 541-488-1700, or 888-795-4545, www.ashlandspringshotel. com. Elegant 1920s hotel on Main Street.
Mt. Ashland Inn, 541-482-8707, or 800-830-8707, www.mtashlandinn.com. Rustically romantic log bed-and-breakfast lodge near the Mt. Ashland Ski Area.
The Peerless, 541-488-1082, or 800-460-8758, www.peerlesshotel.com. Individually decorated accommodations in a turn-of-the-century hostelry in the Railroad District.
The McCall House Bed & Breakfast, 541-482-9296, or 800-808-9749, www.mccallhouse.com. Ten rooms in an 1883 Italianate mansion that was once home to a prospector who became mayor of Ashland.

Restaurants:
Alex's Plaza Restaurant & Bar, 541-482-8818. Casual dining, sometimes with music, in a historic building overlooking the Plaza.
Beasy's on the Creek, 541-488-5009. Steaks, seafood, and pasta with a valley view.
Chateaulin Restaurant and Wine Shop, 541-482-2264. Fine French dining on Main Street.
Lark's, 541-488-5558. Northwest cuisine in a simple and elegant room at the Ashland Springs Hotel.
Lela's Café, 541-482-1702. Upscale bistro with hints of Asian fusion flavors in the Railroad District.
Liquid Assets Wine Bar, 541-482-9463. Wine bar with small plates and sophisticated decor.
Peerless Hotel Restaurant and Bar, 541-488-6067. Fine Northwest dishes in a cottage next to the historic hotel in the Railroad District.
Standing Stone Brewery, 541-482-2448. Pizzas, salads, and small plates with handcrafted beer in the atmospherically renovated Whittle Garage.

ASTORIA

For more information, Astoria Warrenton Chamber of Commerce, 111 W. Marine Drive, P.O. Box 176, Astoria, OR 97103, 503-325-6311, or 800-875-6807, www.oldoregon.com.

Hotels:
Cannery Pier Hotel, 503-325-4996, or 888-325-4996, www.cannerypierhotel.com.

Stunning luxury riverfront hotel on the site of the old Union cannery.
Hotel Elliott, 503-325-2222, or 877-378-1924, www.hotelelliott.com. Sophisticated rooms and suites in a beautifully renovated historic downtown hostelry.

Restaurants:
Bridgewater Bistro, 503-325-6777. Eclectic menu in a contemporary setting with a river view.
Clemente's, 503-325-1067. Seafood in a sleek downtown space.
Drina Daisy, 503-338-2912. Superb and generous Bosnian dishes in an Old World-style dining room.
Gunderson's Cannery Café and Lounge, 503-325-8642. Fish and pasta specialties in part of a former cannery building.
Silver Salmon Grille, 503-338-6640. Northwest seafood in an atmospheric room.

BAKER CITY

For more information, Baker County Chamber of Commerce and Visitors Bureau, 490 Campbell Street, Baker City, OR 97814, 541-523-5855, or 800-523-1235, www.visitbaker.com.

Hotels:
Best Western Sunridge Inn, 541-523-6444, www.bestwesternoregon.com/hotels/best-western-sunridge. Large, comfortable motel at the edge of Baker City's historic district.
Geiser Grand Hotel, 541-523-1889, or 888-434-7374, www.geisergrand.com. Meticulously renovated landmark hotel built in 1889.

Restaurants:
Baker Bistro, 541-523-9797. Casual eatery for breakfast and lunch.
Barley Brown's Brew Pub, 541-523-4266. Locals' favorite for burgers and locally brewed beer.
El Erradero, 541-523-2327. Well-prepared Mexican dishes.
The Palm Court, 541-523-1889. Fine dining in the Geiser Grand Hotel.

BANDON

For more information, Bandon Chamber of Commerce, 300 Second Street, Bandon, OR 97411, 541-347-9616, www.bandon.com.

Hotels:

Bandon Dunes Golf Resort, 541-347-4380, or 888-345-6008, www.bandondunesgolf.com. Rooms, suites, and cottages in an extensive resort with four oceanside links-style golf courses.

Bandon Inn, 541-347-4417, or 800-526-0209, www.bandoninn.com. Comfortable motel-style accommodations overlooking Old Town Bandon.

Best Western Inn at Face Rock Resort, 541-347-9441, or 800-638-3092, www.innatfacerock.com. Spacious rooms and suites across from the beach at Face Rock.

Restaurants:

Alloro Wine Bar & Restaurant, 541-347-1850. Creative Italian cuisine in a sophisticated setting in Old Town.

Bandon Coffee Café, 541-347-1144. Pastries and sandwiches in a locals' favorite gathering place.

Bandon Bill's Grill, 541-347-8151. Seafood, steaks, and casual fare with a water view near Face Rock.

Wheelhouse Restaurant, 541-347-9331. Seafood and steaks in an Old Town location with a view of the harbor.

CANNON BEACH

For more information, Cannon Beach Chamber and Information Center, P.O. Box 64, 207 N. Spruce, Cannon Beach, OR 97110, 503-436-2623, www.cannonbeach.org.

Hotels:

CB Hotel Lodgings, 503-436-1392, or 800-238-4107, www.cannonbeachhotellodgings.com. Several small inns near Haystack Rock.

Inn at Cannon Beach, 503-436-9085, or 800-321-6304, www.atcannonbeach.com. Comfortable lodge-style rooms near the beach.

Stephanie Inn, 503-436-2221, or 800-633-3466, www.stephanie-inn.com. Sedate, luxurious wood-and-stone inn overlooking the sand.

The Argonauta Inn, Waves Motel, and White Heron Lodge, 503-436-2205, or 800-822-2468, www.thewavesmotel.com. Oceanfront and oceanview rooms, suites, and houses in the heart of Cannon Beach.

The Ocean Lodge, 503-436-2241, or 888-777-4047, www.theoceanlodge.com. Friendly contemporary lodge facing the ocean.

Restaurants:

Bill's Tavern & Brewhouse, 503-436-2202. Locals' favorite for casual meals on the site of a longtime saloon.

Ecola Seafood, 503-436-9130. Fish market and seafood dishes.

Newman's at 988, 503-436-1151. Elegant French and Italian cuisine in a converted house.

The Bistro, 503-436-2661. Northwest dishes in a cozy restaurant with a garden setting.

The Warren House Pub, 503-436-1130. Oysters and pub dishes across from the beach south of downtown.

FLORENCE

For more information, Florence Area Chamber of Commerce, Visitor Information Center, 290 Hwy 101, Florence, OR 97439, 541-997-3128, www.FlorenceChamber.com.

Hotels:

Driftwood Shores Resort and Conference Center, 541-997-8263, or 800-422-5091, www.DriftwoodShores.com. Oceanfront motel-style rooms and suites.

Edwin K Bed & Breakfast, 541-997-8360, or 800-833-9465, www.edwink.com. Cozy six-room bed-and-breakfast in a 1914 Craftsman home in Old Town.

Heceta Lighthouse Bed & Breakfast, 541-547-3696, or 866-547-3696, www.HecetaLighthouse.com. Six atmospheric rooms in the Keeper's House at Heceta Head Light, with a seven-course breakfast.

The River House, 541-997-3933, or 888-824-2750, www.riverhouseflorence.com. Modern rooms and suites on the river at the edge of Old Town.

Restaurants:

Bliss' Hot Rod Grill, 541-997-6726. Casual fare in a retro-style diner that includes booths in convertibles.

Bridgewater Restaurant and Lounge, 541-997-9405. Seafood, burgers, and sandwiches in a historic turn-of-the-century mercantile building.

Crave's Fine Dining, 541-997-3284. Fine dining with eclectic menu at the edge of Old Town.

Mo's, 541-997-2185. Local waterfront institution for clam chowder and other seafood dishes.

Waterfront Depot Bar & Restaurant, 541-902-9100. Cozy, atmospheric bistro on the river, in a renovated train depot.

HOOD RIVER

For more information, Hood River Chamber of Commerce, 720 E. Port Marina Drive, Hood River, OR, 97031, 541-386-2000, or 800-366-3530, www.hoodriver.org.

Hotels:

Best Western Hood River Inn, 541-386-2200, or 800-828-7873, www.hoodriverinn.com. Modern accommodations on the Columbia riverfront.

Columbia Gorge Hotel, 541-386-5566, or 800-345-1921. www.columbiagorgehotel.com. Historic hotel overlooking the Columbia River on the edge of downtown.

Hood River Hotel, 541-386-1900, or 800-386-1859, www.hoodriverhotel.com. Boutique hotel in a historic building downtown.

Villa Columbia Bed & Breakfast, 541-386-6670, or 800-708-6217, www.villacolumbia.com. Five well-appointed guest rooms with river views.

Restaurants:

Celilo, 541-386-5710. Regional cuisine in an upscale setting.

Brian's Pourhouse, 541-387-4344. Lively spot for casually elegant meals.

Nora's Table, 541-387-4000. Global and Northwest specialties in an easygoing but sophisticated setting.

Sixth Street Bistro, 541-386-5737. Bistro cooking in an upscale cottage with a garden and loft.

Sophie's Restaurant, 541-386-1183. Fine dining off the beaten path.

Sushi Okalani, 541-386-7423. Locals' favorite for Japanese and other Asian cuisine.

3 Rivers Grill, 541-386-8833. Gourmet meals in a stylish house with a panoramic deck.

JACKSONVILLE

For more information, Jacksonville Chamber of Commerce, Visitor Information Center, P.O. Box 33, Jacksonville, OR 97530, 541-899-8118, www.jacksonvilleoregon.org

Hotels:

McCully House Inn, 541-899-2050, or 800-367-1942, www.mccullyhouseinn.com. Gracious accommodations in a restored 19th-century house.

Nunan Estate, 541-899-1890, www.nunanestate.com. Four Victorian rooms in an elaborate 1892 Queen Anne mansion and three modern accommodations in the carriage house on a huge estate at the edge of town.

The Jacksonville Inn, 541-899-1900, or 800-321-9344, www.jacksonvilleinn.com. Eight charming rooms in the historic 1861 downtown inn, plus four romantic cottages a block away.

TouVelle House Bed & Breakfast, 541-899-8938, or 800-846-8422, www.touvellehouse.com. Six spacious guest rooms in a 1916 Craftsman-style home.

Restaurants:

Bella Union Restaurant & Saloon, 541-899-1770. Casual fare in a lively spot on the main street.

Garden Bistro, 541-899-1942. Café-restaurant in a garden setting with an emphasis on local ingredients.

The Jacksonville Inn, 541-899-1900. Fine dining or bistro cuisine, with an extensive wine list, in a historic building.

JOSEPH

For more information, Wallowa County Chamber of Commerce, P.O. Box 427, Enterprise, OR 97828, 541-426-4622, or 800-585-4121, www.wallowacountychamber.com.

Hotels:

Belle Pepper's Bed & Breakfast, 541-432-0490, or 866-432-0490, www.bellepeppersbnb. com. Comfortable accommodations in the century-old McCully Mansion.

1910 Historic Enterprise House Bed & Breakfast, 541-426-4238, or 888-448-8825, www.enterprisehousebnb.com. Well-appointed rooms in an elegant 1910 house in Enterprise.

Wallowa Lake Lodge, 541-432-9821, www. wallowalakelodge.com. Historic lodge and cabins on Wallowa Lake.

Restaurants:

Caldera's, 541-432-0585. Gourmet meals in an artfully crafted dining room.

The Embers Brewhouse, 541-432-2739. Casual meals in a lively main street setting.

Old Town Café, 541-432-9898. Locals' favorite for breakfast and lunch.

Terminal Gravity Brewery, 541-426-3000. Outdoor dining in a well-known brewpub in Enterprise.

Vali's Alpine Restaurant, 541-432-5691. Central European specialties at Wallowa Lake.

McMINNVILLE

For more information, McMinnville Downtown Association, 105 NE Third Street, McMinnville, OR 97128, 503-472-3605, www.downtownmcminnville.com.

Hotels:

A' Tuscan Estate, 503-434-9016, or 800-441-2214, www.a-tuscanestate.com. Four beautifully appointed rooms in a 1920s home with gourmet breakfasts and dinners on request.

Baker Street Inn, 503-472-5575, or 800-870-5575, www.bakerstreetinn.com. Cozy accommodations in a Craftsman-style house.

McMenamins Hotel Oregon, 503-472-8427, or 888-472-8427, www.mcmenamins.com. Eclectic, lively art-filled European-style hotel in a historic property in the center of town.

The Pinot Quarters, 503-883-4115, www. pinotquarters.com. Guest suite in a 19th-century home.

Restaurants:

Bistro Maison, 503-474-1888. French dining in a 19th-century house.

Crescent Café, 503-435-2655. Well-prepared breakfasts and lunches on the main street.

Farm to Fork, 503-538-7970. Gourmet wine-paired dinners in Dundee.

Golden Valley Brewery & Restaurant, 503-472-

2739. Hamburgers, seafood, and casual fare in a brewpub setting.

La Rambla Restaurant & Bar, 503-435-2126. Tapas and other Spanish dishes in a sophisticated dining room.

McMenamins Hotel Oregon, 503-472-8427. Eclectic menu served in several atmospheric spaces including a rooftop bar.

Nick's Italian Café, 503-434-4471. Fine five-course meals with a Mediterranean emphasis.

WASHINGTON

For more information, Washington State Tourism, 800-544-1800, www.experiencewa.com.

COUPEVILLE

For more information, Central Whidbey Chamber of Commerce, 107 S. Main Street, Building E, P.O. Box 152, Coupeville, WA 98239-0152, 360-678-5434, www. centralwhidbeychamber.com.

Hotels:

Anchorage Inn Bed & Breakfast, 360-678-5581, or 877-230-1313, www.anchorage-inn.com. Replica Victorian with seven comfortable rooms.

Blue Goose Inn, 360-678-4284, or 877-678-4284, www.bluegooseinn.com. Two beautifully restored historic 19th-century homes make up a bed-and-breakfast with ten suites.

The Coupeville Inn, 360-678-6668, or 800-247-6162, www.thecoupevilleinn.com. Modern 26-room accommodations near the waterfront.

Restaurants:

Kim's Café, 360-678-4924. Vietnamese dishes, burgers, and sandwiches on the town wharf.

Mosquito Fleet Chili, 360-678-2900. Cozy lunch place for soups and chili on the water side of Front Street.

The Cove Thai Cuisine, 360-678-6963. Asian cooking in a converted gingerbread-trimmed 1889 residence.

The Oystercatcher, 360-678-0683. Casually elegant cuisine with an emphasis on Whidbey Island ingredients.

Toby's, 360-678-4222. Locals' tavern in an atmospheric 1890 mercantile building, with Penn Cove mussels specialties.

ELLENSBURG

For more information, Ellensburg Chamber of Commerce, 609 Main Street, Ellensburg, WA 98926, 509-925-2002, or 888-925-2204, www.visitellen.com.

Hotels:

Best Western Lincoln Inn, 509-925-4244, or

866-925-4288, www.bestwesternellensburg. com. Comfortable motel accommodations.

Guesthouse Ellensburg, 509-962-3706, or 888-699-0123, www.guesthouseellensburg.com. Cozy suites in an 1887 house with a wine shop downstairs.

Holiday Inn Express Ellensburg, 509-962-9400, or 800-465-4329, www.hiexpress. com/ellensburgwa. Well-appointed new lodgings.

Restaurants:

Roslyn Café, 509-649-2763. Eclectic eatery in Roslyn.

Sazon, 509-925-2506. Globally inspired dishes in the historic district.

Starlight Lounge and Dining Room, 509-962-6100. Local gathering spot with Western flair.

Sugar Thai Restaurant, 509-933-4224. Asian specialties in downtown.

Valley Café, 509-925-3050. Sophisticated dining in an easygoing setting.

Yellow Church Café, 509-933-2233. Casual meals in a converted old church.

FRIDAY HARBOR & EASTSOUND

For more information, San Juan Islands Visitors Bureau, P.O. Box 1330, 640 Mullis Street, Friday Harbor, WA 98250, 888-468-3701, www.visitsanjuans.com.

Hotels:

Bird Rock Hotel, 360-378-5848, or 800-352-2632, www.birdrockhotel.com. Boutique lodgings in a historic hotel in Friday Harbor.

Friday Harbor House, 360-378-8455, or 866-722-7356, www.fridayharborhouse.com. Sophisticated 23-room inn with views over Friday Harbor.

Harrison House Suites Bed and Breakfast, 360-378-3587, or 800-407-7933, www. harrisonhousesuites.com. Well-appointed suites in Friday Harbor.

Inn on Orcas Island, 360-376-5227, or 888-886-1661, www.theinnonorcasisland.com. Romantic bed-and-breakfast in Deer Harbor.

Outlook Inn, 360-376-2200, or 888-688-5665, www.outlookinn.com. Historic hotel overlooking the water in Eastsound.

Roche Harbor, 360-378-2155, or 800-451-8910, www.rocheharbor.com. Resort rooms, suites, cottages, and condos at Roche Harbor.

Tucker House Inn Bed and Breakfast, 360-378-2783, or 800-965-0123, www.tuckerhouse. com. Upscale accommodations in a turn-of-the-century house in Friday Harbor.

Restaurants:

Coho, 360-378-6330. Fine Northwest cuisine in Friday Harbor.

Blue Water Grill, 360-378-2245. Burgers, clams, and casual fare in one of the earliest buildings in Friday Harbor.

Inn at Ship Bay, 360-376-5886. Upscale dining room in an inn at the edge of Eastsound.

McMillins Dining Room, 360-378-5757. Gourmet meals in the turn-of-the-century home of the founder of the historic lime kiln company at Roche Harbor.

The Bluff, 360-378-8455. Water-view dining in Friday Harbor.

Vinny's Ristorante, 360-378-1934. Locals' favorite for Italian specialties in Friday Harbor.

GIG HARBOR

For more information, Gig Harbor Visitor & Volunteer Information Center, 3125 Judson Street, Gig Harbor, WA 98335, 253-857-4842, or 888-VIEW-GIG, www.gigharborguide.com.

Hotels:

The Maritime Inn, 253-858-1818, or 888-506-3580, www.maritimeinn.com. Friendly, well-run small hotel across from a waterfront park in the heart of town.

Waterfront Inn, 253-857-0770, www.waterfront-inn.com. Bed-and-breakfast accommodations in a Craftsman-style waterside home at the head of the harbor.

Restaurants:

Brix 25, 253-858-6626. Fine Northwest cuisine with an emphasis on wine pairings.

Green Turtle Restaurant, 253-851-3167. Seafood dishes in a well-appointed setting with water views.

Kelly's Café & Espresso, 253-851-8697. Bustling spot for sandwiches and ice cream in the center of town.

Tides Tavern, 253-858-3982. Lively bar and local gathering place, with pizza, burgers, and other fare, on the water.

LA CONNER

For more information, La Conner Chamber of Commerce, 606 Morris Street, P.O. Box 1610, La Conner, WA 98257, 360-466-4778, or 888-642-9284, www.laconnerchamber.com.

Hotels:

Estep Residences, 360-466-2116, www.estep-properties.com. Condominium accommodations in several locations in La Conner.

Hotel Planter, 360-466-4710, or 800-488-5409, www.hotelplanter.com. Historic 1907 inn on the main street, with twelve atmospheric rooms.

Katy's Inn, 360-466-9909, or 866-528-9746, www.katysinn.com. Four-room bed-and-breakfast in a 19th-century residence on the hill above the main street.

La Conner Country Inn, 360-466-3101, or 888-466-4113, www.laconnerlodging.com. Country-style accommodations in the heart of downtown.

Restaurants:

La Conner Brewing Company, 360-466-1415. Local brewpub serving pizzas and burgers amid contemporary decor.

Nell Thorn, 360-466-4261. Sophisticated dining in a downtown bistro, with a cozy pub.

Seeds, 360-466-3280. Informal bistro and bar with an emphasis on regional ingredients.

Sweet Haven Baking Company, 360-466-2960. Homemade soups, pastries, and sandwiches in the Lime Dock Building.

La Conner Thai Restaurant, 360-466-9999. Asian cuisine in a café setting.

OYSTERVILLE, ILWACO, SEAVIEW & LONG BEACH

For more information, Long Beach Peninsula Visitors Bureau P.O. Box 562, Long Beach, WA 98631, 360-642-2400, or 800-451-2542, www.funbeach.com.

Hotels:

Charles Nelson Guest House, 360-665-3016, or 888-862-9756, www.charlesnelsonbandb.com. Three rooms in a 1928 home with a bay view just south of Oysterville.

The Breakers of Long Beach, 360-642-4414, or 800-219-9833, www.breakerslongbeach.com. Spacious condominium units overlooking the beach.

The Shelburne Inn, 360-642-2442, or 800-466-1896, www.theshelburneinn.com. Fifteen antique-filled rooms in an 1896 country inn in Seaview.

Restaurants:

Jimella's Seafood Market, 360-665-4847. Fresh seafood dishes in a casual setting on the peninsula.

Pelicano, 360-642-4034. Sophisticated seafood and Mediterranean dishes on the waterfront in Ilwaco.

The Depot, 360-642-7880. Fine dining in a converted depot of the "Clamshell Railroad" in Seaview.

The Shelburne Inn, 360-642-2442. Northwest cuisine in a historic inn in Seaview.

PORT TOWNSEND

For more information, Port Townsend Visitor Information Center, 440 12th Street, Port Townsend, WA 98368, 360-385-2722, or 888-365-6978, www.EnjoyPT.com.

Hotels:

Ann Starrett Mansion, 360-385-3205, or 800-321-0644, www.StarrettMansion.com. Boutique hotel in a luxurious 1889 Victorian home.

Bishop Hotel, 360-385-6122, or 800-824-4738, www.bishopvictorian.com. Sixteen suites in a renovated turn-of-the-century hotel.

Palace Hotel, 360-385-0773, or 800-962-0741, www.palacehotelpt.com. Historic downtown hotel with spacious rooms and Victorian atmosphere.

Restaurants:

Courtyard Café, 360-379-3355. Locals' favorite for breakfast and lunch.

Fins Coastal Cuisine, 360-379-3474. Fine regional seafood with a water view.

Sweet Laurette's Café & Bistro, 360-385-4886. French-inspired bistro dishes and superb pastries in the Uptown area.

Silverwater Café, 360-385-6448. A sophisticated eclectic menu emphasizing local and organic ingredients.

Sirens of Port Townsend, 360-379-1100. Upscale waterview bar with casual fare.

The Belmont, 360-385-3007. Classic cuisine in an 1885 building on the waterfront.

WALLA WALLA & DAYTON

For more information, Tourism Walla Walla, 8 S. Second Avenue, Suite 603, Walla Walla, WA 99362, 877-998-4748, www.wallawalla.org.

Hotels:

Marcus Whitman Hotel & Conference Center, 509-525-2200, or 866-826-9422, www.marcuswhitmanhotel.com. Luxurious accommodations in a Walla Walla landmark.

The Weinhard Hotel, 509-382-4032, www.weinhard.com. Fifteen Victorian-style rooms in Dayton's historic district.

The Maxwell House Bed & Breakfast, 509-529-4283, or 866-377-0700, www.themaxwellhouse.com. Rooms in a restored Craftsman-style inn.

Restaurants:

CreekTown Café, 509-522-4777. Fine wine country cuisine.

Manila Bay, 509-382-2520. Asian specialties in historic Dayton.

Merchants LTD., 509-525-0900. Locals' favorite deli for breakfast and lunch.

T. Maccarone's Italian, 509-522-4776. Gourmet pasta dishes in a casually elegant setting.

The Marc Restaurant, 509-525-2200. Sophisticated dining in the Marcus Whitman Hotel.

Whitehouse-Crawford Restaurant, 509-525-2222. Northwest cuisine and wines in a strikingly converted mill building.

WINTHROP

For more information, Winthrop Chamber of Commerce, 202 Highway 20, P.O. Box 39, Winthrop, WA 98862, 509-996-2125, or 888-463-8469, www.winthropwashington.com.

Hotels:

Chewuch Inn & Cabins, 509-996-3107, or 800-747-3107, www.chewuchinn.com.

Beautifully appointed Craftsman-style bed-and-breakfast inn.

Hotel Rio Vista, 509-996-3535, or 800-398-0911, www.hotelriovista.com. Comfortable riverside rooms in the heart of town.

Sun Mountain Lodge, 509-996-2211, or 800-572-0493, www.sunmountainlodge.com. Luxury resort in the hills outside Winthrop.

Restaurants:

Arrowleaf Bistro, 509-996-3919. Northwest cuisine in a casually elegant setting.

Duck Brand Restaurant, 509-996-2192. Mexican specialties in a cozy setting with an outdoor deck in summer.

Old Schoolhouse Brewery, 509-996-3183. Sandwiches, salads, and locally brewed beer.

Sun Mountain Lodge Dining Room, 509-996-2211. Fine dining with a spectacular view.

Three Fingered Jack's Saloon, 509-996-2411. Pizza, burgers, and other fare in an Old West atmosphere.

BRITISH COLUMBIA

For more information, Tourism British Columbia, 800-435-5622, www.hellobc.com.

FERNIE

For more information, Tourism Fernie, Box 1928, Fernie, BC V0B 1M0, 250-423-2037, or 877-933-7643, www.tourismfernie.com.

Hotels:

Best Western Fernie Mountain Lodge, 250-423-5500, or 866-423-5566, www. bestwesternfernie.com. Large, comfortable motel next to the Fernie Golf & Country Club.

Cornerstone Lodge, 250-423-6855, or 888-423-6855, www.cornerstonelodge.ca. Suites in a lodge with rustic decor in the center of the village at Fernie Alpine Resort.

Island Lake Lodge, 250-423-3700, or 888-422-8754, www.islandlakeresorts.com. Chalet accommodations in a spectacular lakeside setting, featuring cat-skiing in winter.

Old Nurses Residence Bed and Breakfast, 250-423-3091, or 877-653-6877, www.oldnurse.com. Victorian rooms in a restored turn-of-the-century nurses' residence close to the historic district.

Park Place Lodge, 250-423-6871, or 888-381-7275, www.parkplacelodge.com. Spacious rooms and suites in a well-kept hotel within walking distance of downtown.

Restaurants:

Island Lake Lodge, 250-423-3700. Sophisticated dining with a view of a mountain lake.

The Blue Toque Diner, 250-423-4637. Locals' favorite for breakfast and lunch in a renovated railway station.

The Brickhouse Bar & Grill, 250-423-0009. Upscale pub meals in a turn-of-the-century bank.

The Old Elevator, 250-423-7115. Fine dining in a historic grain elevator building.

Yamagoya Japanese Restaurant, 250-430-0090. Sushi bar and other Japanese dishes in a casual setting.

FORT LANGLEY

For more information, Tourism Langley, Unit 2, 7888 200th Street, Langley, BC V2Y 3J4, 604-888-1477, or 888-788-1477, www.tourism-langley.ca.

Hotels:

Willoughby Manor Bed & Breakfast, 604-888-1520, www.willoughbymanor.com. Spacious Victorian-style rooms in a replica turn-of-the-century residence with an expansive garden.

Restaurants:

Eighteen 27, 604-455-0211. Upscale tapas, pizzas, and martini bar, with live jazz.

Lampliter Gallery Café, 604-888-6464. Italian and Northwest specialties on the main street.

The Fort Pub & Grill, 604-888-6166. Casual fare in a friendly sports bar atmosphere.

Wendel's Bookstore & Café, 604-513-2238. Breakfast, lunch, and snacks in the heart of downtown.

FORT STEELE

For more information, Fort Steele Heritage Town, 9851 Highway 93/95, Fort Steele, BC V0B 1N0, 250-417-6000, www.FortSteele.ca.

Cranbrook & District Chamber of Commerce, Box 84, Cranbrook, BC V1C 4H6, 250-426-5914, or 800-222-6174, www.cranbrookchamber.com.

Hotels:

St. Eugene Golf Resort Casino, 250-420-2000, or 866-292-2020, www.steugene.ca. Luxury accommodations in a beautifully renovated historic First Nations residential school, with a golf course and casino, in Cranbrook.

Restaurants:

Allegra, 250-426-8812. Mediterranean flavors and a seasonally changing menu in Cranbrook.

Fisher Peak Lounge, 250-420-2025. Tapas and burgers in an intimate bar at the St. Eugene Golf Resort Casino in Cranbrook.

International Hotel Restaurant, 250-417-6000. Barbecue lunches and special evening and holiday meals in a re-created Victorian hotel dining room at Fort Steele Heritage Town.

GANGES

For more information, Salt Spring Island Visitor Centre, 121 Lower Ganges Road, Salt Spring Island BC V8K 2T1, 250-537-5252, or 866-216-2936, www.saltspringtourism.com.

Hotels:

Harbour House Hotel, 250-537-5571, or 888-799-5571, www.saltspringharbourhouse.com. Comfortable rooms in a long-established waterview hotel in Ganges.

Hastings House, 250-537-2362, or 800-661-9255, www.hastingshouse.com. Elegant country-style hotel on the water in Ganges.

Restaurants:

Hastings House, 250-537-2362. Gourmet European and Northwest cuisine in a beautifully appointed dining room with a harbor view.

House Piccolo, 250-537-1844. European specialties in an intimate house setting in Ganges.

Oystercatcher Seafood Bar & Grill, 250-537-5041. Fish dishes in a casually elegant bistro near the marina.

LADYSMITH & CHEMAINUS

For more information, Ladysmith Visitor Information Centre, 411B First Avenue, Ladysmith, BC V9G 1A4, 250-245-2112, www.tourismladysmith.ca.

Chemainus Visitor Centre, P.O. Box 575, 9796 Willow Street, Chemainus, BC V0R 1K0, 250-246-3944, www.chemainus.bc.ca.

Hotels:

Chemainus Festival Inn, 250-246-4181, or 877-246-4181, www.festivalinn.ca. Spacious suites in a well-run motel at the edge of Chemainus.

Hawley Place Bed & Breakfast, 250-245-4431, or 877-244-4431, www.hawleyplacebandb.com. Three atmospheric guest rooms in a replica Victorian residence in Ladysmith.

Sandpiper Bed & Breakfast, 250-245-5794, www.sandpiperbb.com. Two guest rooms in a home near the center of Ladysmith.

Restaurants:

Crow and Gate Pub, 250-722-3731. English-style pub just north of Ladysmith in Cedar.

Jimmy O's Grill, 250-245-2312. Waterview dining on Ladysmith Inlet.

Royal Dar, 250-245-0168. Indian cuisine in a turn-of-the-century house in Ladysmith.

SaltAir Pub, 250-246-4942. Casual meals in a cozy watering hole between Ladysmith and Chemainus.

Willow Street Café, 250-246-2434. Breakfast, lunch, and light fare in Chemainus.

NELSON & KASLO

For more information, Nelson & District Chamber of Commerce, 225 Hall Street, Nelson, BC V1L 5X4, 250-352-3433, or 877-663-5706, www.DiscoverNelson.com.

Kootenay Lake Historical Society, 334 Front Street, P.O. Box 537, Kaslo, BC V0G 1M0, 250-353-2525, www.klhs.bc.ca.

Hotels:
Beach Gables, 250-353-2111, www.beachgables.ca. Three theme rooms with stunning views of Kootenay Lake in Kaslo.
Blaylock's Mansion, 250-825-2200, or 888-788-3613, www.blaylock.ca. Accommodations in a Tudor-style mansion, with heritage gardens, just outside Nelson.
Kaslo Hotel, 250-412-5300, or 866-823-1433, www.kaslohotel.com. Small Western-style hotel on the lake in Kaslo.
The Hume Hotel, 250-352-5331, or 8787-568-0888, www.humehotel.com. Atmospherically renovated 1898 hotel in the heart of Nelson's historic district.
The Prestige Lakeview Inn, 250-352-3595, or 877-737-8443, www.prestigehotelsandresorts.com/nelson-lakeview-prestige-hotel.php. Resort-style lodgings on Kootenay Lake in Nelson.

Restaurants:
All Seasons Café, 250-352-0101. Fine dining in a heritage home in Nelson.
Blue Belle Bistro and Beanery, 250-353-7361. Casual fare in Kaslo.
Main Street Diner, 250 354-4848. Greek dishes and burgers for lunch and dinner in Nelson.
Max & Irma's Kitchen, 250-352-2332. Locals' favorite for pizzas from a wood-burning oven in Nelson.
Outer Clove, 250-354-1667. Garlic-inspired global menu in a heritage building just off Baker Street in Nelson.
Redfish Grill, 250-352-3456. Fusion cuisine in a youthful atmosphere in Nelson.
Silver Spoon Bakery, 250-353-2898. Delectable home-baked creations for breakfast and lunch in Kaslo.
The Library Lounge, 250-352-5331. Intimate bar-restaurant with live jazz in the historic Hume Hotel in Nelson.
The Rosewood Café, 250-353-7673. Barbeque and seafood specialties in a turn-of-the-century house in Kaslo.
The Treehouse Restaurant, 250-353-2955. Informal, family restaurant in Kaslo.

REVELSTOKE

For more information, Revelstoke Chamber of Commerce, 204 Campbell Avenue, Box 490, Revelstoke, BC V0E 2S0, 250-837-5345, or 800-487-1493, www.seerevelstoke.com.

Hotels:
Amble Inn, 250-837-4665, www.bbcanada.com/ambleinn. Three-room bed-and-breakfast in a historic house close to downtown.
Day's Inn & Suites, 250-837-2191, or 800-663-5303, www.daysinnrevelstoke.ca. Spacious accommodations in a comfortable motel at the entrance to downtown.
Minto Manor Bed and Breakfast, 250-837-9337, or 877-833-9337, www.mintomanor.com. Edwardian-style rooms in a 1905 heritage mansion in the historic district.
Nelsen Lodge, 250-814-5000, www.sandmansignature.com/revelstokelocation.html. Contemporary alpine condominium accommodations at the base of Revelstoke Mountain Resort.
Regent Inn, 250-837-2107, or 888-245-5523, www.regentinn.com. Boutique hotel just off the main downtown street.

Restaurants:
Emo's Restaurant, 250-837-6443. Pizza, pasta, and Greek dishes.
Kawakubo, 250-837-2467. Japanese cuisine in an intimate setting.
Modern Bakery, 250-837-6886. Pastries and lunch in a historic building in the main street.
The Last Drop, 250-837-2121. British pub dishes.
Woolsey Creek Bistro, 250-837-5500. Casually elegant café with finely prepared world cuisine.
112 Restaurant and Lounge, 250-837-2107. Steaks and fine dining in the Regent Inn.

WHISTLER

For more information, Tourism Whistler, 4010 Whistler Way, Whistler, BC V0M 1B4, 800 944 7853, www.whistler.com.

Hotels:
Chateau Fairmont Whistler, 604-938-8000, or 800-606-8244, www.fairmont.com/whistler. Grand resort hotel in the upper village.
Four Seasons Whistler, 604-935-3400, or 800-819-5053, www.fourseasons.com/whister. Luxe contemporary hotel near Blackcomb Mountain.
Nita Lake Lodge, 604-966-5700, or 888-755-6482, www.nitalakelodge.com. Boutique hostelry on the shores of Nita Lake near Creekside.
Pan Pacific Whistler Mountainside, 604-905-2999, or 888-905-9995, www.panpacific.com/WhistlerMountainside/overview.html. Well-appointed rooms just steps from the ski lifts.
Pan Pacific Whistler Village Centre, 604-966-5500, or 888-966-5575. www.panpacific.com/WhistlerVillageCentre/overview.html. Sophisticated rooms and suites in the heart of the village.

Restaurants:
Araxi, 604-932-4540. Gourmet Northwest cuisine in an elegant dining room.
Bearfoot Bistro, 604-932-3433. Innovative dishes from a prize-winning chef.
Dubh Linn Gate, 604-905-4047. Irish pub with live music in the village.
Dusty's Bar & BBQ, 604-905-2146. Longtime favorite watering hole for beer and barbecue in Creekside.
Elements Urban Tapas, 604-932-5569. Asian-flavored small plates and martini bar.
Garibaldi Lift Company, 604-905-2220. Lively bar, restaurant, and club for après-ski.
Rimrock Café, 604-932-5565. Fine dining with fish and game specialties in an intimate setting.
The Mix by Ric's, 604-932-6499. Upscale breakfast, lunch, and small plates in the village center.

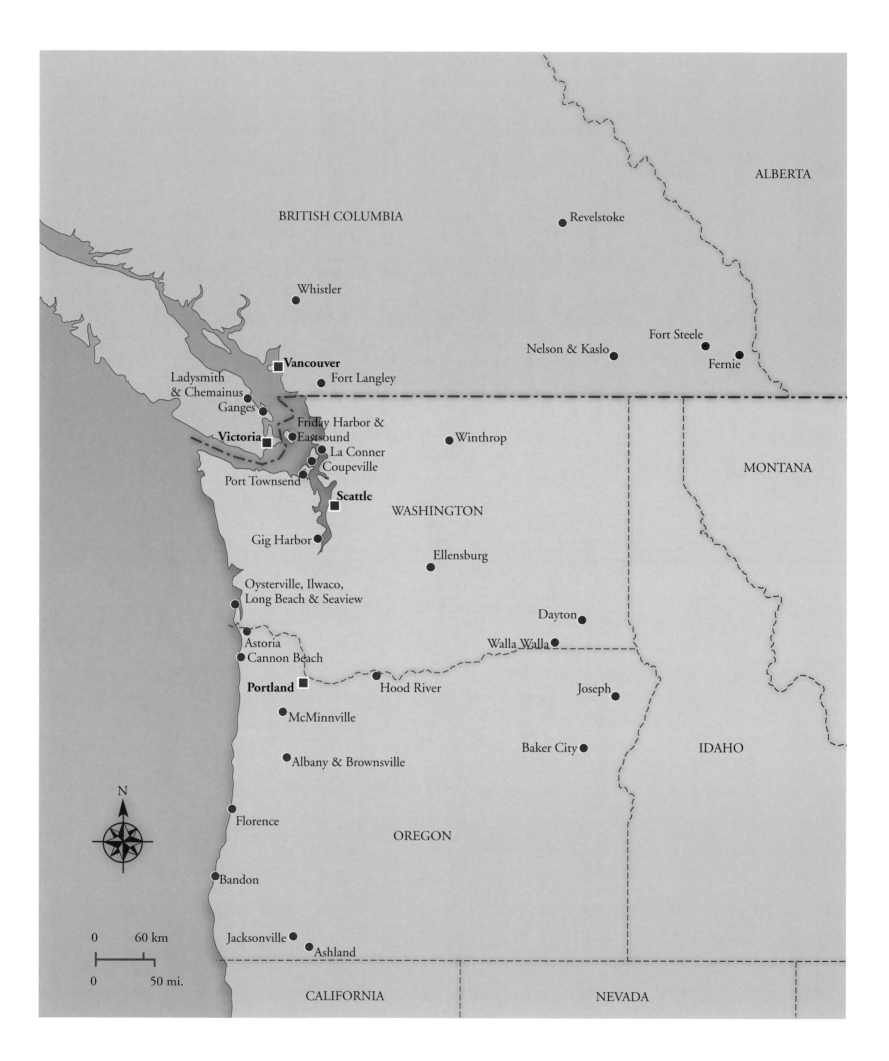

ALBERTA

BRITISH COLUMBIA

Revelstoke

Whistler

Fort Steele

Nelson & Kaslo

Fernie

Vancouver

Ladysmith
& Chemainus

Fort Langley

Ganges

Friday Harbor &
Eastsound

Winthrop

MONTANA

Victoria

La Conner

Coupeville

Port Townsend

Seattle

WASHINGTON

Gig Harbor

Ellensburg

Oysterville, Ilwaco,
Long Beach & Seaview

Dayton

Astoria

Walla Walla

Cannon Beach

Portland

Hood River

Joseph

McMinnville

Albany & Brownsville

Baker City

IDAHO

Florence

OREGON

N

Bandon

Jacksonville

0 60 km

Ashland

0 50 mi.

CALIFORNIA

NEVADA

Selected Reading

The following books provide interesting background for the chapters and essays in this book.

History, Natural History, and Culture

Ambrose, Stephen E., *Undaunted Courage: Meriwether Lewis, Thomas Jefferson, and the Opening of the American West* (1996)

Barman, Jean, *The West Beyond the West: A History of British Columbia* (3rd edition, 2007)

Dary, David, *The Oregon Trail: An American Saga* (2004)

Gordon, David, Nancy Blanton, and Terry Y. Nosho, *Heaven on the Half Shell: The Story of the Northwest's Love Affair with the Oyster* (2003)

Hayes, Derek, *Historical Atlas of the Pacific Northwest: Maps of Exploration and Discovery: British Columbia, Washington, Oregon, Alaska, Yukon* (2002)

Jones, Ray, *Pacific Northwest Lighthouses* (1997)

Lavender, David, *Land of the Giants* (1979)

O'Connell, Nicholas, *On Sacred Ground: The Spirit of Place in Pacific Northwest Literature* (2003)

Ruby, Robert H., and John A. Brown, *Indians of the Pacific Northwest* (1981)

Schwantes, Carlos, *The Pacific Northwest: An Interpretive History* (1989)

Individual Towns, Local History, Memoirs, and Biographies

Bown, Stephen, *Madness, Betrayal, and the Lash: The Epic Voyage of Captain George Vancouver* (2009)

Egan, Timothy, *The Good Rain: Across Time and Terrain in the Pacific Northwest* (1990)

Jacob, Greg, *Fins, Finns, and Astorians* (2006)

Kessler, Lauren, *Stubborn Twig: Three Generations in the Life of a Japanese American Family* (1993)

MacDonald, Betty, *The Egg and I* (1945)

McLean, Kit, and Karen West, *Bound for the Methow* (2009)

Nerburn, Kent, *Chief Joseph and the Flight of the Nez Perce* (2005)

Nisbet, Jack, *Sources of the River* (2007)

Nobbs, Ruby M., *Revelstoke: History and Heritage* (1998)

Peacock, Christopher M., *Rosario Yesterdays* (1985)

Stevens, Sydney, *Oysterville: The First Generations* (2006)

Vouri, Michael, *The Pig War: Standoff at Griffin Bay* (1999)

Arcadia Publishing Company has issued numerous local and narrow-focus photographic histories, including many of the towns, counties, and means of transportation in this book. See www.arcadiapublishing.com.

Fiction

Dillard, Annie, *The Living* (1992)

Guterson, David, *Snow Falling on Cedars* (1994)

Kesey, Ken, *Sometimes a Great Notion* (1964)

Le Guin, Ursula, *Searoad* (1991)

Robbins, Tom, *Another Roadside Attraction* (1971)

Acknowledgments

The author and photographer would like to thank the following individuals and organizations for their assistance with this project.

Dick Boushey
Monica Campbell-Hoppe
Kit McLean Cramer
Helen Grace
Andrea Johnson
Rob Johnson
Mike Pennock
Donna Quinn
Amy Richard
Kathy Shiels
Sandy Strehlou
Sydney Stevens
Bill Tennent
David Wheeler

Canadian Tourism Commission
Washington State Tourism
Air Canada

OREGON

Albany
Albany Visitors Association
Pfeiffer Cottage Inn

Ashland
Ashland Chamber of Commerce
Oregon Shakespeare Festival
Albion Inn
Mount Ashland Inn

Astoria
Cannery Pier Hotel

Baker City
Baker County Chamber of Commerce & Visitor Center
Best Western Sunridge Inn

Bandon
Bandon Chamber of Commerce
Best Western Inn at Face Rock Resort

Cannon Beach
Cannon Beach Chamber of Commerce
Inn at Cannon Beach

Florence
Florence Area Chamber of Commerce
Driftwood Shores Resort and Conference Center

Hood River
Hood River County Chamber of Commerce
North Pacific Management

Jacksonville
Jacksonville Chamber of Commerce
Southern Oregon Historical Society
The Jacksonville Inn

Joseph
Wallowa County Chamber of Commerce
The Historic Enterprise House Bed & Breakfast

McMinnville
McMinnville Downtown Association
A' Tuscan Estate
Baker Street Bed & Breakfast
McMenamins Hotel Oregon
The Pinot Quarters

WASHINGTON

Coupeville
Central Whidbey Chamber of Commerce
Blue Goose Inn

Ellensburg
Ellensburg Chamber of Commerce
Holiday Inn Express Ellensburg

Friday Harbor & Eastsound
San Juan Islands Visitors Bureau
Outlook Inn
Tucker House Inn/Harrison House Suites

Gig Harbor
City of Gig Harbor Visitor Information & Marketing Department
The Maritime Inn

La Conner
La Conner Chamber of Commerce
La Conner Country Inn

Oysterville, Ilwaco, Seaview & Long Beach
Long Beach Peninsula Visitors Bureau
Charles Nelson Guest House

Port Townsend
City of Port Townsend
Port Townsend Chamber of Commerce
Jefferson County Historical Society
Palace Hotel

Walla Walla
Tourism Walla Walla
Marcus Whitman Hotel and Conference Center

Winthrop
Winthrop Chamber of Commerce
Chewuch Inn

Yakima Valley
Wine Yakima Valley
Desert Wind Winery

BRITISH COLUMBIA

BC Ferries
Black Ball Ferry Line

Fernie
Tourism Fernie
Park Place Lodge

Fort Langley
Tourism Langley
Willoughby Manor B & B

Fort Steele
Fort Steele Heritage Town
Cranbrook & District Chamber of Commerce
St. Eugene Golf Resort Casino

Ladysmith & Chemainus
Ladysmith Chamber of Commerce
Ladysmith Tourism Advisory Committee
Chemainus Festival Inn
Hawley Place Bed & Breakfast

Nelson & Kaslo
Kootenay Lake Historical Society
Beach Gables
Hume Hotel

Revelstoke
Revelstoke Accommodation Association
Days Inn & Suites Revelstoke
Nelsen Lodge

Victoria
Tourism Victoria
Fairmont Empress Hotel
Magnolia Hotel & Spa

Whistler
Tourism Whistler
Pan Pacific Whistler Mountainside
Pan Pacific Whistler Village Centre
Whistler-Blackcomb